HUMANS OF DUBLIN

HUMANS OF DUBLIN

PETER VARGA

GILL BOOKS

Gill Books
Hume Avenue
Park West
Dublin 12
www.gillbooks.ie

Gill Books is an imprint of M.H. Gill & Co.

© Peter Varga 2016

978 07171 7256 6

Designed by WorkGroup
Copy-edited by Barrett Editing
Proofread by Emma Dunne
Printed in Italy by L.E.G.O. SpA

This book is typeset in Grotesque MT.

The paper used in this book comes
from the wood pulp of managed
forests. For every tree felled, at
least one tree is planted, thereby
renewing natural resources.

A CIP catalogue record for this book
is available from the British Library.

5 4 3 2 1

Édesanyámnak sok
szeretettel.

If you want to understand the world of humans around you, start with empathy!

'Step outside of your tiny, little world. Step inside of the tiny, little world of somebody else. And then do it again and do it again and do it again. And suddenly all these tiny, little worlds, they come together in this complex web. And they build a big, complex world. And suddenly, without realising it, you're seeing the world differently. Everything has changed. Everything in your life has changed. And that's of course what this is about. Attend to other lives, other visions. Listen to other people, enlighten ourselves.'

Sam Richards (TED Talks)

INTRODUCTION

I used to study car mechanics back in Hungary, but when I was 19 I got an opportunity to go to Dublin to work. I was planning to stay for three months. That was nine years ago and now I feel like a Dubliner. After trying numerous different jobs, I started work as a barista and, although I liked coffee and I was great at latte art, I needed something more. I had to find my passion. I was determined to find a new career path where I ended up in a job that would get the best out of me.

I always liked taking pictures and if I went on trips I was the one who trailed behind the group, photographing the same thing from every possible angle. Although I didn't think I would be better than anyone else, I was interested enough in photography to sign up for a course. Before it began I bought my first DSLR camera and while I was playing around with it I realised it would be a good idea to work on a few small projects before the course started so I could build up some experience. We had a regular customer in the café who worked as a press photographer, and every time he came in, if it wasn't too busy, I would chat with him about photography and ask him for advice and ideas for projects that would challenge my creativity and perspective. Without realising it, he became my mentor. Around the same time my girlfriend introduced me to the Humans of New York Facebook page, and we talked about how great it would be to have a Dublin version.

In August 2014, after a particularly busy and stressful day in the café, I decided to go out and start a project. At the time, I had no idea how to approach people on the street or how to get them to talk to me, but I knew that I desperately wanted to give it a shot. On my first day, my goal was to approach three people and then go home. I ended up doing eight interviews, which were almost all awkward and some of them made me feel very confused and shy, but at the end of the day I was full of adrenalin and felt hugely excited. I knew this was the way I had to go. I really believed in the project from the first moment.

At the beginning it was very hard to approach strangers, but after each interview my confidence grew and the conversations became more and more personal. I got a lot of questions about it from friends: 'Where is this going?', 'What's the end goal?', 'How is this viable?' The only answer I could give at that point was, 'It makes me feel something I want to hold on to.' I just fell in love with it and Humans of Dublin has become the first, and the greatest, photo project of my life.

I have learnt many things from this project, but the most important thing is to believe in yourself. If you do, nothing will stop you in life. Two years and hundreds of portraits later, the process has been more than worth it, and it's finally time to take the next big step. I hope you enjoy discovering more about the ordinary extraordinary people who pass you by every day.

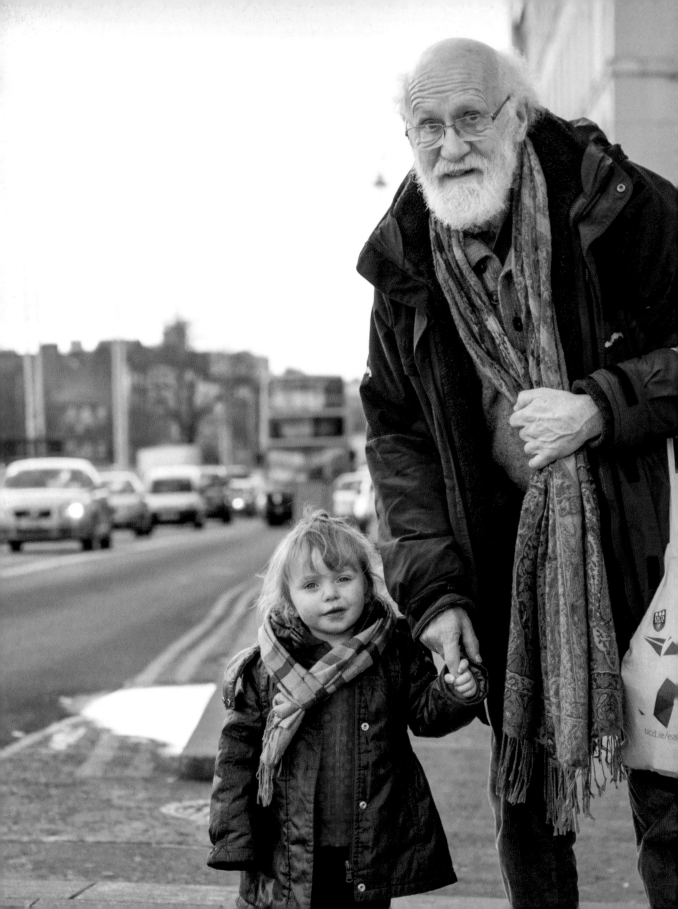

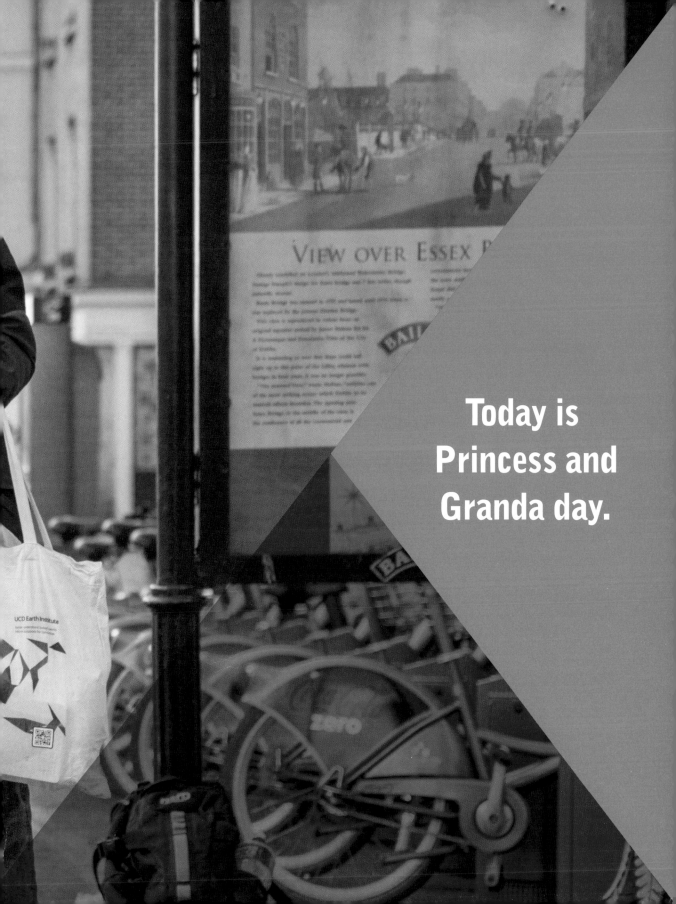

Today is
Princess and
Granda day.

▶ I had a fringe and it annoyed me … So I said fuck it. ◀

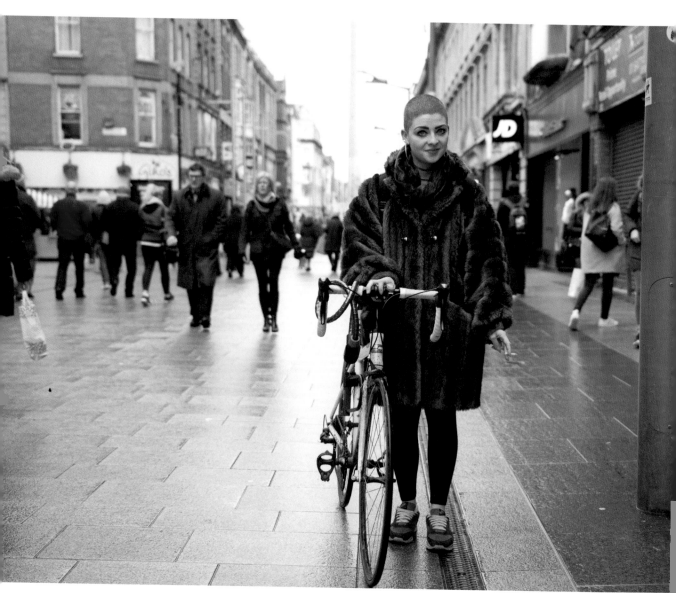

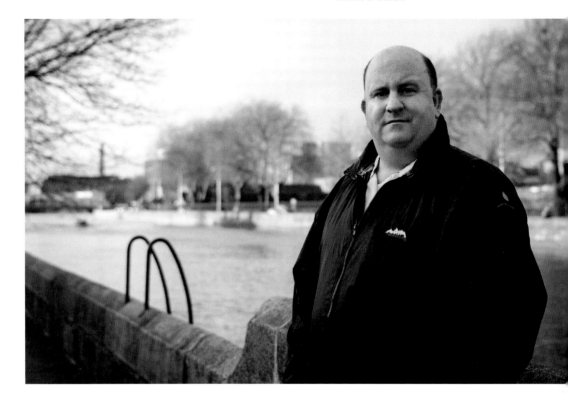

▶ It took me about three months to realise my potential. I could see the difference in clients' faces after the third or fourth week, and they got all the medication and treatments as well, but the healthy and nutritious food made the most visible difference. There was one lady in her fifties, she was in very bad shape, and she was living on the streets a long time. So she started her detox with us, and on her second day she came to me at the counter, still shaking from the treatment, and said, 'Mark, I couldn't tell you the last time I had cabbage … Thank you!' I got very emotional. I thought, 'I really do have a mission with what I do … I'm not a chef in a fancy restaurant, but here I feel important and those happy faces smiling back at the counter are worth more than anything!' ◀

In foster care you may sometimes feel like your home is unstable, or that you don't actually have a home. But I think my foster-mother was the perfect person for me. She knew I needed my own space, and she knew I needed a home much more than a temporary location, so one of my earlier happy memories of being in care was when she asked me if I wanted to change the furniture around in my room. I literally jumped at the chance even though, after some time of moving the furniture side to side and all around the room, I eventually resettled them the way they were originally placed. It may seem like a simple gesture, but it's hard to describe ultimately what it meant for me. Later she asked me if I wanted to decorate the room, so we went shopping and I picked the paint and floor and we decorated it together. After that moment, I strangely felt that this was my forever home, as odd as that sounds, and it wasn't going to be taken away from me so easily. I felt like I was here to stay, which was such a powerful feeling for me. It helped me make the transition from staying in another family's home to becoming a part of that home and family which I love. And I now have that for the rest of my life. ◀

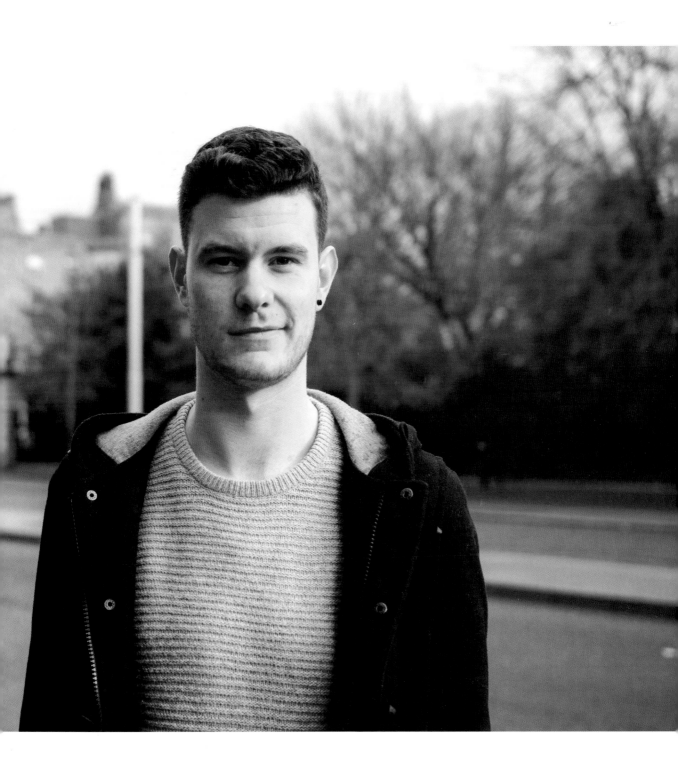

Is there anything you consider unique about yourself?

▶ Well, I guess my name, my eyes, my body shape, the way I talk, that I'm a single parent with four children and studying sociology and psychology full-time. I think all these things make me unique. Being unique is the way you see yourself, not what other people think. Everyone is unique in that way. ◀

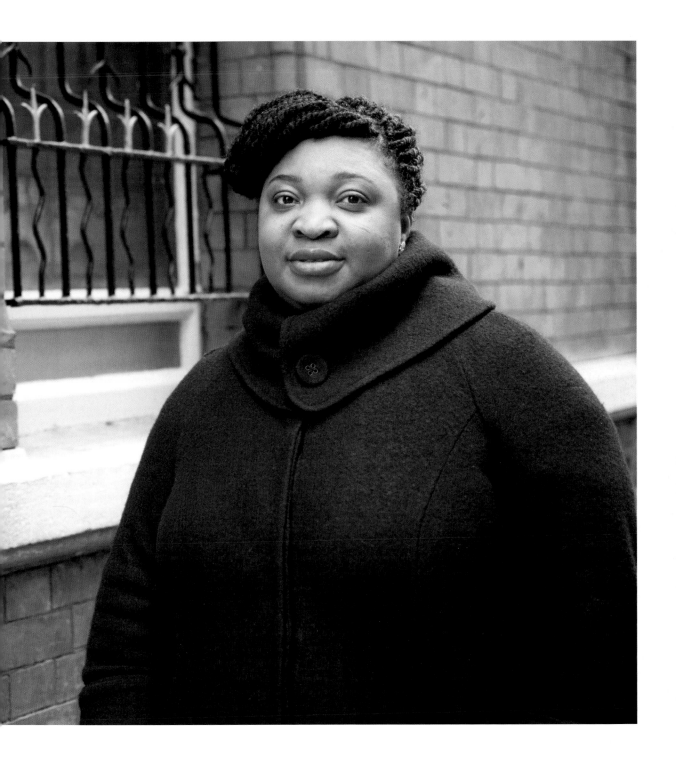

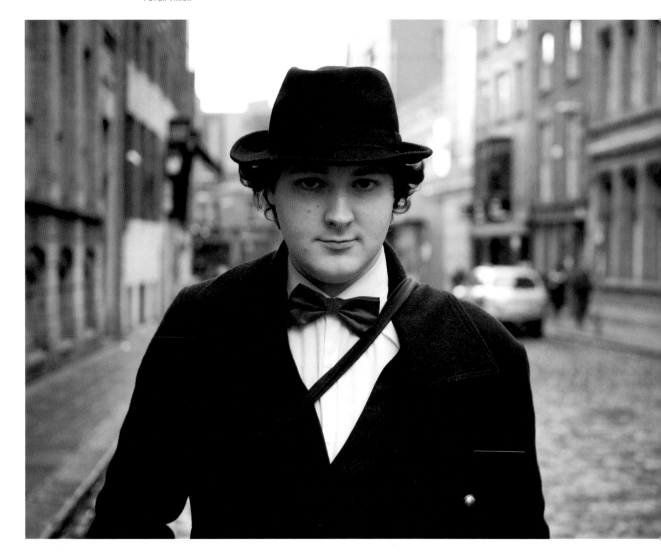

▸ I quite like vintage clothes. People know I collect bow ties
so I get a lot of them as gifts. I have one from almost
everyone I know. If I'm meeting someone, I try to wear
the one I got from them. This one is actually from the
primary school kids I teach. ◂

▸ When I was 21 I bought a Porsche from my own earnings. The year before I was just travelling around, and I spent all my money so I had to come back. When I arrived back I was like 'Now what?' So I joined a company as a financial consultant. I loved it, and the people loved me too. I would say being successful is much more about people than about money and cars. The mutual respect is more important, and to help people for nothing and mentor young people, especially with big hopes and dreams, is great ... When I was 21 I had no prospects, and suddenly things just turned around. But it wasn't just a matter of luck. I made use of people to help me to get where I wanted, and I found the right people and the right time to do that. I think it's very important to look for mentors in your life too. You should actually depend on them and expect to find somebody in your surroundings. I also think people should offer more as mentors, because it's a two-way thing. Incredible friendships and amazing opportunities can be born from these relationships. Being able to help people is the currency which is greater than money. It will give a real value to you being here. ◂

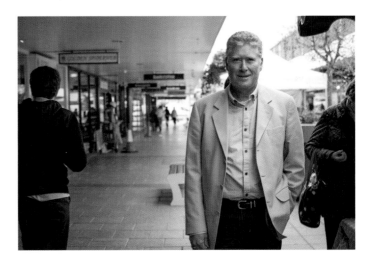

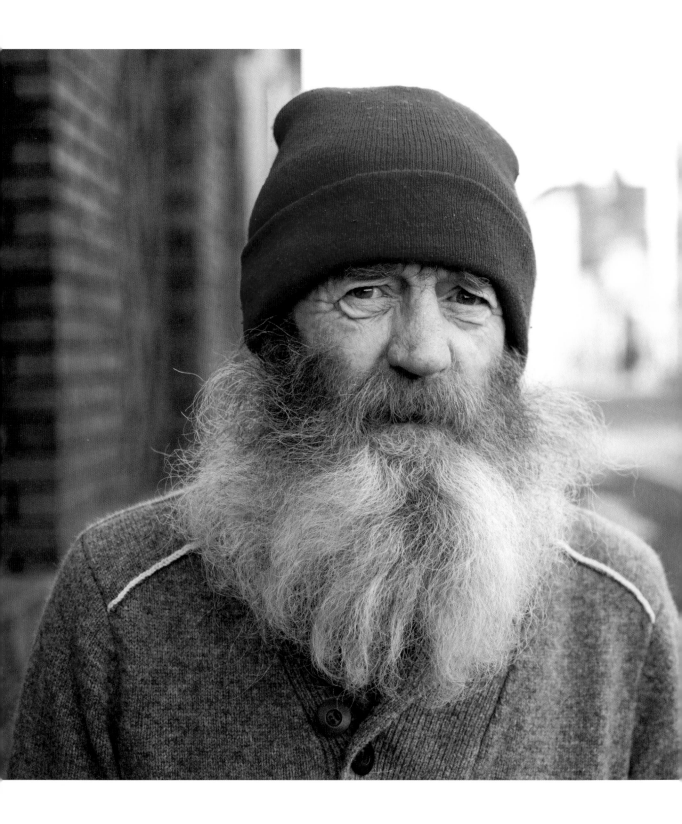

May I ask
for a little
smile?

I'm smiling.

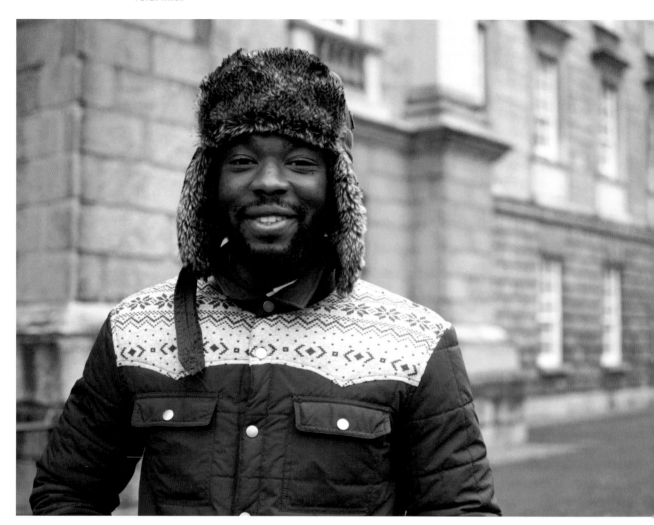

▶ Don't change yourself just to fit in with anyone else, they won't respect you for it.

This is a raw experience I had recently, where I had a couple of friends and I compromised my beliefs to fit in with them. After a while I started to hit my limits and I didn't feel comfortable anymore. They looked at me like I was a hypocrite and they didn't respect me anymore. If I had stood my ground from the beginning, we wouldn't get to that stage, and they wouldn't see me that way. ◀

▸ I'm from Canada, but I met her in England. I was the English and Literature teacher; she was the Art teacher. We kind of had the same sense of humour, and we didn't need much time to fall in love. After the second year my visa expired, so I couldn't stay in England, and she couldn't come to Canada, so we packed up our life and now we're here. We only arrived three weeks ago, so we don't know anybody, we don't have jobs, and we don't have much money. But we're together. ◂

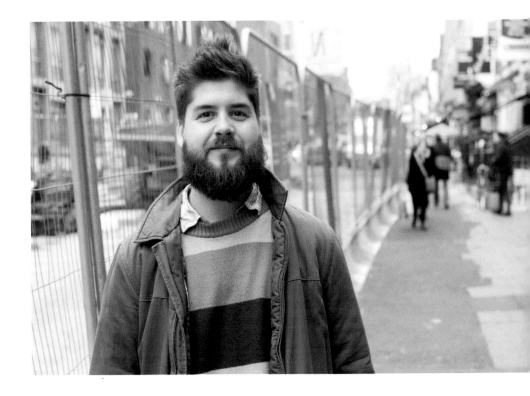

I met him in a sex shop. We were both just doing our shopping and we started to chat. He said he plays music and I said I play music and now we have a band called Mutefish. We play progressive techno folk.

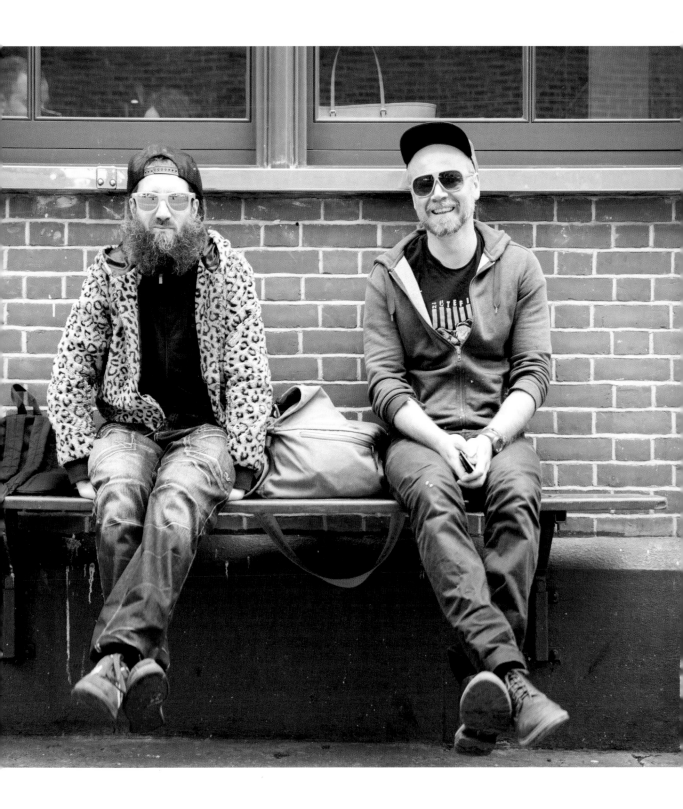

I'm from Hungary, and I started hitch-hiking about five years ago. I felt an inner motivation to transform my life into a journey. I still needed to finance it somehow, so I started street performing with giant bubbles. But after a while I realised it's not the best in every weather. I needed something I could do in underpasses and arcades, and this is how I developed the puppet show.

At first I only hitch-hiked in the summer, but then I did a bigger trip from Hungary to Ireland by bicycle. It took about half a year to get here. I was cycling about 100 km a day, and I slept in a tent, or sometimes in a hostel when I felt it was necessary. The only big expense was the ferry ticket really. ◀

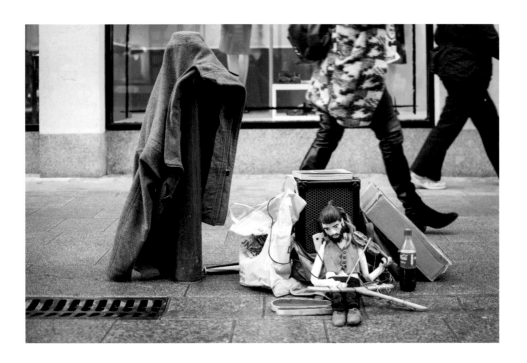

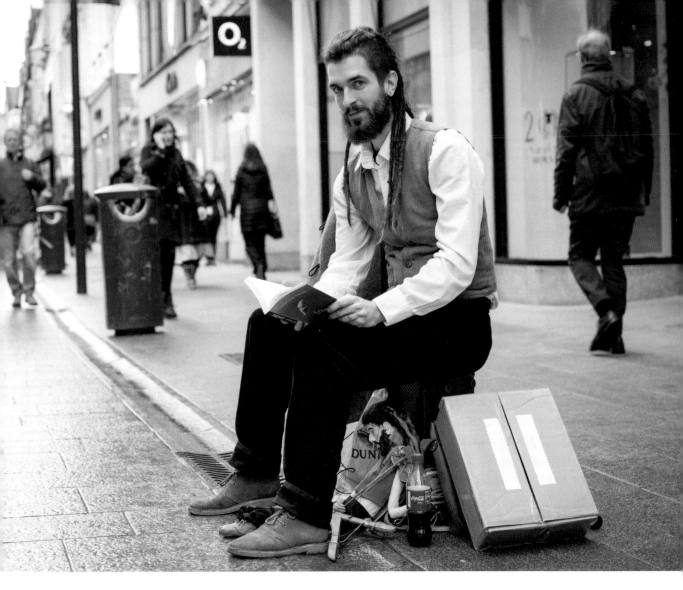

What do you love the most about being a street performer?

▸ I love being free, that I can move my own strings. If I get bored of a
city, I just move. If I get bored of a country, I set up a new journey.
I love to plan and create my scenes and take it to the street and
watch people's reactions. ◂

I guess you can't really manage a long relationship with this lifestyle.

▸ Well, I'm in Ireland since June, and I have a fiancée. We're together
over three years now. She's a street performer as well. She plays
ukulele and sings. I take her with me wherever I can. It looks like we'll
stay in Galway for a while. We're expecting a baby in July, but we
plan to keep ourselves on the move. ◂

▶ I have a child with her, and she's still saying I could go home any time … I just have to be clean. I'm in the process of trying to stop. At that time, I argued a lot with her, and anyway we weren't prepared for her getting pregnant … And at the same time I lost my job, and my mother got breast cancer. I had all these things in my head that day. I met up with some mates and they told me to try it. I'd never even touched drugs, and I still don't understand why I did it. I just put a little on the top of my cigarette and I smoked it. It was like all the problems in the world just flew away. I wasn't thinking about my girlfriend, my mother, my job, my child … I had no feelings. I just existed, but nothing else. And for a while, I thought I had control over it. But then one day I woke up and I had nothing, and I felt sick. I thought I had the flu. My mate told me I was withdrawing and I didn't believe him. So he gave me one line, two lines and then … I was alright. It was then that I knew I'd lost control. I had it all, you know? And then just – gone. And this is me now. I don't want to be here. Nobody wants to be on the streets. I want to get out of this town. I want to be fresh and clean, I want to be under a roof with my family … She is only a year old. I may still have some time to be a normal father. ◀

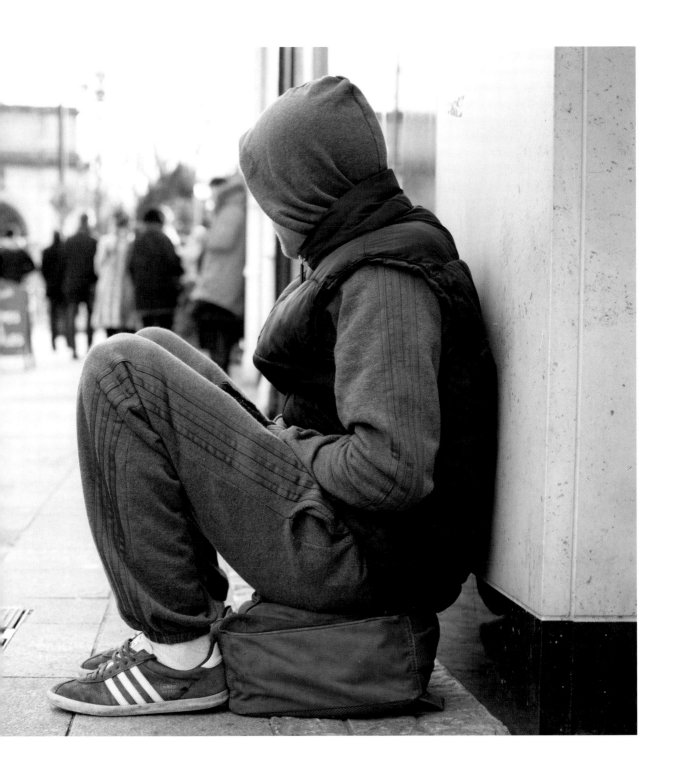

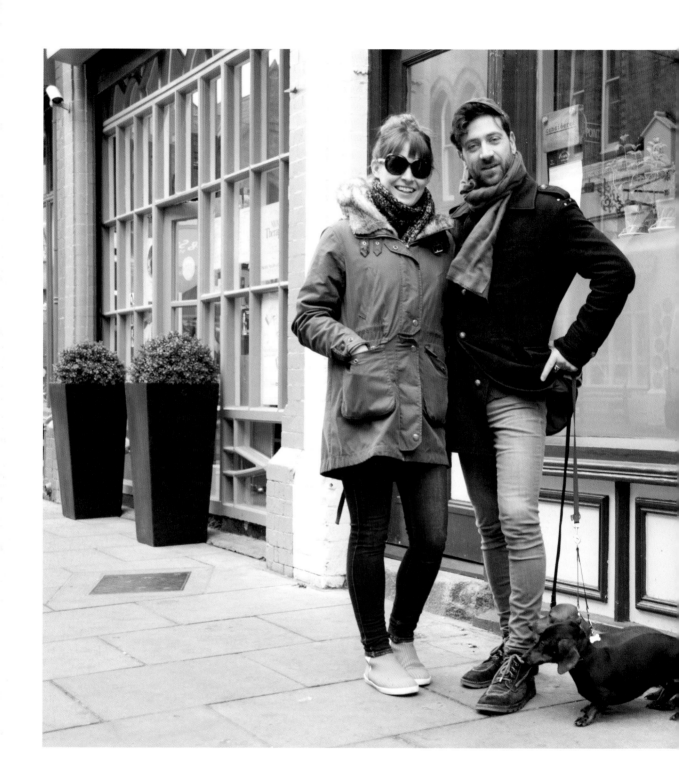

What do you love the most about him?

▸ He's different from everybody else.
Very unique! ◂

Can you tell me why?

▸ Like, he's wearing my jeans right now ... ◂

▶ What makes me happy? Dancing on bridges ... I've been dancing since I was five, and one night in St Petersburg I was walking around the city with my friend who is an actress and dancer as well. It was a beautiful night and in a split second, while crossing a pedestrian bridge, I had this urge ... So I asked my friend if she minded dancing with me. She's about the same crazy as me, so we just started dancing in the middle of the bridge. While people stopped and passed by, some musicians with guitars stopped too and decided to make it even more interesting by playing their music for us. It was pure improvisation without any choreography or rules. It was beautiful. It felt like a perfect moment where you just have to focus on the next step and go with the flow. It became such a great memory that I felt I'd have to repeat it one day. I kept this little dream to myself, but I waited years. I travelled to Japan, Germany, Spain, having this little wish with me, but somehow the moment never came. A few weeks before Christmas last year, here in Dublin, I was going out with a guy who's a musician and a composer. We had a nice night out but on the way home the weather was terrible; it was windy and cold. While passing the Seán O'Casey Bridge I felt this urge again, so I asked him. He was a bit surprised, but said okay, and even started singing while we danced. I loved it so much. I felt like I was back, completing a dream ... So yeah. Dancing on bridges makes me happy! And it became my favourite project for life too. ◀

Do you find it challenging walking hand in hand on the streets of Dublin?

▶ Depends where we are. It can be challenging, but we do it anyway. Sometimes we get abused by people passing by, not only with words but physically too … For us, as girls, it's still easier. We can get away with it like we're friends – for guys it's not the same. But don't think this is what we pay attention to. There are a lot of supportive people around, and negative comments don't happen as often as you think … We've been through so many things together, and they've made a really strong bond between us. It's happened that we went separate ways before, and it wasn't always easy, but in the end we always found each other on the same road again. ◀

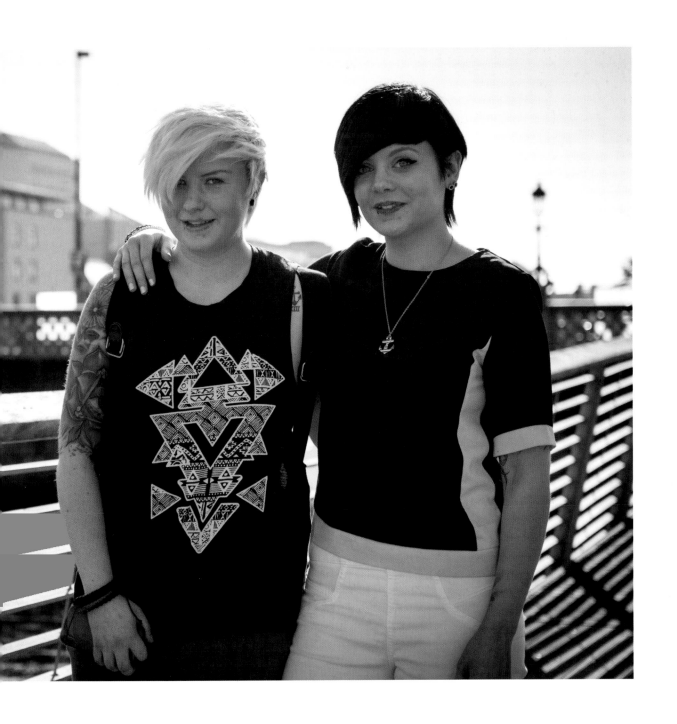

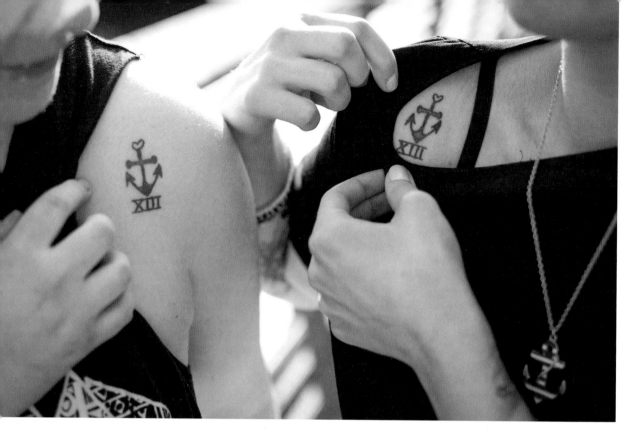

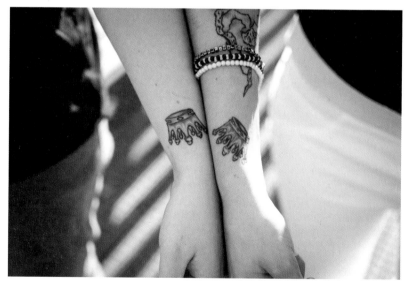

We're together over three years now, which is why we decided to get matching tattoos.

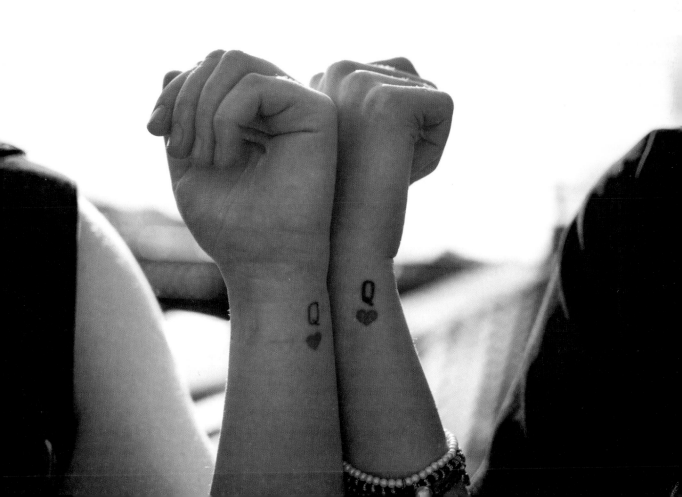

▶ I was morbidly obese, my body fat was over 40 per cent. The doctor told me that I'd got to a level where my heart could stop at any time. But then I decided I actually want to live. This was 14 months ago now.

I met my trainer, and in 8 months we transformed my body. At the start I couldn't even squat, not even without weights, but I started it very slowly. I also started a diet based on fish, chicken, broccoli and rice for the first whole year. Ninety per cent diet and 10 per cent exercise – this is the recipe. Now my body fat is under 18 per cent and I leaned up. I've no loose skin on my body, which is a brilliant feeling! Now this is my lifestyle. I started college, I became a personal trainer, and I bought this place. Now I run it together with my trainer. We're helping others together – to lose weight and be healthy. The last year was an incredible success in my life and I won't stop now.

I was someone who didn't even leave the couch, was living on pizza and curry, watching TV all day. My life was just passing away. Today I'm learning Olympic lifting, and I'm full of energy and plans for the future

You really can be anything you want, it's all on you. You just need to BELIEVE and take the first step. ◀

▶ We were together for seven years. Two months before the wedding, we broke up. My best friend was already here and I thought I needed a change … So I came here and almost straight away started work in a restaurant. I'm working and living with my three best friends who all came to Dublin, one after the other. We grew up together. This week I worked six days – 110 hours.

I don't really have time to go out or to meet girls. Since I got here I've only gone out about three times. But, you know, I like it here. You work hard and they pay you for it. ◀

What are you saving the money for?

▶ I'm not saving it. I send about 75 per cent to my mother and my little brother, back home, where life isn't so easy. So I'm helping them from here. ◀

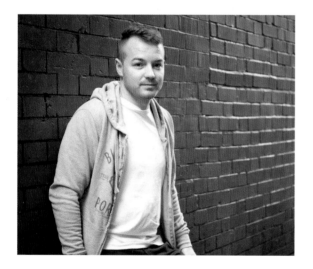

▸ I work as a barman, but I like to think of myself as more of a rebel than a barman. I'm going to work now in my uniform, full of tattoos and piercings, on a BMX, and nobody will look twice ... This is why I love Dublin. It's so free, you know? You can just be yourself. You do your job and you get paid, and that's all there is to it ... It's not the same in Croatia. ◂

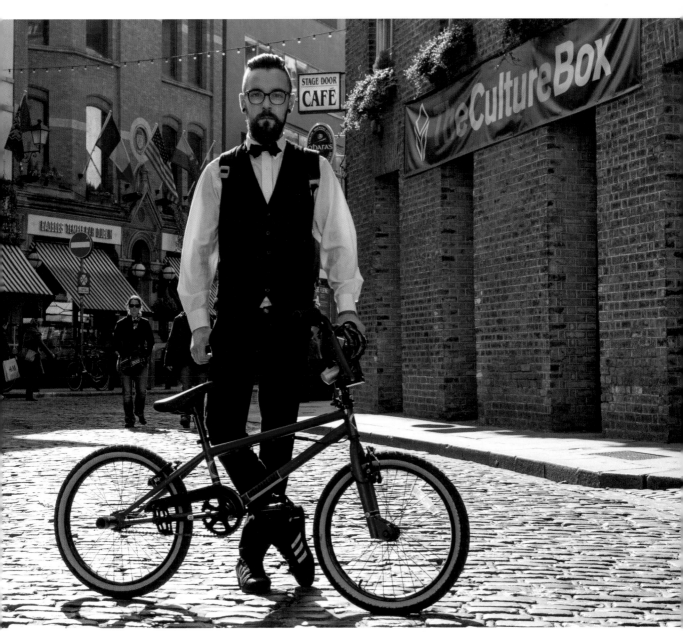

▶ I'll tell you a story about how lucky I was! Last year on the 19th of November I was running across the road on Dorset Street and a female hit me with her automobile. She hit me from the back, and I had a broken shoulder, two broken ribs, and a few scratches. But I tell you what! I think somebody was looking after me from up there. I didn't hurt anything from my shoulders up! I even remember people screaming around me … I'm sure they thought I was dead! I only spent eight weeks in the hospital. I was a great patient. I was running around after four weeks, and now I'm back again! I walk a lot to keep myself fit, you know? The only thing is my shoulder hurts a bit and it's hard to dress up, but who cares? I'm still alive! ◀

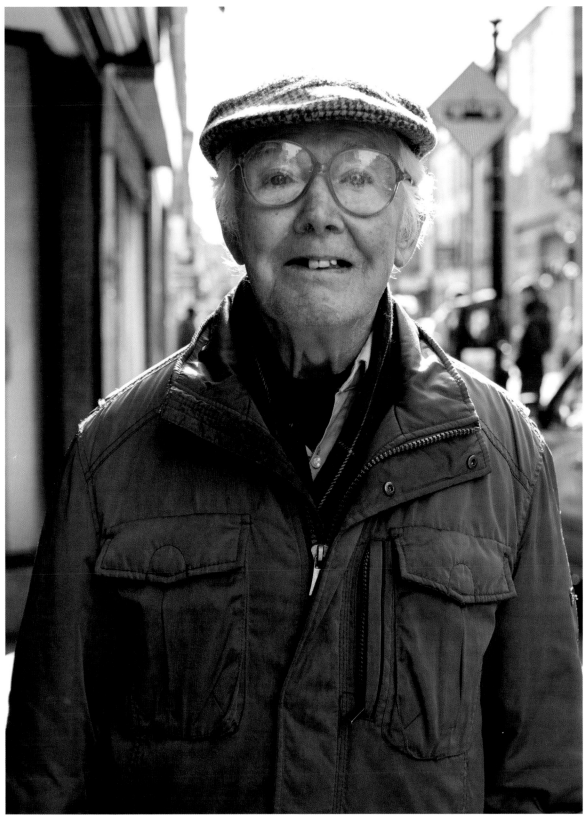

▸ My mother died recently. It was heart-breaking, but for her sake I'm glad she's gone. She was 76, she had kidney failure and Parkinson's disease. I took care of her for over 15 years ... If you take care of someone, your life, your mind and your whole world is taken up by that person, and this is how it should be. Probably the only thing I'd change is to take a bit more time out for myself, to at least take a chance on trying to meet someone special. But now I have a bit more time, so I took a holiday by myself to Tenerife for two weeks, and I had great fun! My biggest problem wasn't my wheelchair, but actually finding somewhere to eat when you have a nut allergy! ◂

Carolyn has Ehlers-Danlos syndrome (EDS), which is a genetic connective tissue disorder. She is one of the most positive and happy people I have ever met in my life.

▸ We get a few suicides a year at the harbour, but there is one that really stuck with me. We got a call for a body that had probably drowned the night before, and as we pulled it out, a phone rang in the body's pocket. I hesitated for a moment, but I had to pick it up ... Her mother was looking for her. And in that moment, she wasn't just a body anymore ... ◂

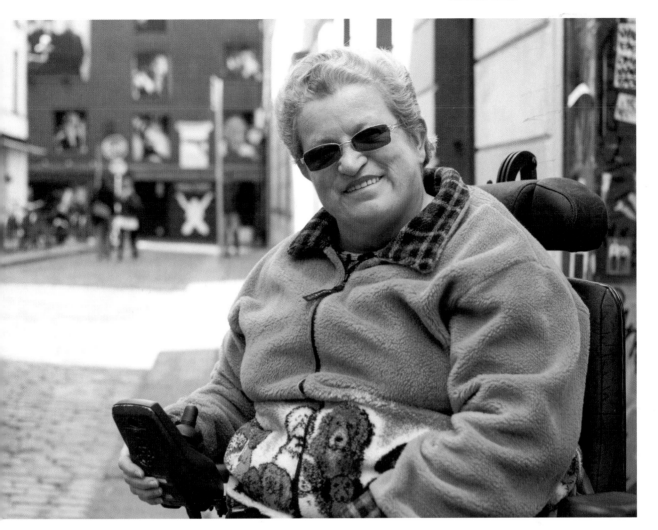

I've lived in Dublin for about 11 years now, but I only really started to **LIVE** about two years ago. Until I was like 15, I was very shy. I walked the streets looking down, only looking up to make sure I didn't walk into anything. It was only when I was about 18 that I became a little more social. But then there was a phase of my life being a cycle of going to work, working, going home, playing FIFA, sleeping, and just repeating it all the next day. That was my life for two years … I didn't know anything about Dublin, even though I lived in it. Everything changed really when I met my girlfriend. I always wanted a BMX, and one day she bought one for me. I began cycling and realised there's so much to see in this city … I got an Instagram account and took pictures of whatever I thought was interesting, people started following me, and it just snowballed … This is how I came up with **Picture This Dublin**. It made me feel a sense of adventure for Dublin. The more I saw and the more I learned made me even more curious, and now it seems like a never-ending adventure. Dublin is a small city, but because it's so small, it's really big. So many different people make it so vibrant and diverse. If you do the same things every day, you close your eyes to the things around you. But life really starts when you take a few steps out of your comfort zone, and Dublin is the perfect place to do that! ◄

I used to be supervisor in a store. The pay was competitive and I was a brilliant salesperson, frequently near the top of the global charts. The world was my oyster, right? It started slowly at first, and I began thinking I was the one in the wrong. Little things, like being constantly reminded that I had 'forgotten' this and 'forgotten' that. I started writing down things I was asked to do on my hand, and that was when I realised I was being toyed with. I wasn't forgetting anything. And things got worse. There were snide remarks here and there, like 'you're not good enough for this job', and worse, 'you're useless ...' And then they would walk away like it was the most normal thing in the world. I worked harder, obviously. And I worked very hard already. However instead of working hard because I loved my job,

I did it because I didn't want to be on the receiving end of that abuse. Things got even worse, and they happened right in front of my co-workers. It got worse still. This person would get people to say things to me and gang up on me. I felt horrible, so one day I just walked in, gave over my keys and badge, packed up my stuff and left. I left with no guarantees and no job to go to. I learned a lot about myself then. To talk to people closest to me, that I can walk away from negativity. I learned that I can still smile. I walked away from a bully, just like I would in a school playground. I'm in a much better place; I've been at my most creative, I've almost completed a degree, and I have a job with a large financial firm where the culture is perfect for personal and professional growth. ◀

▸ I'm a heroin addict. I was born in Coolock. The heroin is everywhere there, you don't even have a choice. I was 20 when I got addicted, but I know people who are my age and they've been addicted since they were like 14 … They don't even know what it feels like to be clean. When I was 25 I got away from the heroin, and I had a few clean years in England. I had a family and I had kids, but the heroin kept dragging me back … It's like a magnet! But I won't be here forever, I'm just waiting for big money. After I get it, I'll go back to England and I'll change my life. ◂

Where do you expect that money from?

▸ I gamble, on horses. I feel it, you know? The big money's coming! ◂

▶ We used to do weekly pushbike workshops for kids in Ballymun.
There was no bike shop around at the time and it was a very isolated
area, meaning the kids didn't really have any other way to get
around. The only freedom for them was the bicycle. It was a working-
class area, and those kids literally grew up in the streets, so they
were very independent and much more interactive with adults.
They would talk to us just like they would talk between each other.
I always had a really good time with them, but at the same time
you had to be careful and distance yourself from them in a way –
to be more professional. Because I wasn't a teacher, they would
automatically see me as a sort of father figure. There were some kids
with really dark backgrounds and had stories that you wouldn't take
home with you. ◀

▸ I've been on hormones for a couple of years now, and I've become a new person. My personality, my thoughts, the way I react to things, they've all completely changed. I had the opportunity to experience the difference between genders – how it is to be a boy and how it is to be a girl, and right now, pretty much what it's like to be a pregnant woman. And I can tell you, it's so much harder to be a woman … As a boy you tend to be more logical, and if you have any feelings bottling up you can go to the gym, or you can work super hard, and then it's out of your system … You can let things go. As a girl, it works different. It just keeps bottling up and the feelings take over your logic, and at some point, something snaps and the whole world falls apart for two days. It's so hard to just keep yourself in a certain mood when there are storms inside your head. ◂

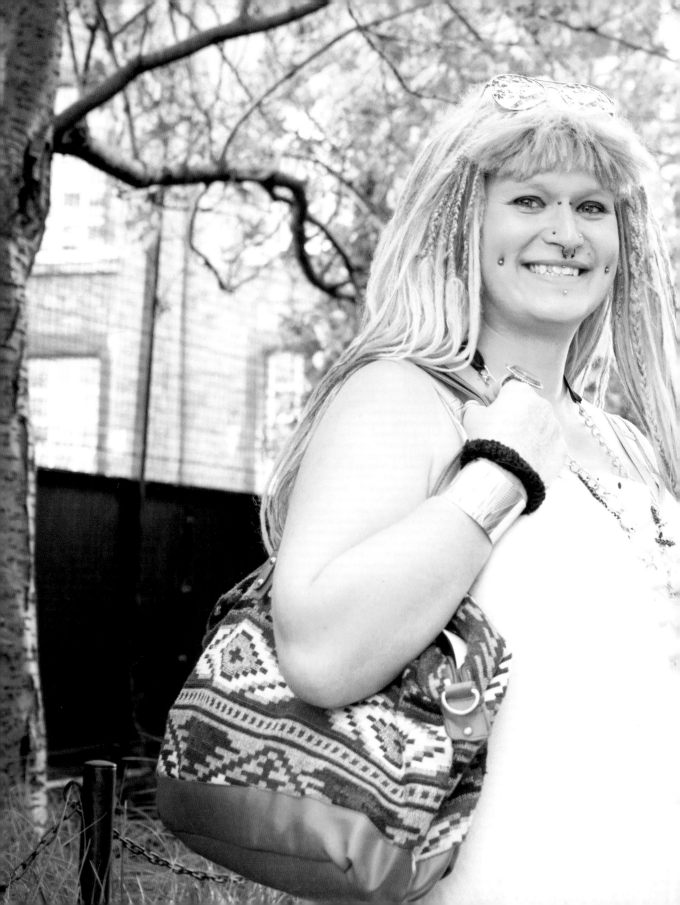

When I was in my first teenage years, as a boy, I had a very tough relationship with my mother. We lived in a small town, and she was working in the military. So she would be very strict with me, like, 'No, you can't wear those jeans, they're too feminine,' 'Don't cry,' 'Stop acting like a girl.' When I was 17 or 18, I was still super-feminine and I moved up to Copenhagen. Only afterwards did our relationship get a bit better. We started to talk more, so she could understand me better. A couple of years later she discovered her own sexuality and confessed to me that she was a lesbian. Looking back, I can really see it … By that time, she had spent 12 years in the military, she always had a short haircut and had a real butch style. So when I went back to see her, she apologised to me a lot. Since then she is my biggest idol and inspiration. She became a completely different person. Her mind is so free. She's been living at a nudist camping beach during summers the last few years … She's nuts and I like to think I'm the same. ◀

▶ I'm from Sweden, but used to live in Dublin. I actually made my career here. I worked in the computer software industry for about four years, and I had a nice life, good pay, a beautiful house, and great friends. Any young man would be more than happy to live the life I did, but I always felt something in my chest, like something was wrong. It took me a long time to realise I was living someone else's life.

After I quit my job I travelled for a year and moved to West Ireland, and never looked back. I'm not looking for a career anymore. I work as little as I want and I plan my time. I do a lot of meditation, and now my time belongs to me. I will not sign a contract saying I'll be there nine to five Monday to Friday again, that's over for me. My dreams are coming true. At the moment, I'm planning to move out to the forest in Sweden in summer, and I'm going to live in a Mongolian yurt, being a nomad for the next eight to ten years.

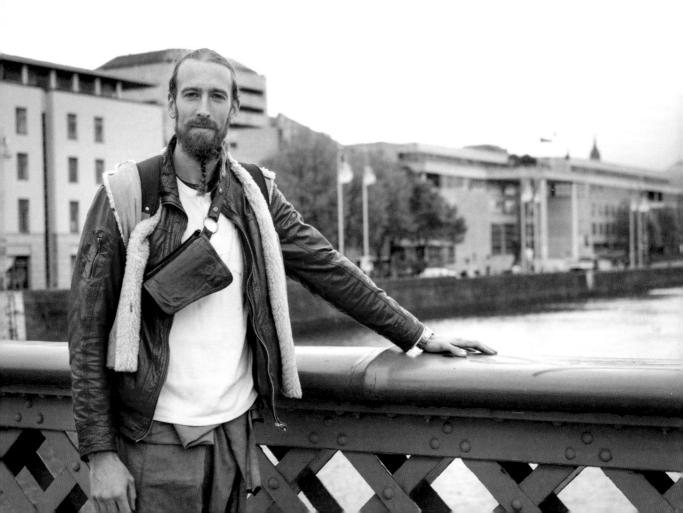

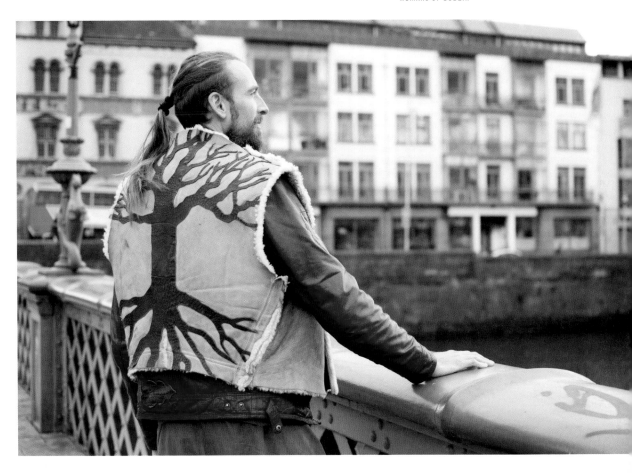

People think life is easier in the city, but I find it the other way round. It's not only cheaper to live in the countryside, but you don't have this pressure all the time to increase your income. My life costs a fraction of what it used to. I grew up in a modern society, but I was always close to nature in Sweden. I read a lot of books about living in the wild and got advice from people who did it. I moved away from society, but I got so much closer to humanity. Since then I learnt how to meditate, I did fire performance, I worked in a health food shop, I worked with autistic children ... The more I do, the more I become. There's still plenty of things to learn before I move out to the forest, like how to work with wood, how to grow my own food, how to build a house, but I enjoy every moment of it. ◄

He doesn't speak English. This is only his second day here. I'm here five months now. We know each other about seven months, and it may sound crazy but we only met four times, yesterday was the fifth. We kept talking on the internet, and a few weeks ago he decided to leave Brazil and come here to live with me.

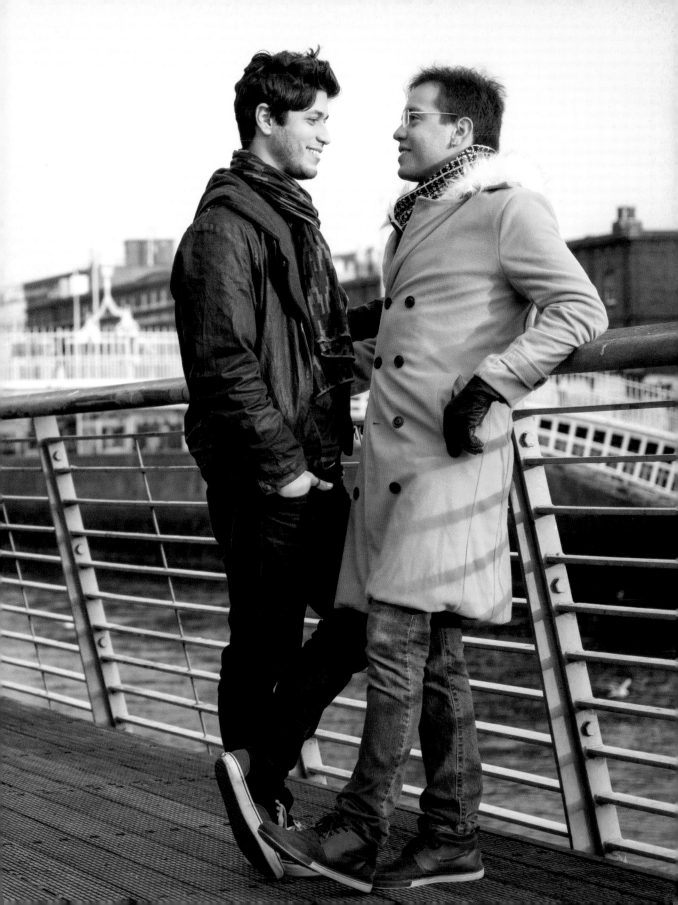

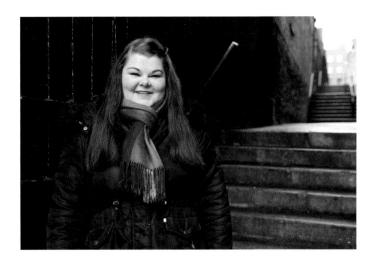

▶ Both myself and my brother lived with my mam who unfortunately was unable to care for us due to her own difficulties. As a result, she made the decision to place us in care in the hope that she would overcome her problems and that we would return to her care. After several unsuccessful attempts, sadly my mam passed away when I was 10. Even though I was very young I remember my mam always telling me to be better than her, to have and do more than she ever could. This has been something internally that has always guided me. When myself and my brother first went into care we were placed in two separate residential care homes. I later moved to my first foster-care placement with the fabulous Smith family with whom I am still in contact. From this home, I was then reunited with my brother in our last and final foster-care placement that would take care of us until we reached 18 years of age. Their names are Anne and Dave and I would be lost without them. They are now my parents.

How they came to foster me is a story in itself. An ad was actually placed in the local newspaper, *The Northside News*, looking for foster-carers to care for these two children that needed a home. I was lucky enough to be sent a copy of this ad years later. But imagine, obtaining these two children from an ad in a paper. My mam and I now joke about which section of the paper I came from. Was I to rent or buy?! Anyway, the lease agreement there is terminated and I am now a lifelong squatter! ◀

▶ We're the best pals in the elderly complex. He's living there 15 years now, but I just moved in 3 years ago. We became neighbours, and since then we're inseparable. We've so many things to discuss, you know? Plus, he was a postman too, so he knows how to talk. ◀

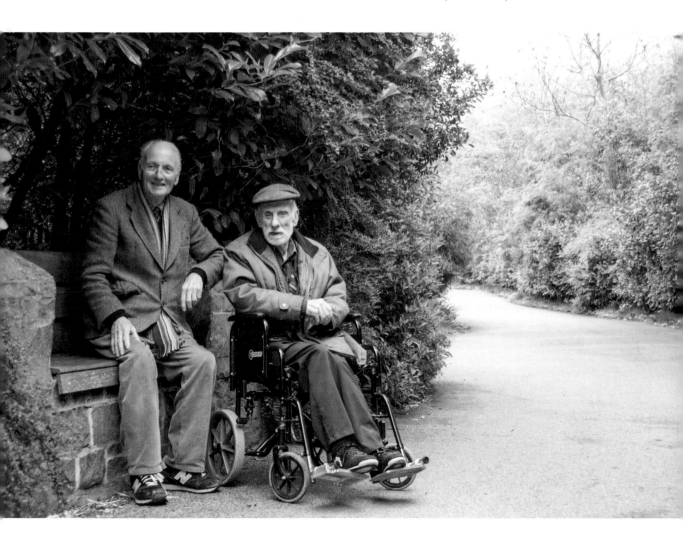

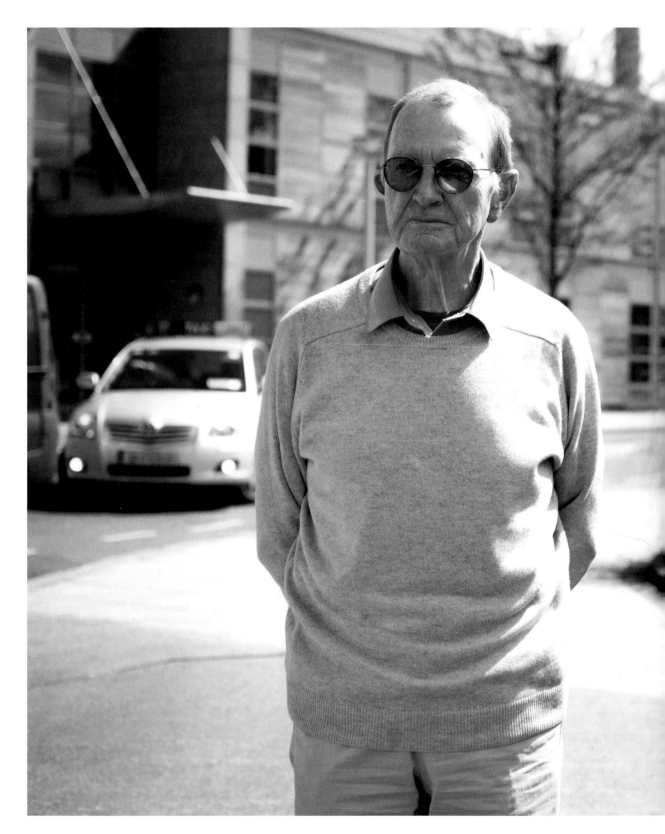

▶ I was walking on the beach in County Sligo, when I reached out to hold the hand of a beautiful girl. I knew in that moment, if she took my hand, we would be together forever. This was in 1959, and we had a beautiful life together.

And I will tell you the secret to a long-lasting relationship! We grew up through our children. Growing up means becoming less selfish, less egotistical ... And we matured through our grandchildren – maturity means to see the mystery in everything. To look at a baby and see the sheer mystery of it ... The secret is to make that commitment on both sides, to see the mystery in each other, and also to make the decision to love. This is hard for young people to understand, but love does happen, just like it happened to me that day ... But to continually love after a certain time is a conscious decision. You must decide that you're going to love. Otherwise it becomes shallow and it can disappear. Because of our decision, I know she's still waiting for me up there, and it's a great feeling. ◀

53

▶ I used to take life too seriously. If you have a house, a wife and kids, and you work nine to five with mean, money-hungry people around you, there's a constant panic over your head that you have to work hard or you lose everything. I just got fed up, I took five minutes to think, and I walked away from everything. I realised it wasn't the life I wanted. If you're willing to work for it, you can make a living out of anything you want. Now I'm a tattooist and I sing in a band. I'm still married, 16 years now, and I'm the happiest father of two boys that you can imagine. Don't take life too serious. You only get one shot at it. ◀

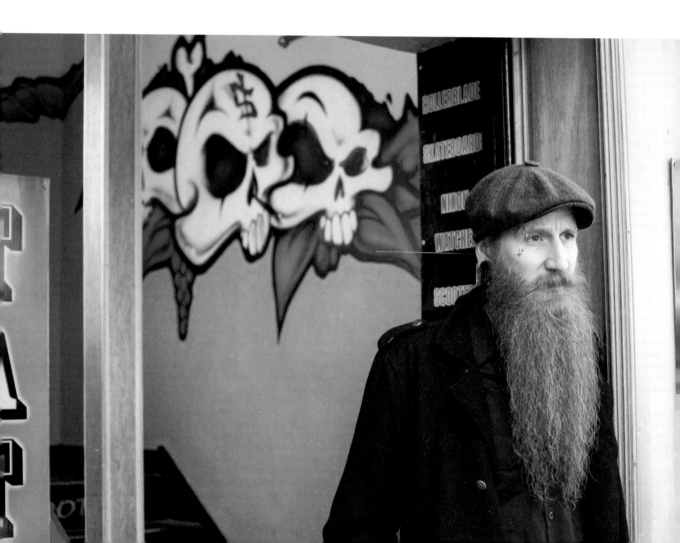

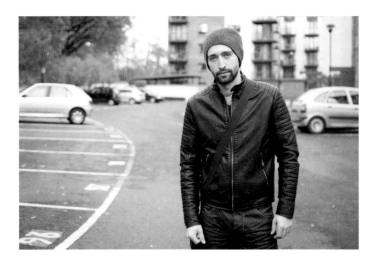

▶ I used to live on the main street in Ballymun. Me and my friend were on the way home from work when we arrived into the hall of the apartment and met two huge guys. They were about to use the elevator as well so we all stepped in. They pressed for the first floor, and we pressed for the second floor.

They had a hand truck and a few Lidl bags with them. When they got out of the elevator they forgot one of the bags, but when we realised, the lift door had closed.

The elevator wasn't in the best condition and often went to different floors, so it took us up to the fourth floor. In the meantime, my friend opened the bag and it was full of weed and envelopes. The envelopes were full with money. A lot of money! I said to him, 'Take the money and get our asses outta here.' He said, 'It's too dangerous, they'd remember us and they'd look for us.' Also our friends were living in one of the apartments, so we decided to give it back.

We went back to the first floor and in a few seconds the same huge guys were running out of their apartment. When they saw us with the bag they said, 'Thank God,' and they took the bag from our hands and went back home.

I can't really explain the feeling … I already felt like the money was ours and they just took it from us. When we told the story to our friends they said we did the right thing. Dirty money cannot bring happiness, only trouble. ◀

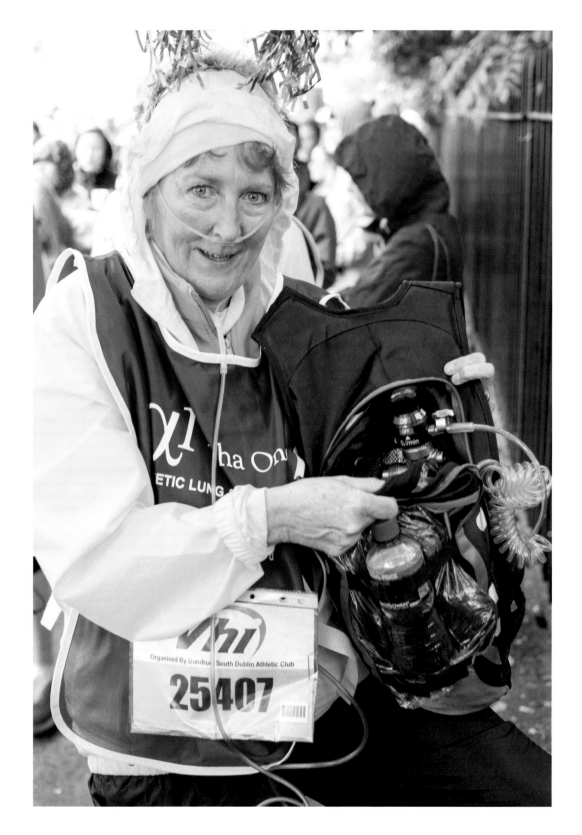

▸ I have to be connected when I exercise. I cycle with my backpack, and in the leisure centre they built a special box where I can put my tank so I can use the gym and do aerobics five days a week. Both my parents were carriers, and because I was fit all my life, my body learnt how to deal with less oxygen. I didn't even realise until a day in 1996. I was cleaning the oven and breathed in the chemicals, and that triggered it. I'm delighted I can still do this and that I don't have to be on a waiting list for a donor. Exercise is a very important part of my life, and today I'm doing the marathon for myself and for those who are in a similar situation. ◂

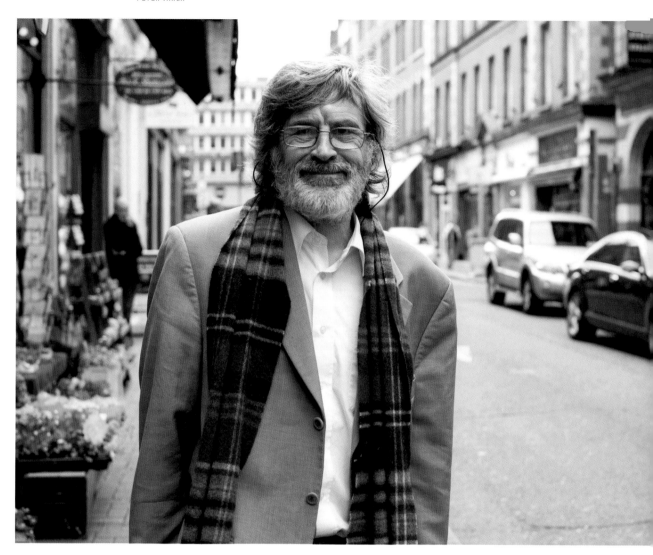

▸ I'm an Anglican priest. I'm just in Dublin for a holiday, but I'm from Clare. ◂

May I ask what you think about the same-sex marriage referendum results?

▸ I know people would expect me to say the opposite, but it's great! It's time to get in touch with our consciousness. Sexuality is not really fully understood or valued, but now we're breaking new ground which is very important. ◂

▶ I'm blogging my experiences in Europe of cheap hostels back to Florida. My age group doesn't seem to have too much experience in this field. Probably a lot of them would have done the same 40 years ago if they had the opportunity ... I'm 64 years old, retired, single, and on a budget. I've got no better thing to do. I used to be a schoolteacher. I love being between young and friendly people. And for people my age, it's kind of interesting. ◀

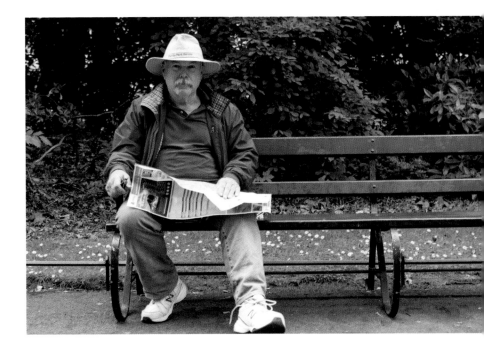

Today is a mother and son date! We had a long walk and a great dinner in the city, and now we're just sitting down for a bit, enjoying the sun before we go home.

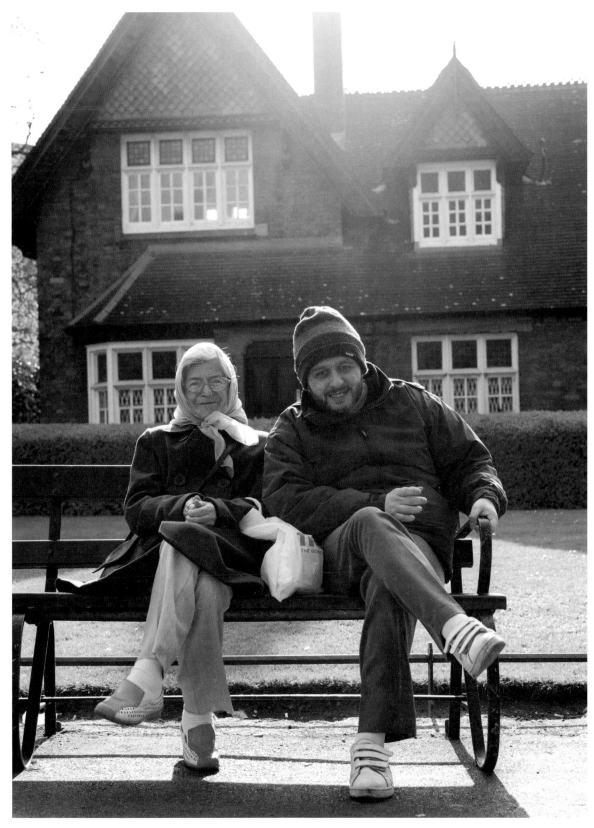

▶ I wasn't born to be a writer, but I wanted to be one so I became one. It was hard, but if you really want something there's nothing that can stop you. To be honest it's a kind of love/hate situation for me now – there aren't many things left to love about writing. It's a hard job if you plan to make a living from it, but it teaches me a lot of things. Like there are things you can't rush. You need to sit down and appreciate every single, tiny successful moment on that road, and never take your eyes off your destination. ◀

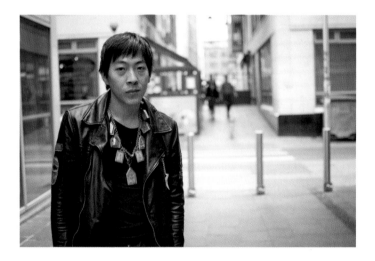

▶ Before I came to Ireland I had no money for a language course, so I bought a dictionary, and I read it all. It took me a year. I still have it. It's very big and heavy. I don't read it that often anymore, but I still use it if I see a word I don't know. The problem is that I know a lot of words, but sometimes people still don't understand me because of my accent. ◀

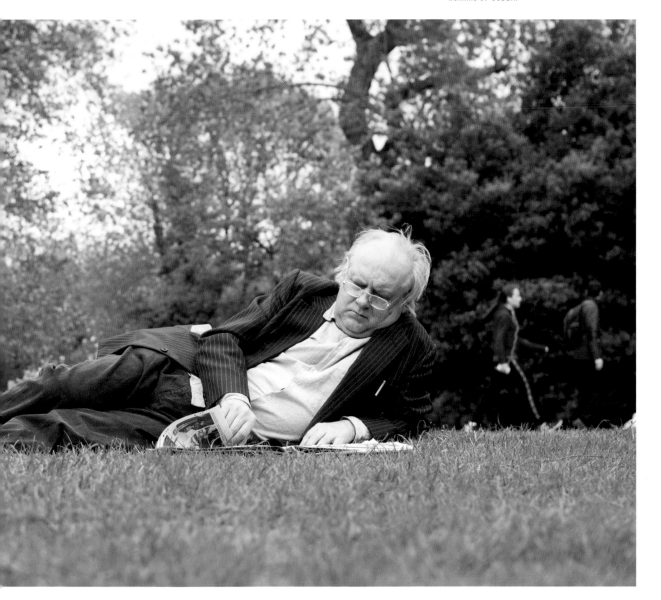

▶ I like to stay alone most of the time – to be honest I feel much more lonely around people. This is natural for me, and I was always like this. I'm very sensitive and get hurt very easily. I've treasured my childhood since I was very young. I never accepted losing my childlike dreams and hopes. I'm still a child, but I'm mature at the same time, because I had to protect my dreams. I was in a relationship for six years before I came to Dublin. It was hell with him. After the second year I felt like I was just waiting for death. The only thing I did was knitting and weaving. They were sort of like meditation, where I could forget about my life. Whatever I made never really turned out like anything. They were all colourful, but shapeless, kind of like I was. I still feel a very strong bond towards them. At the same time, I decided to end this relationship. God showed himself to me, and this is why I started to travel … I found my purpose in my life.

I still like knitting, even though I don't do it that often, but now before I start, I already have a plan of how it's going to look. ◀

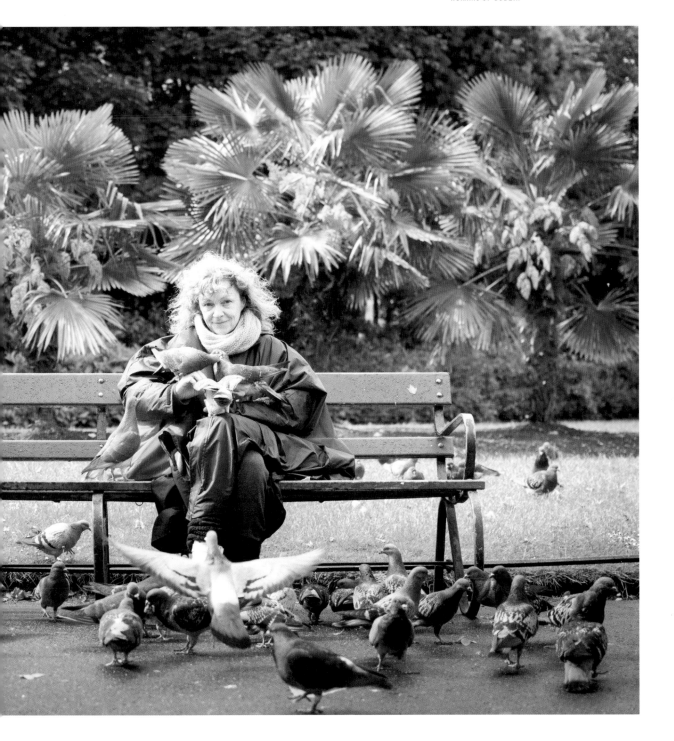

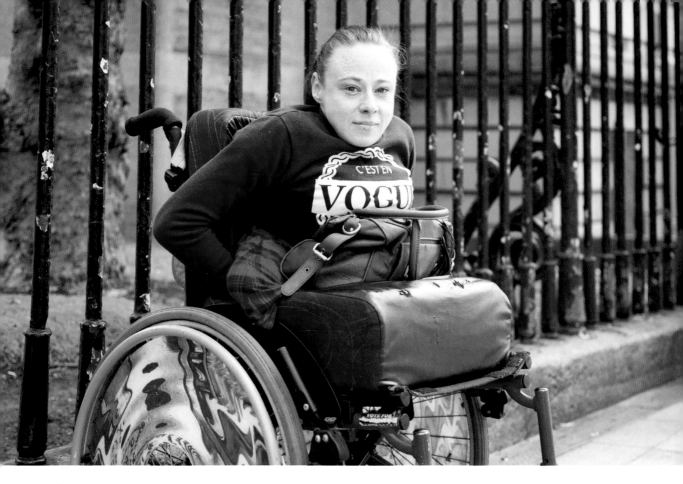

▸ You know, I was born like this, so I really don't
even know what I'm missing. I'm not one of those
people who used to walk and then suddenly their
independence was taken. I had some hard times in my
life when I was a teenager, but as I grow older I care
less and less. This is how I was born and I will never
know any different. The only thing that still hurts is
when people stare at me, or, for example, when kids
come over asking questions and their parents give
out to them. Why are they giving out? They're only
curious. This is how they learn about things … ◂

▶ Usually older people end up in nursing homes towards the end of their lives. One particular man was unhappy with the way his mother was treated there and wanted to see all the notes that were taken in relation to her care, but they wouldn't give them to him. At the time I was working for the Citizens Information Centre in the Office of the Ombudsman, so he appealed to us. We then compelled them to give him the notes and subsequent to that the government changed the policy so that in future people could have access to all records. I think this was one of the most important decisions we made. I'm very proud of it, because I played a big part in the case. ◀

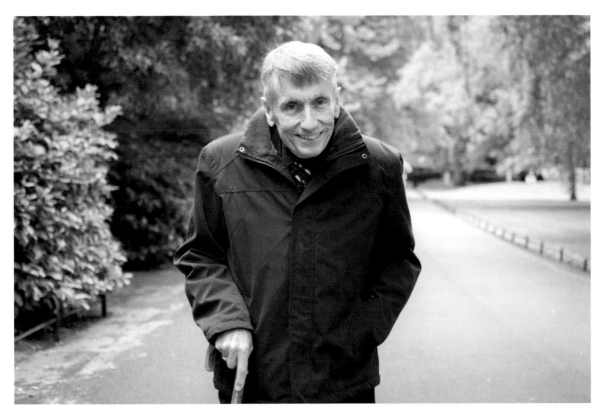

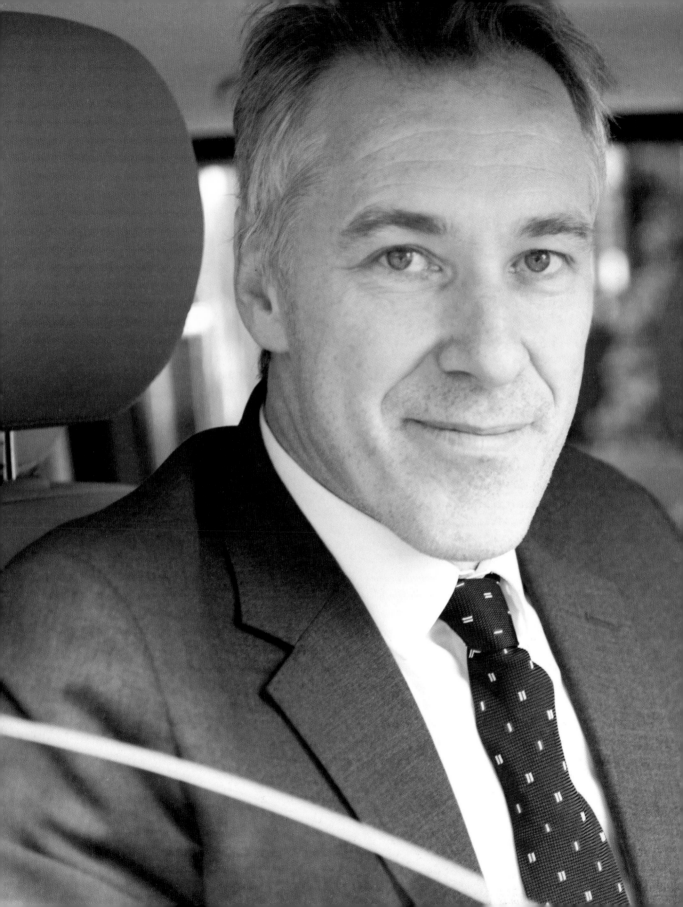

I waited six years for my green card, and now I've ended up coming back and opening a company that takes rich Americans on tours around Ireland. When you live in America and they know you're Irish, they'll keep asking you if they were to go to Ireland, would you know anybody who would look after them. And I used to say, 'I'll look after you!' And then they'd start telling their friends, and before I knew it, I had a new job. I really love the type of people I meet – for example, the client I'm waiting for right now is flying his own jet. I'm not just interested in their money either. These people really understand how the world works, so it's great to have a few of these contacts behind you when you plan to make new business decisions.

But I'll tell you a secret – New York is big. A lot of people want to be models, photographers, dancers, actors, you name it … The competition is huge. So how do you stand out? Sometimes the best place to start is somewhere small, and when you stand out there, there'll be someone who'll have connections to bring you further. You don't need to go to New York if you want to be famous or successful. You're at the perfect place for that! ◀

▶ I was 18 weeks pregnant in an extremely high-risk pregnancy in Australia. I was dressed in scrubs, standing in a surgical theatre as a glioblastoma brain tumour was being removed from a patient, to be handed to me to bring to the lab for research. This day was a little different because I knew it was my last one before compulsory bed rest so I stayed for the follow-up consultation. The patient was awake and drinking tea when I arrived. She was 45. She was a mother of two kids, a mere ten years older than I am now. She knew she wasn't going to live beyond the next six months and there was nothing more they could do. We sat and talked. She asked about my research, about our baby, and what I planned for my career, and then she said something that is what drives me every day. She said, 'When you continue your research in Ireland, make it the type of world for your daughter where people will die WITH a brain tumour and not FROM it. Make it so that it's not a death sentence.'

Since I received my funding from the Irish Cancer Society in 2013, that's what I have been trying to do. I was awarded a three-year project to try and improve how glioblastoma patients respond to chemotherapy, to try and improve survival rates. I realised that for this ambitious change to work you need to work closely with those who are affected by brain tumours, with other researchers, with doctors and social workers. I immerse myself in every aspect of this type of cancer, to try and understand it better, to try and make a difference. I set up the Irish Brain Tumour Research Initiative (IBTRI) to help further fund this research and hopefully keep a promise I made to someone, a request that broke my heart. ◀

▸ My boat was damaged and it was in a shipyard that day. A friend of mine asked me to come sail with them. The weather was bad, and one part of the day when we lifted up the net to empty the prawns onto the deck, the boat rolled. I lost my balance and fell into the sea. It was dangerous to stay too close to the boat in that type of weather, so I spent about half an hour in the water until eventually I could hold on to the rope and they could pull me back. I came very close to losing my life that day.

But the funny part of the story is that it happened on the 11th of November in '93 and I had a watch on and when I got out of the water the watch had stopped at 11 past 11. My grandfather was in the First World War, and the 11th of November was the day it ended. It was always a great day in his life. He always had a few drinks to celebrate it, even 70 years later, so I often wonder if at that moment, the 11th day of the 11th month, at 11 past 11, whether he was looking after me. ◂

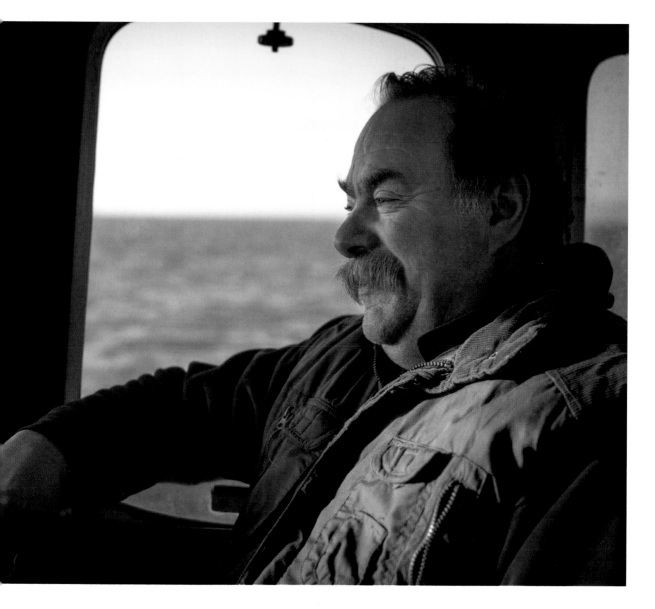

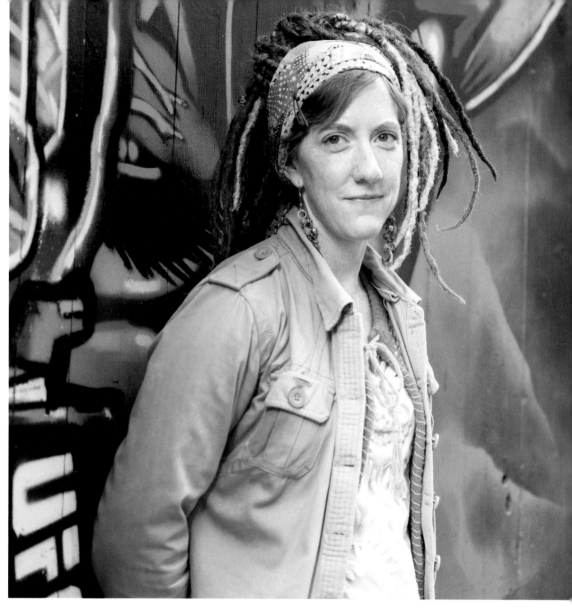

▶ My husband and I have been trying for a baby for a very long time now. We've been through IVF treatments and everything, and obviously we seem to struggle with it … We both love children – he's a psychiatric nurse for teenagers and I've been a youth worker over 21 years now. If I don't get pregnant soon, we'll be looking into fostering and adopting. You know, there's people in and out of our house all the time and people staying with us, which they love, so I know we'll be fantastic foster parents. I often wonder, maybe that's our mission in life …

My husband has a completely different style to me. He's very sporty, and he used to work in animation. He drew the *Teenage Mutant Ninja Turtles* show back in the nineties, and when they stopped it his friends moved to America to continue doing art. He stayed and went to Trinity College to become a psychiatric nurse because there was no work in animation back then. He's an amazing artist – I can show you some of his drawings! ◀

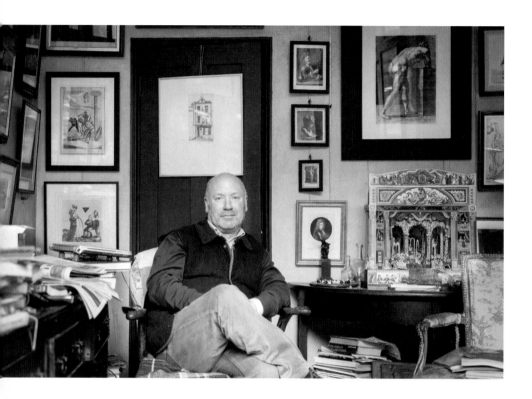

▶ I'm sitting in this room 25 years now. When I was a student, I wrote my first thesis on the influences of people like Albrecht Dürer. I became interested in his work which brought me to the world of prints. It sort of came as a disease for me. My life quickly changed into research and exchange of these prints. I love meeting the people who buy prints from me – they can be quite interesting. Of course there are days when nothing happens, but every now and then big things come up, like selling prints for museums. It's not really a walk-in shop, even though the doors are open to everybody. Most of the people who come are collectors, and they come from all around the world. I've been in here so long now, I mean, look around! This is my living room. ◀

▸ I met her in India – we were working with a Christian group teaching children. Since then we're best friends. I can't even remember how many years it's been now. We've gotten a bit older, but still feel the need for travel and discovering all the wonderful things in the world, so we decided to see it together. ◂

▶ I'm an artist, and my biggest struggle is keeping a roof over my head. 1991 was my year. I used to go down to the Liffey in the early morning when the tide is out to look for inspiration. One day I found a bike and it was all covered in dirt and seaweed. I'd say it was at least 50 years old. I brought it to my studio, cleaned it, and put it up as a statue in the window. Now, '91 was the City of Culture in Dublin, and the sculpture society was having an exhibition in front of my studio – right at my window. The *Evening Herald* photographed it, thinking it was part of the exhibition. It was one of those moments, you know? And it appeared in the newspaper as part of the sculpture society. That was my moment. People started talking about me and looking for me. After that I went back to the Liffey and took more junk out and recycled them to various sculptures, and this is how I got the name Zorro of the Liffey. They even made a documentary about me – you can find it on YouTube! Anyway, I'm sorry but I gotta go, there's only a few minutes left to get my meal ... ◀

▶ I think I'm kind of childish, in a good way. I mean, I can look at simple things and be amazed by them. Everything can be interesting, though, if you give it enough time. Life can be very complicated sometimes, so I feel like the best way to stay happy is to find simple things entertaining. ◀

▶ When I'm travelling I feel very happy! I've been going around the
world for 15 years now, and I always go to nature areas like mountains
and forests. This is my lifestyle. I was working when I was in college,
I saved some money, and I decided I'm going to see the world. I got a
job in South America teaching English for a while, and since then I've
been on almost every continent. If you decide to live like this, you need
to be extremely confident and maybe a bit crazy ... I don't have a lot
of costs. I don't have a house, just this car. I mean, this is not the
only thing I have, but I try to own as little as possible. Usually I only
travel with a backpack because once you stop focusing on money and
things, and start living for experiences, you really start enjoying life. ◀

▸ Their names are Angel and Kala. They are my babies – literally my life! Angel is 14 now – unfortunately she had a stroke last week and almost died. I've been preparing myself for a couple of years now with the thought that she won't be with me forever, but I still don't know how I'll manage without her. She is my shadow that follows me everywhere. Kala is 9, she's a bit different, she does her own thing. She's a rescue dog and has been with me four years. I used to volunteer for a dog rescue, and at the pound when I got her people said she's going to be a very high energy dog and I'll need a huge garden and big fences … I often smile when people are so terrified by her size. They think she must be very dangerous and I feed her with people, but the truth is that she's just a quiet, lazy dog. I can't even call her a couch potato because she's too lazy to climb up on a couch. She's a real coward too. If you clapped your hands loud enough she'd run away. Look, now I have to rub her belly … ◂

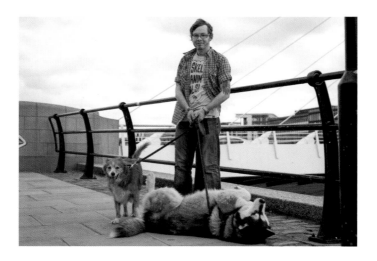

▶ I was in Ethiopia, with these nuns who owned the orphanage, and they said, 'We're going to take you to a place in this jeep, but there's only enough room for six people and if we take you we have to leave a doctor behind. Do you think if you go you will be able to make some money back in Ireland to pay for medicine for these people?' Now you feel it. We were going to a place where two villages were at war with each other. They cut the water supply and built a dam. These are just villages, not even countries. They had no water and were literally dying. They had no clothes because they sold them all for food, and all the children were blind because their eyes were shrivelled up and dried out … I took a picture of this little boy – he was putting his hand up to sort of shake mine, he was about 12, but his hands looked like the hands of a 90-year-old man. So I took this picture and a few others too, but I just sent two photos back to the newspaper. The second photo was of an Irish schoolteacher who was helping to build a school. I was actually there to cover her story. The photos appeared in the newspaper the next morning, and we had no phones or anything so I had to go to a drug dealer's house to use his internet connection to send the photos. All he wanted to do was to look at my cameras and take pictures with them while I was uploading. But anyway, the next day, we were, like, in the fuckin' middle of nowhere, and a car pulled up, and a guy said, 'Are you Niall Carson?' I said, 'Yeah.' He replied, 'There's a phone call for you.' And he handed me a mobile phone, and it was someone from Today FM, the producer of *The Ray D'Arcy Show*. They said, 'Can you talk to us about this photograph you took? Who is this kid and what the hell happened to him?' I told the story and gave them the bank account for the school. It was printed in the newspaper as well. In two days there was something like €50,000 in the bank account. I don't even know how much money went in after that. This was the time I realised photos can really make a difference. ◀

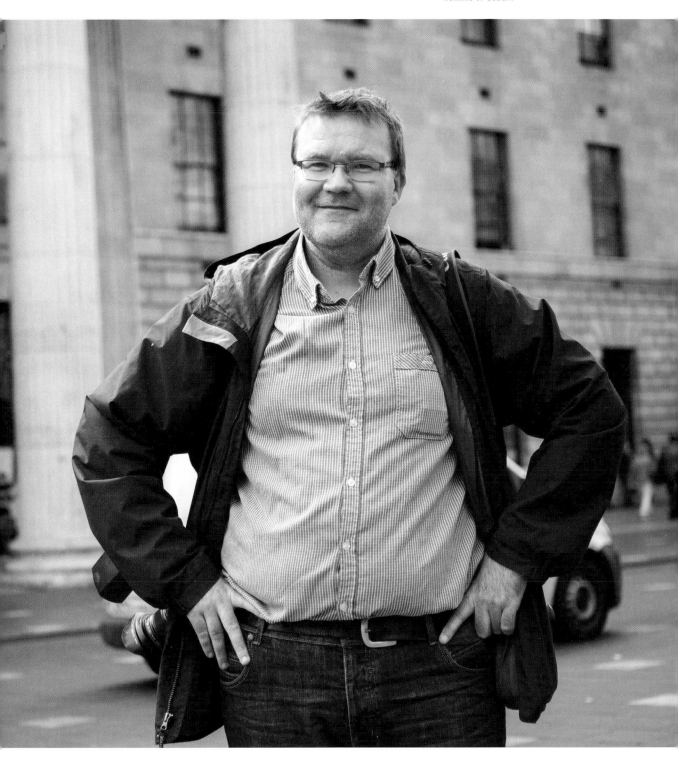

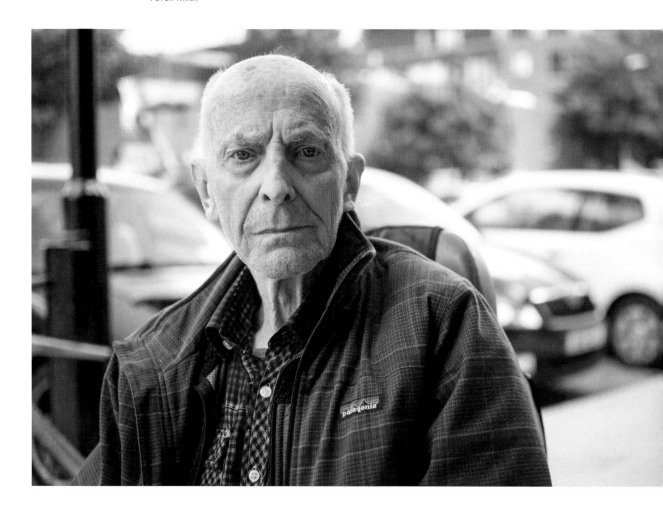

▶ I was a postman for 40 years, and I did an exam to become a telegraph
messenger when I was 16. It was right before machines took over really.
And a telegraph was a gadget that, if you were in America and you
wanted to send a message to Dublin, you'd press buttons on one side and
it printed the message out in paper in Dublin. One of these machines
was in the GPO. They'd put the messages into green envelopes, and the
messengers would wait for a bunch of them, and then we'd deliver them
to your door. These messages often contained news about death, but also
you could send money. It was in the sixties, not long after the war, and
there were no jobs in Ireland, so a lot of men travelled to America for
work and sent money back home. I was the guy on the motorbike flying
around Dublin with the most important messages in my hand, and I
was the man who handed them to mothers of six children. I saw those
emotions, and the light on their faces, that finally they will be able to
buy food. And to be part of that joy made me really love my job. ◀

▶ I believe we are in terrible trouble as human beings because of what we've done to the Earth, our only home. We created a structure on the planet and we polluted the air, the soil, the seas … What more can be done? The problem is people don't think enough, they follow the leader. And what does the leader do? Give simplified answers and choices for everything – yes or no. But life is much more complex. It's more about balance rather than these binary answers, and we need to start using our brains. If you're in a boat, and everybody is just rowing, heads down, you need to stop and look around! Where am I going? Am I going in the right direction? Look at the stars, feel the wind, use your senses. In life we have to pilot our own selves through this journey. We are already in the belly of the mega-machine. Please take a moment now and look up! Life is beautiful. Life is complex. It's a great adventure even for me in my age. And I'm sorry for making that statement, there are times when I do smile, but I want to make sure when I do it's engaged with my heart first. And not just one of those dishonest ones you often see.

I'm vegan, I only eat vegetables. I don't eat any food that comes from animals. I believe that they are fellow mortals and should not be tortured, but this is what humans are doing day in, day out. I won't harm anything and refuse to be part of it. The other day I was emptying a bucket when a spider fell in. I did what I've often done before: I put a little branch down, it climbed out, said 'thank you', and away it went. This is the way I live. I look at life and the animals around me as fellow mortals, and they deserve respect. I believe all of us were given a spark of nobility and I believe we have to nurture that spark throughout our life. If not, this spark will wither like grapes on a vine. You have to have awareness of everything each day in order to live a responsible life. ◀

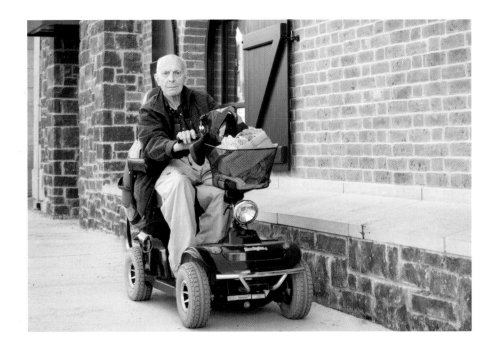

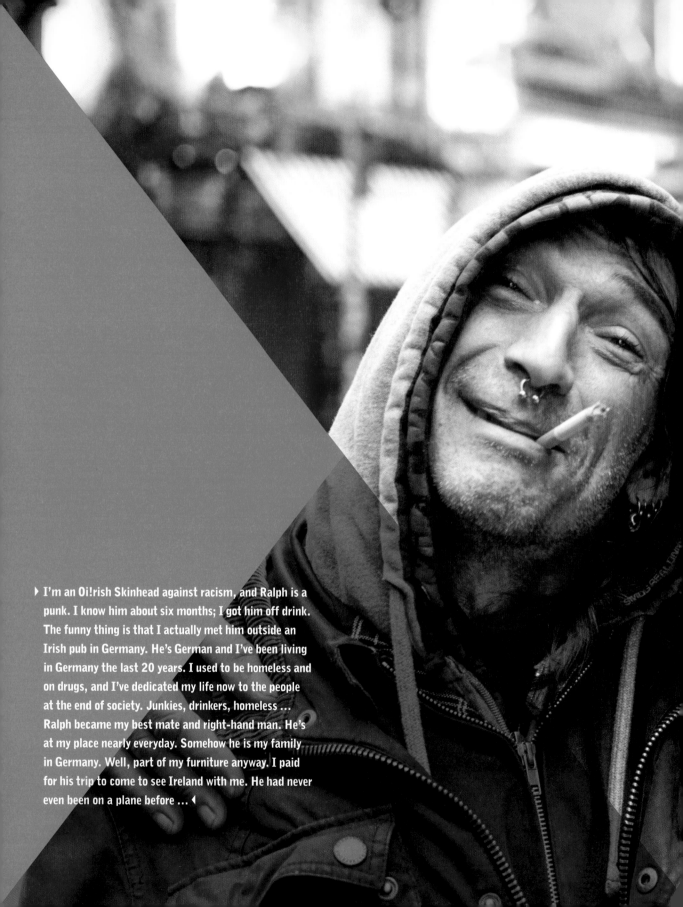

▶ I'm an Oi!rish Skinhead against racism, and Ralph is a
punk. I know him about six months; I got him off drink.
The funny thing is that I actually met him outside an
Irish pub in Germany. He's German and I've been living
in Germany the last 20 years. I used to be homeless and
on drugs, and I've dedicated my life now to the people
at the end of society. Junkies, drinkers, homeless …
Ralph became my best mate and right-hand man. He's
at my place nearly everyday. Somehow he is my family
in Germany. Well, part of my furniture anyway. I paid
for his trip to come to see Ireland with me. He had never
even been on a plane before … ◀

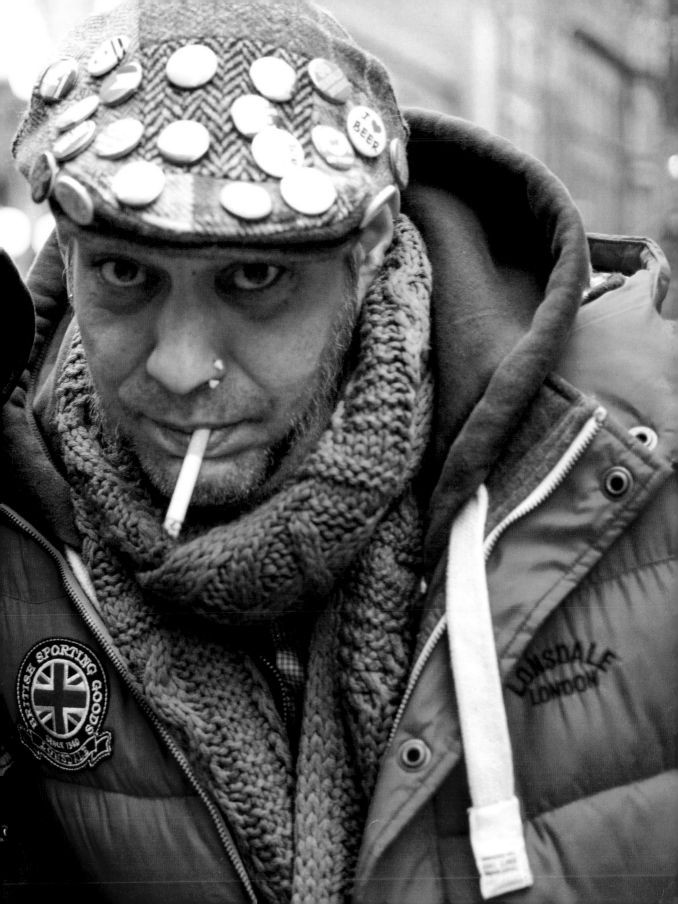

I love to walk through the park and watch the young people enjoying themselves, especially in this weather … The atmosphere grabs me and throws me back to the time when I used to lie in the sun with my friends.

▸ I'm trying to stop smoking and I can tell you it's not easy.
I'm smoking since I was 12, so I can't even remember life
without it, but I have to say I love cigarettes. I like to smoke,
but in my head somewhere there's a little voice saying, 'I'm
going to kill you.' And I know he's not joking. ◂

▶ We've been following each other on Instagram for a long time, and later we started skyping – she's from California – and a few weeks after that we ended up buying a one-way ticket … We're engaged now … When you know it, you know it! She is the **ONE!** ◀

▶ I should have realised much earlier that I needed to ask for help to get out of that relationship … I was also going through a bad depression, and I guess I was just too proud to acknowledge it. I had some very deep trauma during childhood. At home I was forced to be one thing, and outside I had to act. Have you ever been on stage in front of a lot of people? I felt like that every day … Nobody would believe what was going on behind closed doors. I had to look back, several times, to realise my thoughts … I thought this was normal. I thought it was all part of some kind of plan …

I had a dream – to live in a caravan and to be on the road. I don't like houses. They just don't feel safe … But now I can move whenever I want, and this is the first time in my life I feel safe and free. ◀

▸ I'm 83 at the moment and still working. I worked my whole life cleaning sewerage and drains. I spent 44 years working for Dublin City Council cleaning the sewers right under us. There's actually a whole system down there, just like up here. Some parts could be 8 feet high and 20 feet wide. There were times it was easier to find your way around down there … But on the streets I use this bike, which is about 90 years old now. I got it from my father-in-law, and I still use it every day. ◂

He was married for 62 years and sadly lost his wife last year, but, as he said, they loved each other all the way throughout.

▸ The company got fed up with crashes, so they gave us these vests. They definitely work, you know? We get noticed much more. But it's a great job, when it's not raining … I love the comradeship the most. We're really friends more than colleagues, always messing around. We usually go out for pints together as well! ◂

▸ Yeah, right before work! ◂

▸ Shut up you! ◂

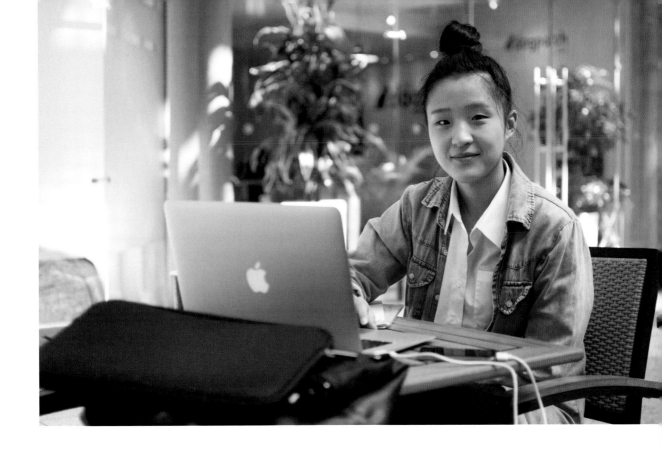

▶ I love walking over **O'Connell Bridge** after a long day. I feel happiness every time I see all those different faces walking by. Where I'm from, you don't see many happy faces … You don't have much time to think about your future. Usually you go to the college your points let you, and there's no questions about what you'd like to do for the rest of your life. It's like clockwork … But those faces remind me that I made it! I learnt English, I'm living in a different country, and I must say I've got a bigger picture in my life now. ◀

▶ In the back garden we used to grow tomato plants, but she died about 18 months ago so I stopped growing them. She was a month younger than me, and I was already surprised that she passed away before me, so I was just waiting for my turn. A few months later my neighbour arrived with a box of tomato plants, about 12 little sprouts, and he said they're not giving up on me. I was looking down at these little sprouts and thinking how the hell I'm going to plant them if I can't even bend down anymore. Anyway, I thought I'd give it a try! I spent half the day in the glasshouse planting them. They're about 16 inches high now, and the tomatoes are beautiful on them. I started to grow these new ones as well, what do you call them? Cherry tomatoes …

To be honest with you, I didn't think I'd see Dún Laoghaire harbour again, but my son and his wife forced me out here. They went for a walk, but they bought me a tea and an ice-cream, and now that I'm here, I feel happy. ◀

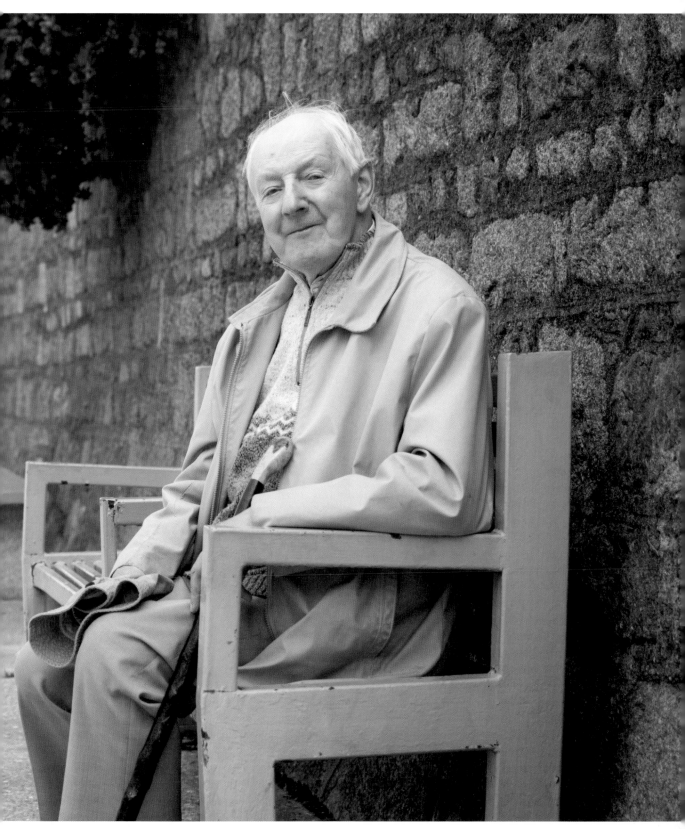

▸ I'm from Italy, and in our town there was an earthquake which destroyed the city. Our parents didn't want us to stay there in case it happened again, and anyway there weren't too many opportunities at the time. So we made a decision together that they would rent an apartment for us in another city. They couldn't leave because they had to renovate the house and also because of their jobs. I was 13 at the time, my brother was 16. It was the hardest year of my life, but my brother was always there for me. He did the shopping, he made my lunch, we went to school together, and he came to see my basketball matches … This is probably the reason we have such a strong bond. He might be the best brother in the world. For me, he definitely is. ◂

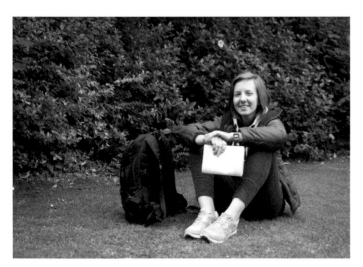

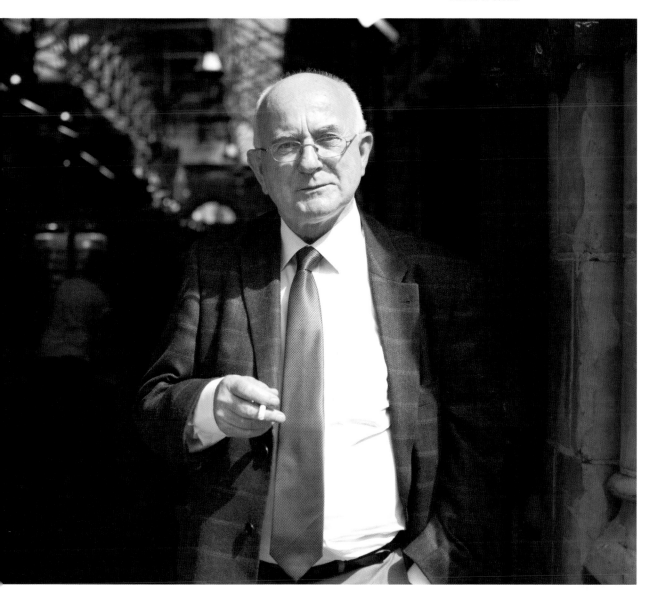

▶ I'm a solicitor and I have never had a mobile phone. I knew from my colleagues they often took calls at 11 pm on the weekends … I am the one who doesn't have a mobile phone and they know it, they accepted it. I don't think I ever lost any client because of this. It was a conscious decision. If somebody wanted me they could reach me in the office hours – this way I was the guy who had a family life as well. ◀

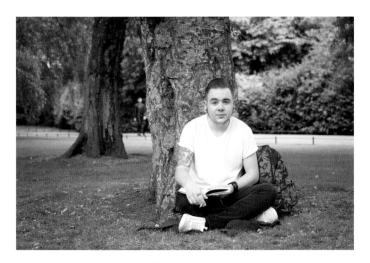

▶ I live in a two-bedroom flat with my mother and five brothers and sisters. Believe me, it's not something you get used to … Sometimes it gets really chaotic and you get no personal space at all. Don't misunderstand me, I love them. I just really appreciate days like this, when I can just sit down in the park alone and read a book. ◀

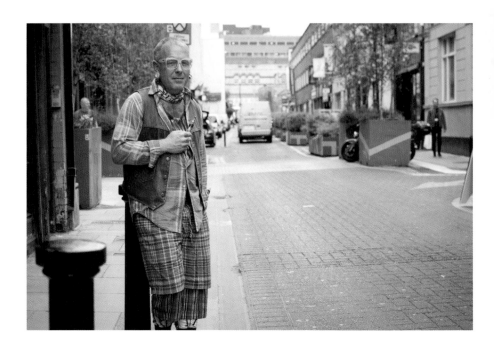

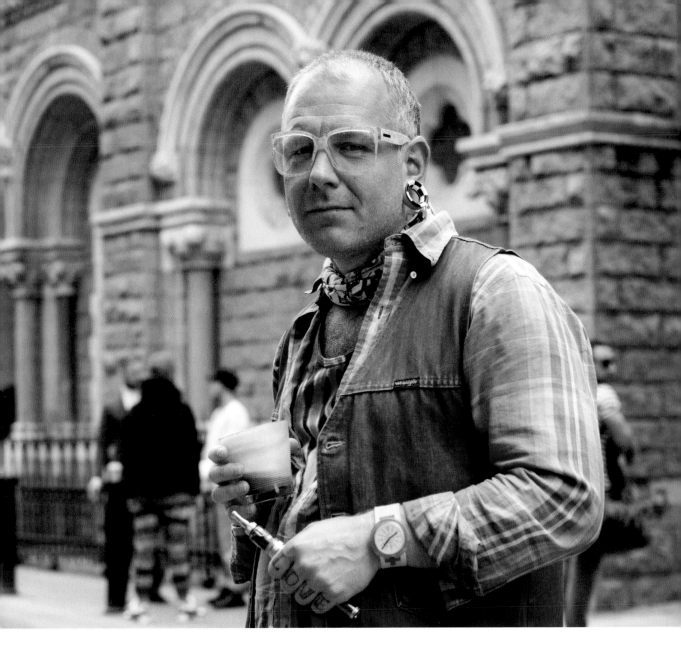

▶ I still remember the first time I saw a billiard table as a kid. All those coloured balls on that big table ... It was just so new to me, and somehow I felt happiness and a sort of excitement seeing it. That was probably the last time, as I remember, I looked at something the way it is; I was fully present in life. That was the last time I saw something without judgement or without commenting on it in my mind. Throughout education, and as I got older, I left the 'now' and got preoccupied with the past and worried about the future.

[My colourful clothes] is the way I strive to be optimistic for the future! ◀

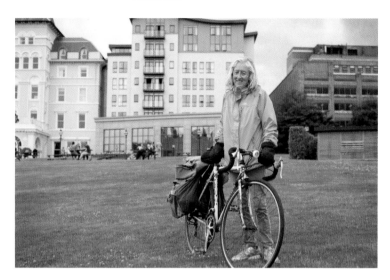

▶ I'm on a bike ever since I could ride it. I always cycled everywhere, and I did a good few trips around the world as well, but it only got more serious after I divorced in the mid-80s. I always had this hunger for adventure, so I decided to travel. Well it ended up a five-year trip … I was a nurse too, so I worked as a nurse in most of the places. ◀

Can you describe one of your scariest memories of travelling alone?

▶ I was backpacking in Africa, and I was going to see the mountain gorillas. So I was on this truck, and actually, I was the only white backpacker on it, alongside all the locals, and on the way the truck suddenly swerved all over the road. When I looked up I saw a guy with a big, long gun, who had shot the driver in the chest. He lined us all up, and I remember the only thing I said out loud was 'Sweet Jesus don't let him shoot us!' We had to put all our belongings out on the road, but I held on to some dollars and my passport. He took $200 off me and all the belongings of those poor people. After he left, the driver's son, who was with us by his father's side when the guy shot him, had to take the body to the back of the truck and continue driving … This is African life. Tough! I mean, it was back in the '90s but I don't think much changed since then. ◀

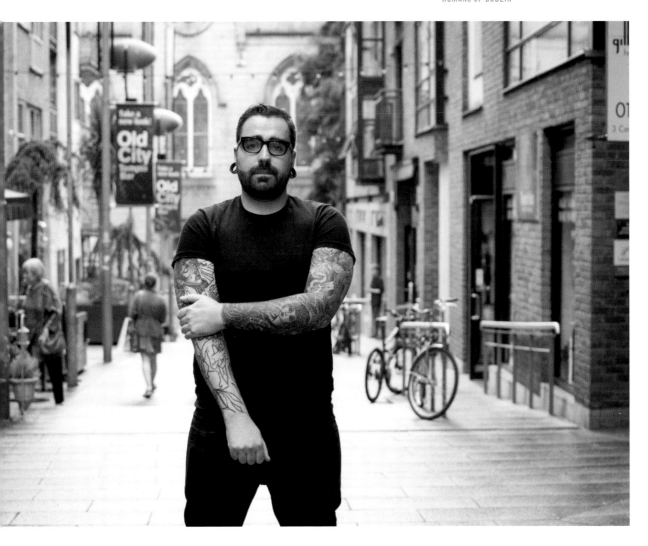

▶ My parents were always very supportive of me, but they never wanted me to have any tattoos or piercings. My father especially was very strict about it, so my proudest moment would probably be last year, when my father said he'd love to get a tattoo done by me. He didn't care what it was, as long as I did it. That was a real turnaround in our relationship too. He's actually called me and asked for another one since then. ◀

What was one of the strangest jobs you've done?

▶ We had this guy come to the studio, back from Thailand, and he had a naked girl tattoo he got when he was drunk. He was afraid his parents would find out, so he asked for a bikini for her ... ◀

103

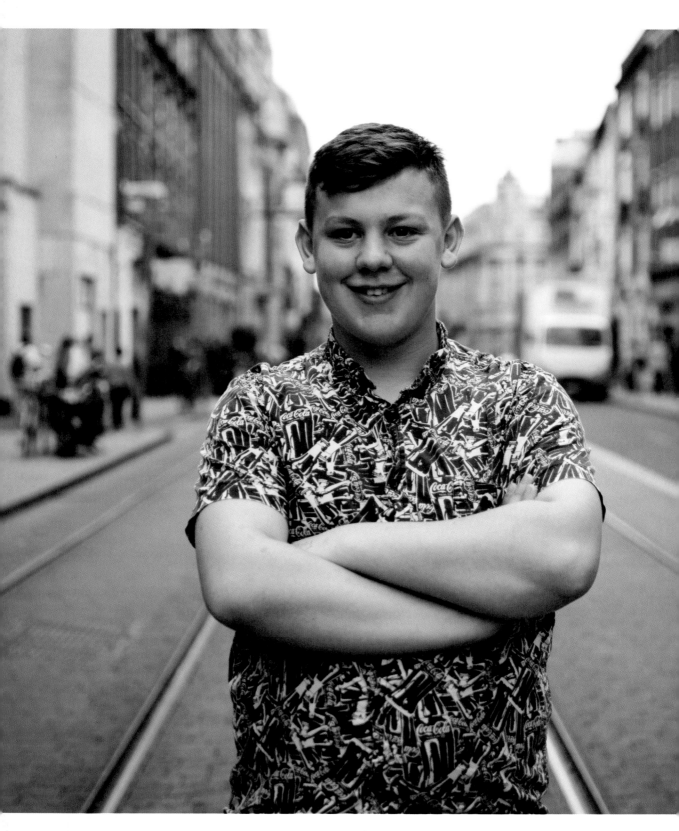

▶ I was just on my way to the American sweet shop to buy some Gatorade when I saw this guy in his 30s sitting on the ledge of the bridge. I just thought, 'Wow ...' I stopped and asked him if he was okay, but I knew from the look in his eyes he wasn't, and he didn't say anything either, but I saw tears coming from his eyes. I pleaded with him for a while to come down and sit on the steps, and eventually he did. We sat on the sidewalk on the south side of the Liffey and talked for about 45 minutes, about what was happening to him, why was he feeling that way ... I couldn't leave him there alone, but I had to go, so I was going to ring an ambulance. I told him they could help him feel better. But he was like, 'Please, please, don't call them, I'm fine. I just want to walk around for a while, I'm gonna be okay!' I told him to please let me ring an ambulance, that I wouldn't sleep knowing he was just walking around alone. So I rang it, and he was taken to St James's Hospital. I got his number so I would know what was going on with him for a good while ... And about three months ago, he texted me that his wife is pregnant, they're having a boy, and they're naming him after me. Can you believe that? They're going to name their child after me ... He said in that moment that I approached him, he was just about to jump, and those few words saved his life, that they're still ringing in his head every day: 'Are you okay?' I can't really understand how these few words could save his life, but he told me, 'Imagine if nobody ever asked you those words ... ' ◀

▶ Back in Brazil, I used to work nine hours at work and three to four more hours at home. Every day was becoming the same … I felt like I needed a change. Since I was a child, my dream was to travel – long trips on planes, to meet people, to have challenges in my life, to learn English. And you know what? I did it! I quit my job and I sold everything! I sold my car, my apartment, my furniture, even most of my clothes. I didn't have anything left but money. So I bought a ticket here and an English course. I rented out a bed, not even a room … But I had a goal – to learn English. I had enough money to keep me alive while I was studying. And I had time to decide what I'd like to do after.

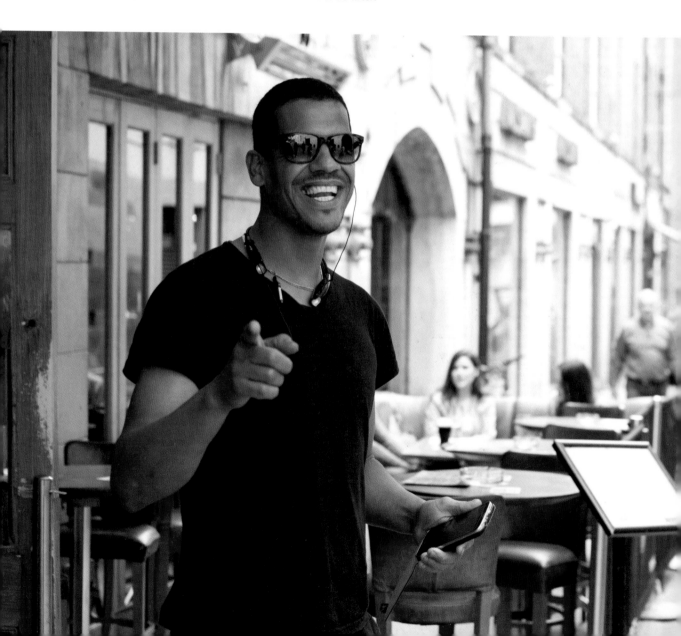

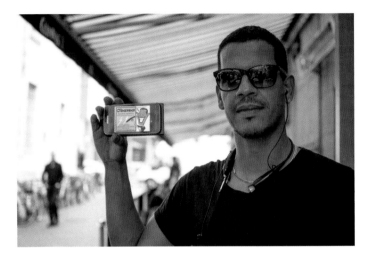

The opportunities are right in front of you, but you must train your eyes to see them. While people complain about the rain, I look up to the rain and see an opportunity – rain plus wind equals dirty windows. When I started the company, I wasn't doing anything new. I do what other people do. The only difference is that I put extra effort in! I add more value to it. I expanded my business, as I'm a mechanical technician – I do everything for my clients. I don't only clean windows, but I clean around them too, for the same price. If they have something broken, I'll fix it. If I don't know how to fix it, I check it on the internet. So simple! The other day a restaurant owner called me and asked if I could fix something for him. I said, 'Yes, no problem!' I was ready with it in 15 minutes. He was asking how much he owes me. I thought, I could charge him for it, but it was ready very quick, and I was a bit hungry, so I just asked him if he could give me a discount on a lunch. But then he said, 'You know what? I have a better deal for you. You can eat here from now, at staff price!' It's 60 per cent off, man! In the long-term, I'll get more money than I would have for 15 minutes' work. Life is easy. We just got used to complicating everything! ◀

▶ I'm a stylist and fashion designer. I always felt lucky that from a very young age I knew what I want to do! I've been cutting fabrics since I was about five. I studied and worked in **Paris** for a very long time and worked with big names like **Karl Lagerfeld**, the designer of **Chanel** … I feel comfortable the way I dress, even though people stare at me sometimes. I often look at them and think, 'Well, you dress a little weird. I'm perfectly normal.' Being different from everybody else can sometimes be hard, but it's only a matter of confidence! ◀

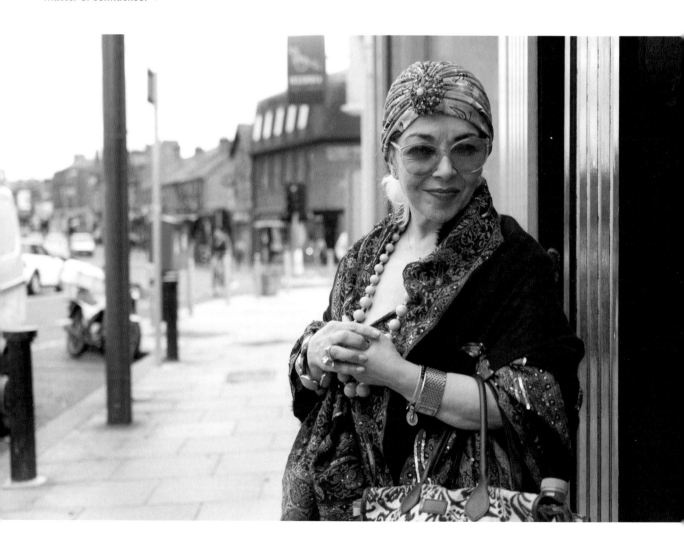

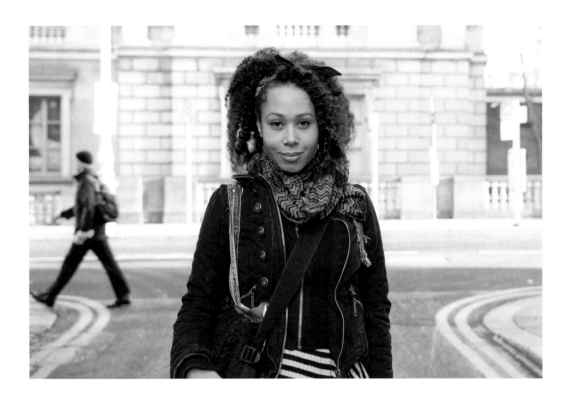

▶ When I was **19** my daughter was born, so having her made me grow up very quickly. It was very hard in the beginning because I was a lone parent, but I would never change it. Being a young parent is the coolest thing ever. Our relationship is super-strong and we are like best buddies. She is becoming more independent now, so this means I can start to focus back on myself again. I actually just got accepted to college and I'm going to start tomorrow. I'm going to study fashion design and I'm very excited about it. ◀

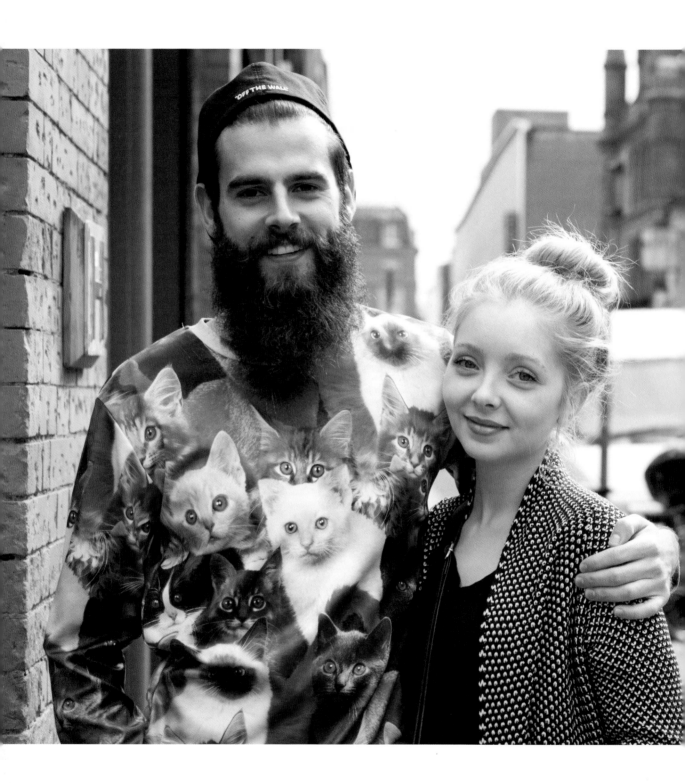

At a beer festival I got too drunk, and I got in a fight with someone. While we were fighting I lost my shoe, and she was the one who gave it back to me. This is how we met four years ago.

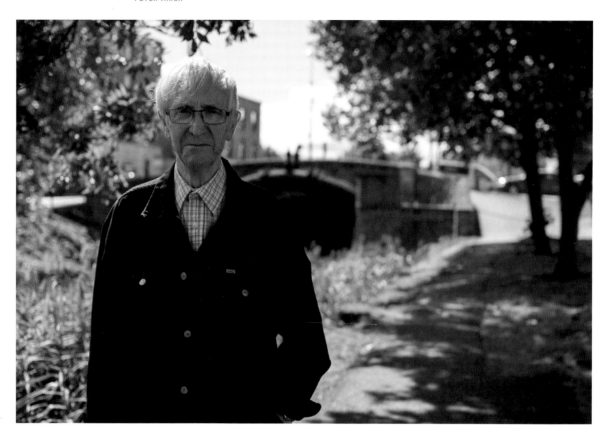

▶ Being an artist was never easy for me. It's like being on a roller coaster. I'm 80 years old now and I painted almost all my life. I loved every moment of creation. There were times it was going well, I sold a lot of paintings, I had exhibitions, and life was great. But there were times I had no choice but to work in a supermarket or drive a taxi. Art taught me a lot about life, and I strongly think that if you ever find out what you want to do in life, you have to go for it. Don't let anybody put you off it. ◀

‣ It means victory in Japanese. I just bought it. Yesterday, after three years of treatment, I was told I don't actually have cancer ... They changed their minds. So now I'm going to get my hair done, and then I'll sue them. ‣

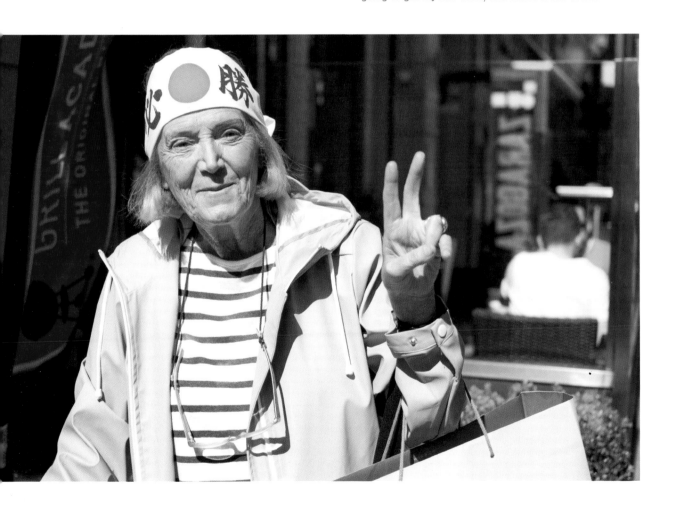

Growing up, I was always quite lazy. By nature, I find it easy to do nothing, my personality always leaned that way. I kind of always preferred to be alone and never really found my place in society. I knew it wasn't a good thing, but I never tried to change it, and it's probably one of the reasons I became homeless. But to be honest, I don't really mind ... I got used to a minimalist life. I studied science once, you know? My parents actually invested a lot of money in my education, so I do have the ability to completely mask my mental issues, but never long enough to get a job, or even for me to try get one. To be honest, I'm happy if I can read a newspaper in a park after a good breakfast. I grew up in the country, so I was always close to nature and I grew to love it. The only reason I'm in the city is because of the facilities and the cheap food. If you're homeless you need these things to keep you going.

There are three types of homeless people. The addict, the one released from prison, and those with mental issues. If you are considering living on the streets, the bullying, see, is a thing you should really look out for. Bullying among homeless people is unbelievably serious ... This is possibly the worst thing about it all. Most of the homeless choose to sleep outdoors, even if they would have a place in a hostel, and the reason why is that the people who live there are mostly from the first two groups. Some of those people got used to prison life, and they experienced being beaten up, being abused, and being shamed every day, and they bring this prison life with them. In those places choices are made for you – you join the gang or you get beaten. I grew up very kind of sheltered, and quiet, so I never even go close to these places. ◀

So where do you sleep?

▸ I stay in internet cafés, they have a night rate; you pay €10 and can stay there until 8 am. The only problem is you can never lay down. I can't even remember the last time I slept lying down. Because of that I almost lost my leg – the circulation was so bad it got infected and I had to go to the hospital.

The other problem with internet cafés is that a lot of drug addicts would use the toilets as a space to inject. These people are really desperate. I actually feel really sorry for them, you know? They get one pack of heroin for €20, and they need it so desperately you wouldn't even believe it. So when they try to sell a bike or a phone to you, you could offer them €20 and no more, and they'll be happy to sell it to you because it's all they need for one bag. Their whole life revolves around it, and they don't care about anything else anymore. ◂

Have you ever gotten connected to drugs?

▸ No. Fortunately I never did drugs. I don't drink, I don't gamble ... I don't even smoke. I guess I'm very lucky in that way, and it kind of makes me unique in the homeless community. I don't even have many connections with people who are involved. I used to help a fella. He was a nice guy, very intelligent actually, and we used to talk a lot, but he was a heroin addict. It got to a point that he'd keep begging for money from me, he would keep saying please, please, please, and I'd tell him to stop, that I have no money, but then he pulled out a scissors from his pocket and put it against my neck. He searched my pockets, and, well, obviously my pockets were empty, so when he realised, he said sorry and ran away. These people are so desperate, you know? After this experience I just turned away from all of them. It's just easier this way. ◂

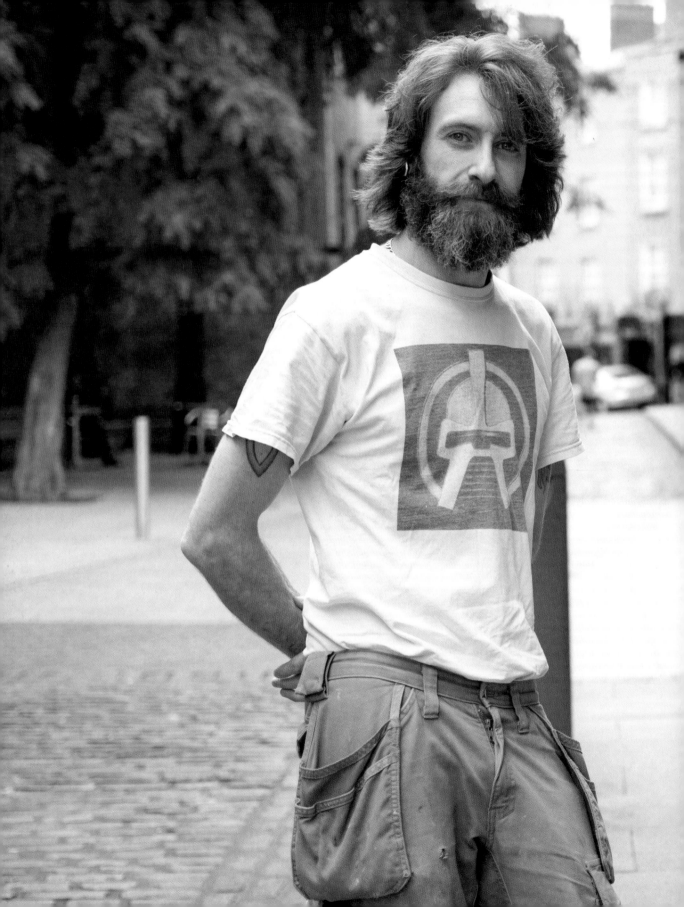

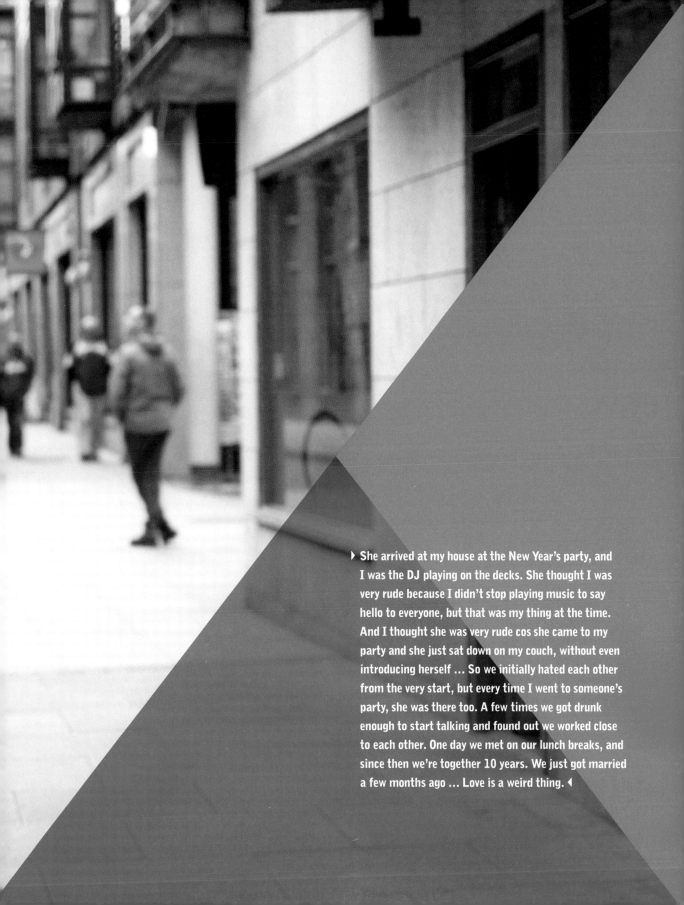

She arrived at my house at the New Year's party, and I was the DJ playing on the decks. She thought I was very rude because I didn't stop playing music to say hello to everyone, but that was my thing at the time. And I thought she was very rude cos she came to my party and she just sat down on my couch, without even introducing herself … So we initially hated each other from the very start, but every time I went to someone's party, she was there too. A few times we got drunk enough to start talking and found out we worked close to each other. One day we met on our lunch breaks, and since then we're together 10 years. We just got married a few months ago … Love is a weird thing. ◀

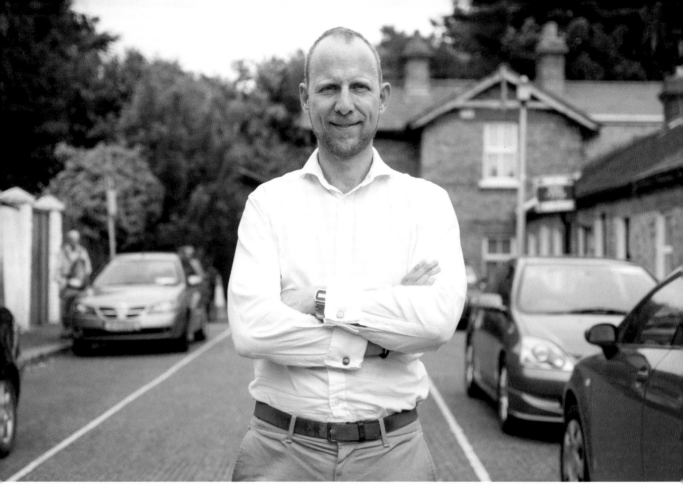

▸ My dad was diagnosed with a brain tumour just over 10 years ago, and he was only given 4 months to live. Basically it was the end of his life, so I wrote to every single person he admired. All the famous celebrities, newsreaders, singers, football teams ... It took a lot of work, and a lot of letters back and forth, and he received loads of cards which was very kind. But later Katie Melua came to the house and played him a live set. The most amazing thing about that was, even though he was a very sick man – the tumour affected him cognitively, and it was very difficult to see somebody change so much – when Katie Melua came that day, he switched back to his old self. It was as if the adrenalin totally changed him. When I look at the overall relationship with my father, we've had our ups and downs, but having such a beautiful memory, where you can see you're losing somebody and then they just come back, was very special ... just to show 'I'm still here', and the love we shared in that moment ... It was a beautiful day, and the great last memory I have of him being truly happy. ◂

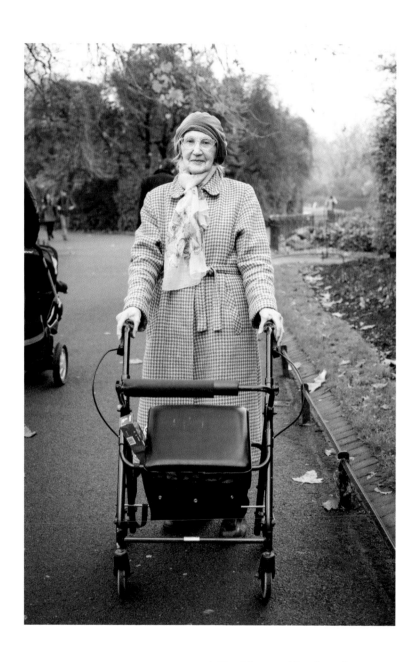

▶ I'm 86 years old and, you know,
these rainy days I keep thinking if I
could be 80 again. Not 21 or 30, but
80, so I could see him again ... ◀

▶ I was born with a lot of disabilities. The funny thing is that I don't see my deafness as a disability, especially in the Deaf Village. It's an amazing place. Everyone signs there. When I'm at home I have TV with subtitles, my books, and my phone. Technology on phones and apps like Facebook, Skype, and FaceTime have revolutionised communication for Deaf people. We love Facebook! Nobody else in my family is deaf so if I spend a few days with them I become exhausted and sometimes lose my voice because I'm not used to talking all the time. This might sound weird to some people but sometimes I really love getting home and just turning off my hearing aid. It feels amazing. It feels more normal, and actually it is the hearing aid that makes me feel disabled.

One hundred and sixty years ago in Dublin there were two schools built for deaf people: one was for boys and the other was for girls. The buildings were close to each other, but boys and girls could never mix, which was how the Christian Brothers and Dominican Nuns did it back in the day. Amazingly, because the students couldn't communicate, two different types of Irish sign languages developed. Ireland is the only country in the world that developed male and female sign languages. Nowadays, the two dialects have merged, but some differences still remain. It's really interesting to meet some older deaf couples. You can tell who wears the trousers at home by which sign language the couple use. The differences and challenges don't stop there. In Northern Ireland, Irish Sign Language (and British Sign Language) is officially recognised; sadly in Ireland Irish Sign Language still isn't legally recognised. It's a constant struggle to get ISL interpreters in areas like court and hospital. Hopefully this will change soon. ◀

▶ Dublin means freedom for me! This is the place I can be myself for the first time! Only a few people knew it back in Portugal. I'm from a small city so everybody would talk about it ... I'm not saying it was difficult for me, because I don't have a gay attitude or feminine manners, but often there were situations I had to act or have fake chats with people that made me feel very uncomfortable. When I came here I had no idea that this country can be so open-minded, and I had no idea that I could get in the gay scene so fast ... The first few days made me feel like, yes, I can finally be myself without acting and without being afraid who will comment on it ... This is the first time I've lived alone and am responsible for myself. Like, I never even had a boyfriend before, I mean, a long relationship ... So I guess it's a new life starting here for me, and I'm very excited ... ◀

▶ I've been a big football fan since I was young, and when I was about 21, me and my friends would travel around Europe on trains to see different football matches. We didn't have much money so we never stayed anywhere, and we'd sleep on trains and shower at the train stations. You're probably too young to remember, but we were there in Stuttgart in 1988 when Ireland beat England in the European Championships. That was one of the most memorable days of my life. We were there with another 6,000 Irish fans, and the whole vibe was just incredible … Imagine, we hadn't beaten England for 50 years … English hooligans had a very bad reputation at the time and the whole stadium was very well secured, but at the end when we were leaving we saw about 200 English fans at the exits and we thought, 'Wow, what do we do now?' And before we could even think, they all faced us and started clapping. That night we ended up in Heidelberg drinking all night, the Irish and English, all together. I was only 21 but I felt like they'd write that day into the history books … ◀

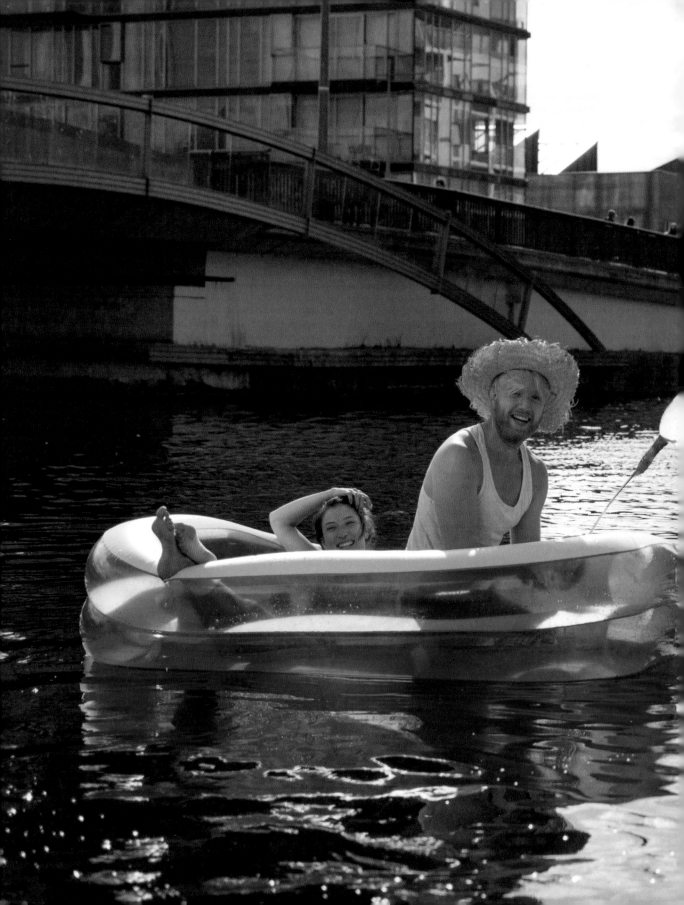

I guess I'm good at spontaneous ideas …

▶ This 'be yourself' thing kind of works for me since I finished school ... ◀

▶ I have three children; me and their mum separated. In the last six months I've been fighting for the access I've always had. I've just been ousted by my ex; the courts have also ousted me and heavily lean in favour of mums ... People think that it's fine for the family court to operate behind closed doors, but it's not. It's a social scandal ... There's no consistency. I know people who have committed crimes or had drug problems and they get to see their kids more often than I do. I just want to see my kids, and they want to see me ... I'm sure I'm not the only one in these shoes. People talk about equal rights but they must highlight the fact there's nothing even close to equal rights in the family courts. ◀

What is the best thing about having a moustache?

Flies can't fly up your nose.

▶ I think this might be the most difficult time in my life so far. At the moment I'm homeless. I'm not sure if I'm allowed to tell anyone, but my boss lets me sleep on the couches at work. I'm currently waiting to move into an apartment, but today I got the news that it's flooded due to the rain. If I'm lucky I can move in by the end of the week. I think the difficult part is I'm in a relationship and I have to know there's someone who's worried sick about me … I forget that sometimes and might come off as too light-hearted and not worried. ◀

▶ I sold a painting to a production company, and with the money I spent three months in New York City. I always wanted to see a Franz Kline piece in person. I have this Coca-Cola T-shirt, and I was wearing it one day outside the Museum of Modern Art, and I got a Pepsi from a street vendor outside. Some lady coming out of the museum looks at me, with the conflicting brands, and says, 'That's a strong statement, I like it.' I was just thirsty. I thought, 'That's what you're dealing with here.' I was amused at the Coke, Pepsi thing. Here was this lady thinking I was consciously trying to make a statement when I was just doing what came natural to me, as natural as taking a drink … That happens a lot in the art world. People project a lot of meaning where there may not necessarily be any … 'I wonder why he used red, what does that represent?' It was the cheapest colour on sale. It's beautiful, and frightening. ◀

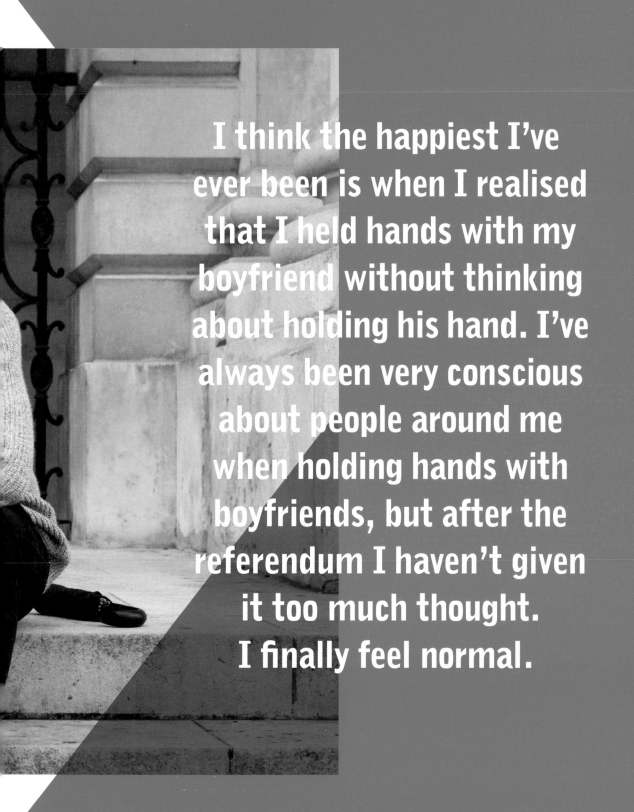

I think the happiest I've ever been is when I realised that I held hands with my boyfriend without thinking about holding his hand. I've always been very conscious about people around me when holding hands with boyfriends, but after the referendum I haven't given it too much thought.
I finally feel normal.

▶ I remember I had a bad feeling long before walking into town that day in 1974.
When I was passing by Trinity College, this huge explosion went off. I only got the
nearby blast from it. I couldn't see what it was, and I couldn't really locate it either,
but after a few seconds two more explosions went off in the streets behind me … I
could hear the tremendous noise of collapsing buildings, but I still didn't understand
what was happening. The weirdest thing was people's reactions around me. They
didn't seem to care much. I thought they obviously had heard it, but nobody seemed
to be injured and they just kept on walking like nothing happened … It made me very
confused. I didn't see a doctor for about 4 days, but after that I was on medication
for 20 years. I got these strong headaches for so long. There were weeks when I
couldn't do anything, but watch TV and smoke cigarettes … ◀

▶ I remember I woke up and all I saw was darkness. I couldn't move and it was silent, and I could only smell death around me. My doctor said if I didn't spend those three days in a coma, I would have died. He said the coma is good for you, and for your mind … I was found under the ruins of our house. I lost one of my eyes, my spine was injured, and I almost lost a leg … I was in a terrible condition. I lost all my brothers and sisters that day, when they threw the bomb on us. If you're from a war country, life in another country is always better than where you came from. I'm very grateful for Ireland, that I can call it my second home, but there is a saying I found true, 'East, West, North, South, there is no place like home.' It's been 12 years now, but I still plan to go back … ◀

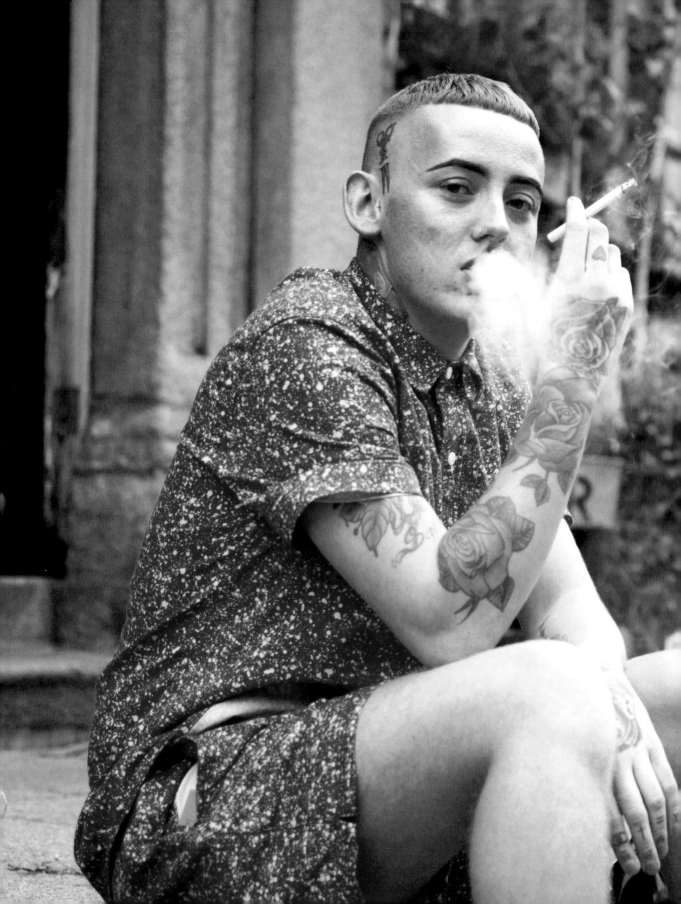

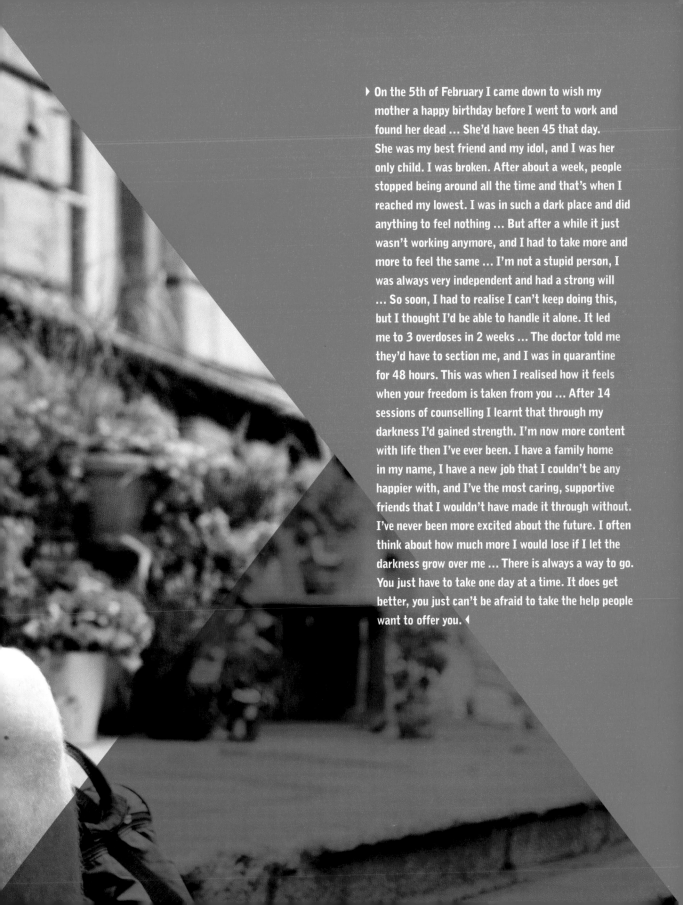

> On the 5th of February I came down to wish my mother a happy birthday before I went to work and found her dead ... She'd have been 45 that day. She was my best friend and my idol, and I was her only child. I was broken. After about a week, people stopped being around all the time and that's when I reached my lowest. I was in such a dark place and did anything to feel nothing ... But after a while it just wasn't working anymore, and I had to take more and more to feel the same ... I'm not a stupid person, I was always very independent and had a strong will ... So soon, I had to realise I can't keep doing this, but I thought I'd be able to handle it alone. It led me to 3 overdoses in 2 weeks ... The doctor told me they'd have to section me, and I was in quarantine for 48 hours. This was when I realised how it feels when your freedom is taken from you ... After 14 sessions of counselling I learnt that through my darkness I'd gained strength. I'm now more content with life then I've ever been. I have a family home in my name, I have a new job that I couldn't be any happier with, and I've the most caring, supportive friends that I wouldn't have made it through without. I've never been more excited about the future. I often think about how much more I would lose if I let the darkness grow over me ... There is always a way to go. You just have to take one day at a time. It does get better, you just can't be afraid to take the help people want to offer you. ◂

▶ I do get a bit angry when I see girls complaining about body image. It hurts a lot. I battled demons with my body for years, and we have been through so much … I just had to learn how to love it. I accept it and give it the love it needs. When it tells me it needs a break, I give it a break. You know, the world is too superficial … Of course aesthetics is important and it makes you feel great, but it is not the be all and end all. We don't need to strive for this unrealistic perfection. We're not all supposed to have double-Ds and a 26-inch waist … The most important thing is to accept and respect your body. Take long walks, eat healthily, and exercise. These things should make you feel beautiful and happy. ◀

Niamh was diagnosed with scoliosis, which is a musculoskeletal disorder, when she was 13. As she said, she believes she was given a cross to carry for somebody else. Probably because she is so strong, they gave her another cross to carry when she was diagnosed with thyroid cancer. Cancer definitely picked the wrong person to mess with!

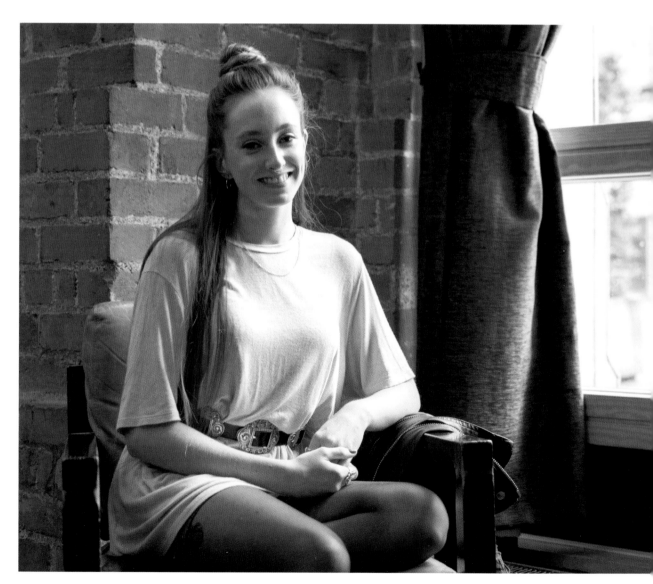

▸ It's a goldcrest, the smallest bird in Ireland. I found it two days ago – it was completely soaked but still alive. I kept it warm in my jacket but eventually it passed away. So I created an art piece out of it. Now I'm fishing for €2 coins. ◂

May I ask how you plan on doing that?

▸ Just the way I did it with you! ◂

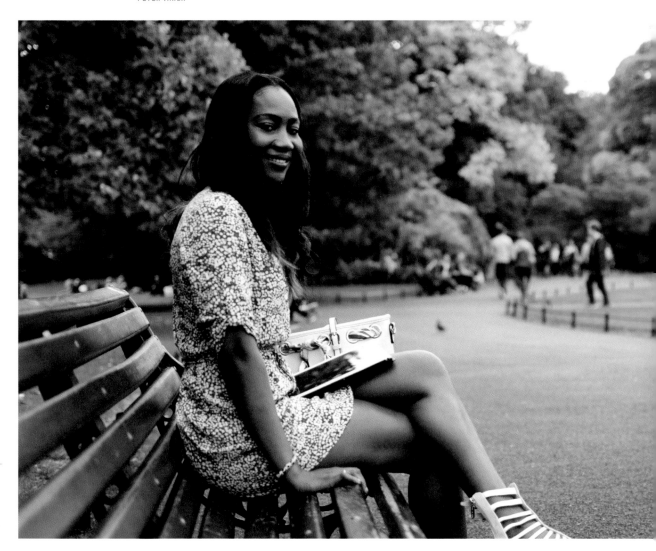

▶ I always tried to make my parents happy in a way, but they were very strict about marriage and would never allow me to have a relationship before I got married, especially not with a white boyfriend ... I actually didn't have many boyfriends, but they were all white and my parents never knew any of them. I was already living alone in Ghana about two years when I met this guy in a restaurant who asked me out. We were dating about seven months, and I had to hide him from my parents for the whole time. He was only in Ghana for a job but then he had to go back to Europe, so the plan was to stay together and that we'd visit each other, but after like a month he said he's so in love that he can't imagine being without me anymore, and he'd like to marry me ... He wasn't in an easy situation either because he's from Slovakia, where not many black people live, and his parents were very conservative too ... But he was determined. It wasn't easy I can tell you, but we made it through our families with a deal that we'd get married in both countries to respect the traditions. We're married four years now, and I still feel the same love for him, or even more! ◀

▶ I think these new generations know too much. We were
better off when we were young and innocent! Everything
seems so much more complicated now ... But you know,
I used to be very good at singing, ever since I was
little. I was also good at playing piano! I still remember
the song I sang on my First Holy Communion; do you
want me to sing it for you?

Hang up the baby's stocking
Be sure that you don't forget
For the dear little dimpled darling
Has never seen Christmas yet!
I told her all about it
She opened her big blue eyes
I'm sure she understood it
She looked so funny and wise.
Gee, what a tiny stocking!
It doesn't take much to hold
But little pink toes as baby's
Away from the frost and the cold.
But then, for the baby's Christmas
It never would do at all
Why! Santa wouldn't be looking
For anything half so small.
I'll know what we'll do for the baby
I've thought of the very best plan
I'll borrow a stocking from Grandma
The biggest that ever I can.
And hang it by mine, dear mother
Right here in the corner so
I'll write a letter to Santa
And fasten it to the toe.
Write, 'This is the baby's stocking
That hangs in the corner here
You never have seen her, Santa
For she only came this year.
But she's just the blessed'st baby
And now before you go
Just cram her stocking with goodies
From the top down to the toe!' ◀

This is a poem from a 101-year-old lady
that she learnt when she was seven.

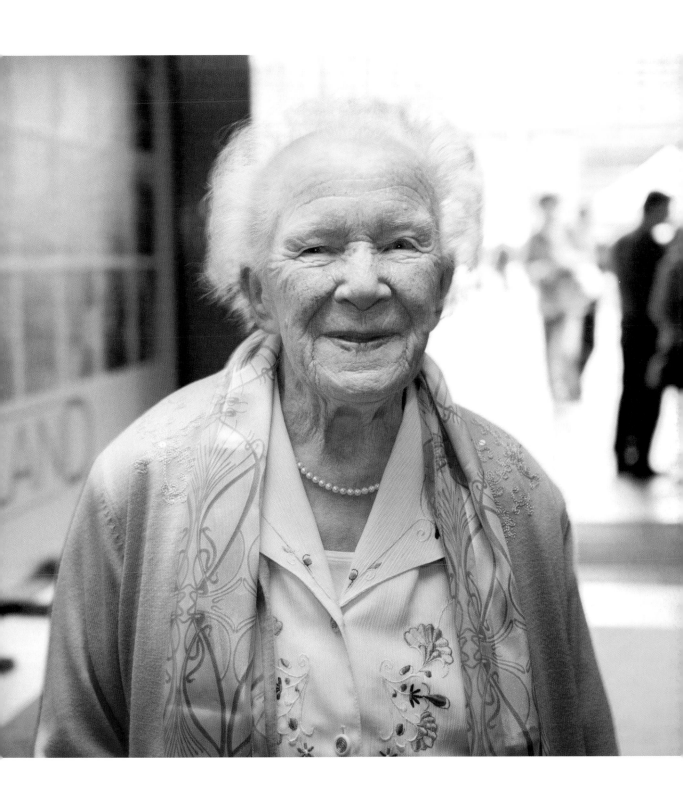

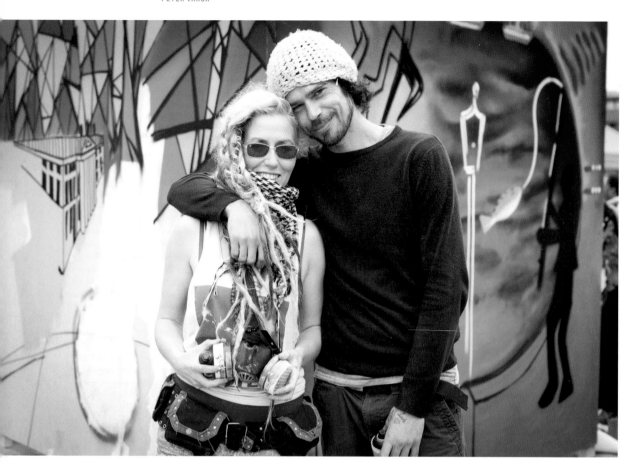

▶ Our parents grew up in the city centre, but they wanted us to have
the experience of growing up in the countryside so they bought a
small bit of land to build a house on, and while it was being built
we lived in a caravan. We had no TV, sometimes no electricity
even, so our mother would buy lots of crayons and we'd draw
pictures every night. If we finished too early, she'd say, 'Draw
another, draw another! More colours!' Not only would she let us
draw on the walls of the caravan, but she'd draw with us too …
So I think being artists and painting on walls was always pretty
natural for us. ◀

▸ Yes, you can take a photo of me, but make sure the litter sign is in it! ◂

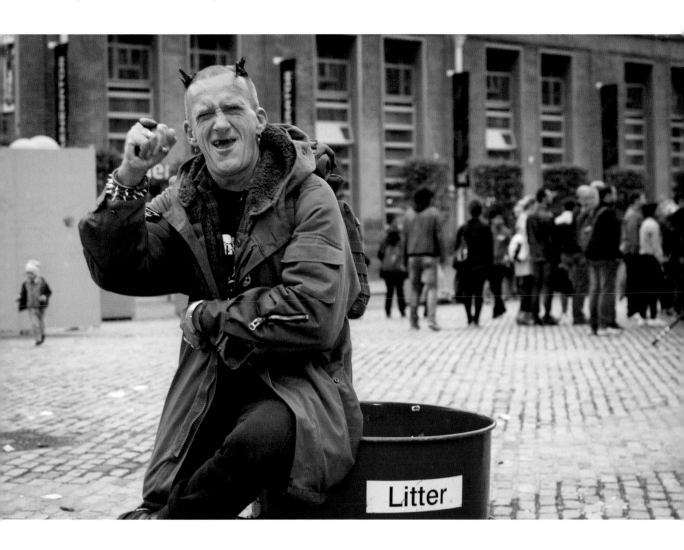

▶ You know, when you're not in a relationship you put yourself in one of two positions. Either you're looking, and cursing yourself, because when you're looking you don't find anything. Or else you're not looking, but your subconscious goes, 'Oh! Did she look at me? Was that a flirt?' I think part of being human means always being on the search for a connection with another human being. And when your life is devoid of love you can feel very lonely. You're going to the cinema and you're sitting there watching a movie, eating popcorn, and you look around and see people hugging or kissing ... On top of that I was uncomfortable with myself and the way I look. I could be around people I really like, chatting and smiling, but still I'd feel very lonely in my heart, and after a while just gave up ... On that day I was working as a volunteer at a second-hand book sale, and I was at the till when a girl came up, and you know, I asked her if she wants a bag, and she said, 'No, it's alright, I've got a canvas bag with me!' And I just remembered there's a song about canvas bags by a guy called Tim Minchin, so I just started rambling on to her about this song, and she was just looking at me ... About an hour and a half later a different girl comes in, straight to the till, and asks me, 'Are you a single?' I said, 'Sorry?' 'My friend wants to know, are you a single?' I can still hear her, in her lively German accent ... She was her best friend. Well I didn't say this, but at that stage I was single for six years. She's an English teacher, and her name is Jen. She's amazing. We're together 18 months now. ◀

▶ I knew from a very young age I was gay and I didn't want to be. At the time it was very different; there was a lot of pressure from society and I found it very difficult to accept. I even had a few girlfriends and really tried to change myself. It's probably my biggest regret – fighting my sexuality. Once I took that first step and accepted that I was gay, suddenly everything fit into place, and basically within a week I told everyone. What surprised me the most was the reactions from people, that each one of them was very supportive, and some people even said, 'We thought you'd never come out', or 'What? I always knew you were gay …' I wish I had been honest with myself much earlier and didn't waste 20 years of my life wearing masks. ◀

▶ In the '50s and '60s, Ireland was so much different than today. My father died when he was 46 and left behind his wife and 10 children, so I had to grow up pretty fast. I started working when I was about six or seven. I had to collect turf and deliver it to old people and widowers. Most of the time we didn't even have a trolley to carry it around, so we had to find unwanted prams and use them. If we finished that we'd call door to door asking for bottles and jars to return them for a bit of money. I finished school when I was 13, and because there were no jobs here, I went to London and had to use my brother's birth certificate to get a job. When I was going around looking for a job I saw these signs on the doors like, 'NO blacks, NO Irish, NO dogs!' Dublin was so different. People would be walking on the streets. In London everybody seemed to be running somewhere. I was very lucky because I found a job quite fast, even though I didn't get much money, just enough to pay rent and feed myself, and the rest I sent home. ◀

▶ The turning point of my life was a young girl in 1999 walking by with her boyfriend at Christ Church on New Year's Eve. It was lashing rain and I was sitting on some concrete steps with my long hair and beard, listening to the bells, wondering where my family were and how they were. Out of nowhere the young girl kneeled down in front of me, and like an angel with her blue eyes, said, 'Hi! What's your name?' I had to think. Nobody calls you by your name on the streets. 'It's Glenn,' I told her, and she asked, 'What would make you happy, Glenn?' I said, 'I'm okay, I'm happy. I'm in a brave phase. Thanks for asking.' She went back to her boyfriend and got some cans from him and a pack of cigarettes and handed them to me. Then she asked again, 'If you could have one wish what would it be?' I told her I wished to be with my family. 'So why don't you go home?' she asked. I said no, that it'd been too long – three and half years. And she said, 'Just go!' Just like that. This girl in her late twenties being the wisest person in the world. Then she gave me a kiss on the cheek and wished me a happy New Year.

She's out there somewhere, not knowing what she did that day. You can make a difference in someone's life that you might never meet again. You have the power. The best thing you can take from this world is the belief that you made a difference. I went home the next day. ◀

Glenn – Actor, Writer, Director and an Ambassador of Dublin Simon Community.

▶ I come here whenever I can, just to sit for a while and to listen to music. This was my mother's favourite place; we used to cycle and walk a lot around the Clontarf coast. Before she died, she asked that I scatter her ashes here. She got cancer when I was 17 and died when I was 21. That whole time feels like a blur; it still doesn't feel real. It was a tough time. I used to get panic attacks and all. It was way too soon losing her, but exercising and work helped a lot to clear my head and get back to living my life. ◀

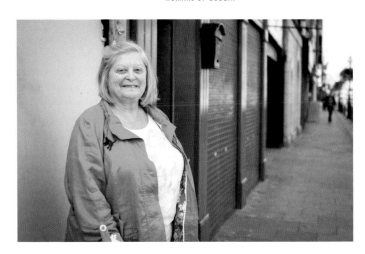

▶ I had a very strong psychic connection with my twin brother. We didn't have to talk to each other to know what the other was thinking, and we were always together even when we weren't, if that makes sense. We played professional piano together – that was probably the best way to project our connection. We never really had to practise to play in sync, it was just so natural to us. I only realised that other people can't communicate that way after he died. I could almost know in my head how he was feeling and what he was doing, not only if he was in another room but in another country. Although there was only a 15-minute gap between us when we were born, it made a major difference between us. My rising sign is Leo, his was Cancer, so he never really left home and I travelled all the time. The difference made him very sick, as he never really went out or exercised, and he got a blood clot in the veins which caused a massive stroke. Even after he died I still had his symptoms for a good while. The doctors made me go to hospitals for regular check-ups, but the tests always came back negative. It's a very special connection. It makes you realise you don't really need other people in your life once you have your soulmate. ◀

▶ I was in a movie with Richard Harris called *The Field*.
Do you know it? Richard was nominated for an Oscar
and a Golden Globe for his performance. I also had a role
in *My Left Foot* which received five Oscar nominations.
Even if you know the movies you probably wouldn't
recognise me now. I had lots of red hair and a big red
moustache. I'm still a working actor but as I've aged I
get less opportunities. I probably do two or three roles a
year but I know I could do more. I miss acting ... ◀

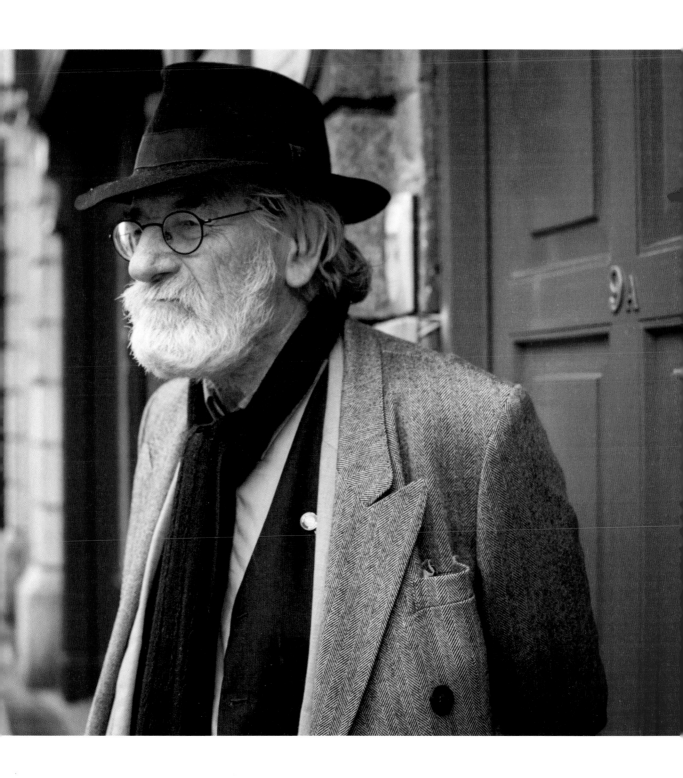

▸ I'm a barrister and I work a lot on probate when people pass away. The really interesting part of my job isn't the treasure that people leave behind but rather the people they choose to leave it to. For example, I recently had a case where a grandmother had passed away and had an engagement ring. The family were more concerned about who she had left it to than the actual value of the ring. People often spend far more money on the legal process than the value of what they are fighting for. At the heart of many fights is the thought that one person was loved more than the other. It can be a very difficult time, but also a great time to learn about yourself and the other people involved. ◂

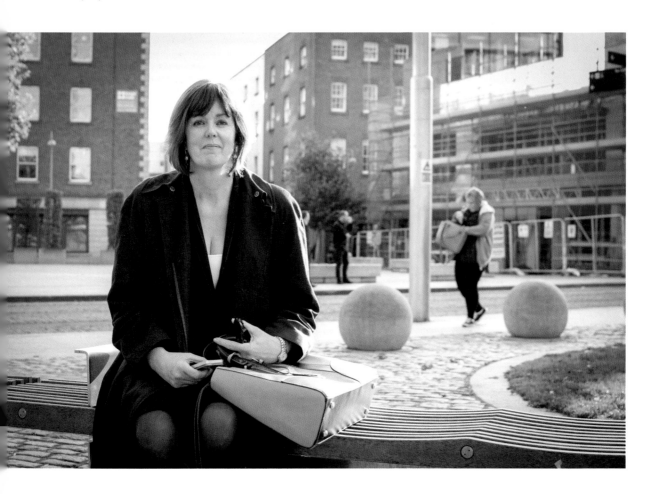

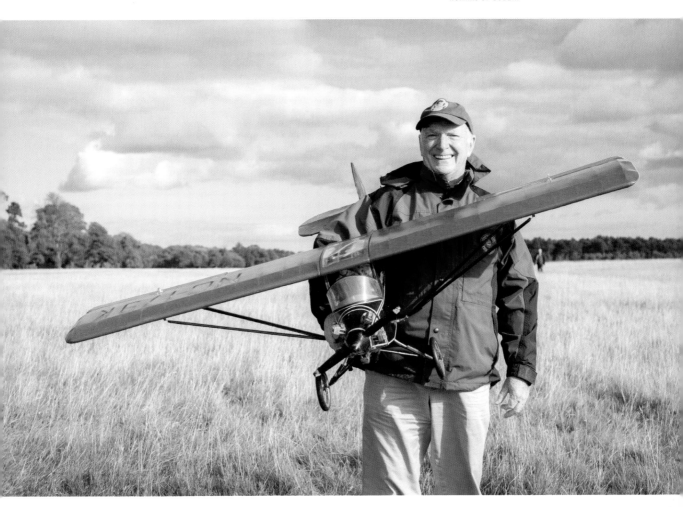

▶ I've been building models since I was about 16 and I'm 78 now. I always wanted to be a pilot, but in my day you were lucky to get educated at all, so I drove with Dublin Bus all my life instead, and I kept my hobby and our model club close to my heart. It's a great hobby, but guess what? My son is a pilot for Aer Lingus! ◀

▶ My son was found dead in a park seven years ago. He was 43 and
healthy ... They said they did all the tests, and they did everything
they could to find out what happened. But they never found out,
and they just closed his case after a while. It probably made it even
harder on us ... Luckily he had no family of his own. That would take
it to a completely different level ... But time heals everything, you
know? It gets a bit easier every day, although there's no day he's not
on my mind. ◀

▶ When my baby girl was born, suddenly my way of thinking changed. You feel a sense of purpose, and it changes your priorities in life. I also tend to question myself much more often – 'What are the bad things about me that I don't want to pass on? And what are the things that I like about myself?' I was always a quiet and calm guy, but I feel a power in me that I could do anything for her! ◀

When I was little, waking up for school and seeing a robbed car burning outside our garden was as normal as seeing a horse in our garden. It was just normal. There were lots of fights and feuds, and a lot of bad things would happen. As I got older there were vigilante riots and marches, all up the road beside my house, shouting 'Pushers out'. It was like a film. It was something to be part of and all of us kids had a great laugh. There were shootings every other week. That was just normal too. Some of my friends ended up in prison or dead, some were on heroin. I didn't feel like the normal one. It's only now I'm older and the street has quietened down a bit that I look from the outside and see that growing up was a bit crazy. That's just how it is for a lot of kids, and it shouldn't have to be, in this day and age. But I turned out alright. I'm grateful for my childhood and I love my memories. I wouldn't want to be from anywhere else. The bad memories made me stronger. And sometimes we had great adventures too! ◀

▶ Since I lost my wife, I come down here every now and then and bring some wheat for them. They're great company, you know? These pigeons know me now. There is one in particular, I can't find her now, but there is one who follows me everywhere. Even if I just walk by with my hands in my pockets. The other day I was running to get the bus and when I stepped on the driver told me no animals allowed on the bus! I was thinking, 'What the hell is he talking about?' He pointed at my feet and I looked down and saw this pigeon right beside me! I literally had to ask her to get off … Ah there she is, look! I have no more wheat, but look, I'm going to walk and they're going to follow me! ◀

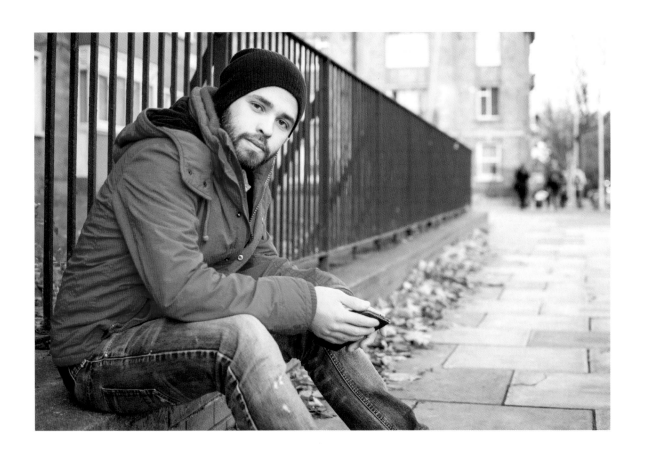

▶ I grew up in Dheisheh Refugee Camp. It's about five minutes from the centre of Bethlehem in the West Bank. Hearing bombs go off, finding out that my relatives and neighbours had died, and having soldiers shout at me and my friends while pointing M16s at us was just part of everyday life. My father left Palestine in 2002. It was a period when the Israeli and Palestinian conflict was incredibly tense. A few months after he left I remember a normal school day when a kid opened our classroom door and shouted that Israeli jeeps were outside. They were looking for someone. Suddenly tear gas and sound bombs were thrown into the school. The whole class jumped up and ran out. Teachers, kids, everyone started throwing stones at the jeeps to hold the Israelis back. I remember when the soldiers entered the school and started searching. One guy hid in one of the classrooms. When they found him, his screams filled the empty school. We all heard him. I saw many things in Dheisheh, but that was when I felt the most terrified. Imagine seeing your friends getting tear-gassed and shot with rubber-covered bullets. That was life in the refugee camps. There were attacks and searches almost every night. Soldiers were always looking for somebody … I feel incredibly lucky to have gotten away!

My father's a film-maker. He documented the conflict in Bethlehem and other dangerous locations. He went where the news agencies were afraid to report from. Even though it was incredibly dangerous he was always paid a fixed rate, no matter what he exposed or how long it took him to make. In 2002, a story unfolded at the church in Bethlehem where Jesus was born. It's called the Nativity Church. Many Palestinians hid in the church hoping that they'd be safe from the Israeli soldiers outside. They were surrounded for 40 days. Many of them starved to death or were killed as they tried to flee. Eventually the Palestinian government made a deal with the Israeli government to end the siege. In return for being allowed to leave, the remaining Palestinians had to leave the country. My father decided to document their departure and their journey through Europe. That was the last time we saw my father for eight years. He followed the survivors until he ended up in Ireland, where he completed the story. When he tried to come back to us he was refused re-entry to his home. He was left in Ireland, and we remained in Palestine. That was a really hard time for us. I will always remember the day that my father told us he had been granted Irish citizenship and that he was applying for visas for us. After eight years we had hope of being together again …

Arriving in Ireland was an amazing time in my life. Europe was a new world to me. A world of freedom and possibilities; a world where you wouldn't be asked for ID constantly; a world where it wasn't the norm to be subjected to degrading body searches for no reason; a world where it wasn't okay for others to hit you and scream questions at you while pointing a gun in your face.

I remember the day that my youngest sister arrived here. We took her to the Dundrum Shopping Centre. She was utterly amazed by its size, especially the supermarket. She had never seen anything like it. I remember how happy and excited she was to be able to run around and explore. That is until she saw two Gardaí. She immediately ran and hid behind my father. She was terrified. Her knowledge of the police force was the opposite of what most people believe. She only knew fear of those people and their tanks and guns. How can you explain to a 10-year-old that the uniformed people who once occupied her city are now the ones who make it their mission to protect her? My father knew exactly what to do! He went after the Gardaí and explained the situation. The two Gardaí came back and spoke with my sister. They were so kind and friendly. Soon they were taking selfies and high-fiving. It was inspiring to see those seeds of trust starting to grow. In that moment I think my sister thought of Ireland as a new home and a safe place … ◀

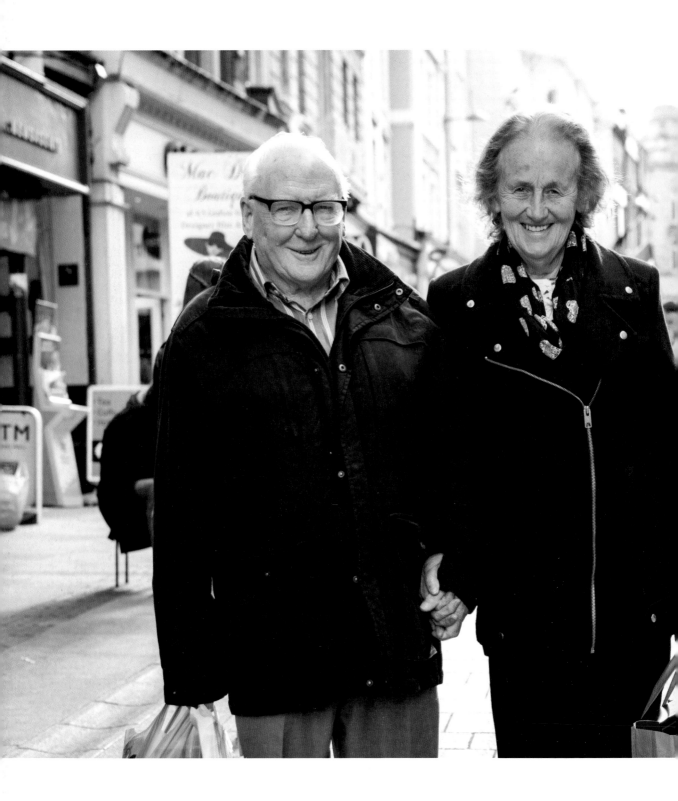

What's the secret to a long-lasting relationship?

▶ Don't ask me, we're a fresh couple. We're together only six months! ◀

May I ask how you met?

▶ On a holiday in the Bahamas. We both missed the bus back to the village! ◀

▶ My dream was always to work as cabin crew, but three years
after I achieved that, I'm not as excited about it anymore. The
antisocial working hours made me lose connection with my
friends and family, and on top of everything I was bullied all the
time because of my looks. I was always quite skinny, and it didn't
really affect me, but being bullied made me very depressed.
I wanted to take the attention away from my skinny face and
body and decided to start going to the gym. First it was very
intimidating because everybody is so big and would lift, like, fifty
kilos while I was lifting two and a half, but still, it was the best
decision I've made. I'm still skinny, but I grew a lot of confidence
and I fought off my depression too. Now I just have to find a new
dream to follow! ◀

▶ I ended up homeless back in May. I was 17 at the time. I never thought this would happen to me. I don't have much family and my dad left when I was two. I lived with my mam in a rented apartment in Carlow. She's an alcoholic but got herself into rehab. I was asked to go to foster care but I didn't want to. I thought I'd go to Dublin, find a job, and start my own life. I learnt the hard way that when you're 17, with no home address and no experience, it isn't easy. I turned 18 three weeks ago and maybe life is going to change now. I'm registering with Dublin City Council for social welfare, which means I'll be able to use public hostels for free. I want to save up some money and finally start my life ... ◀

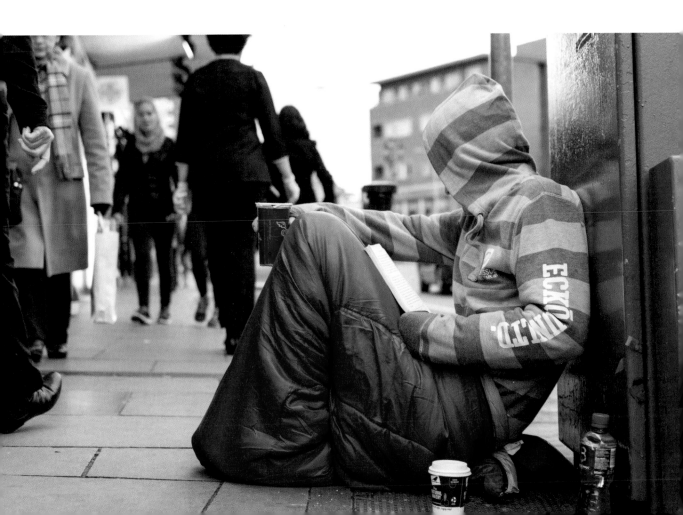

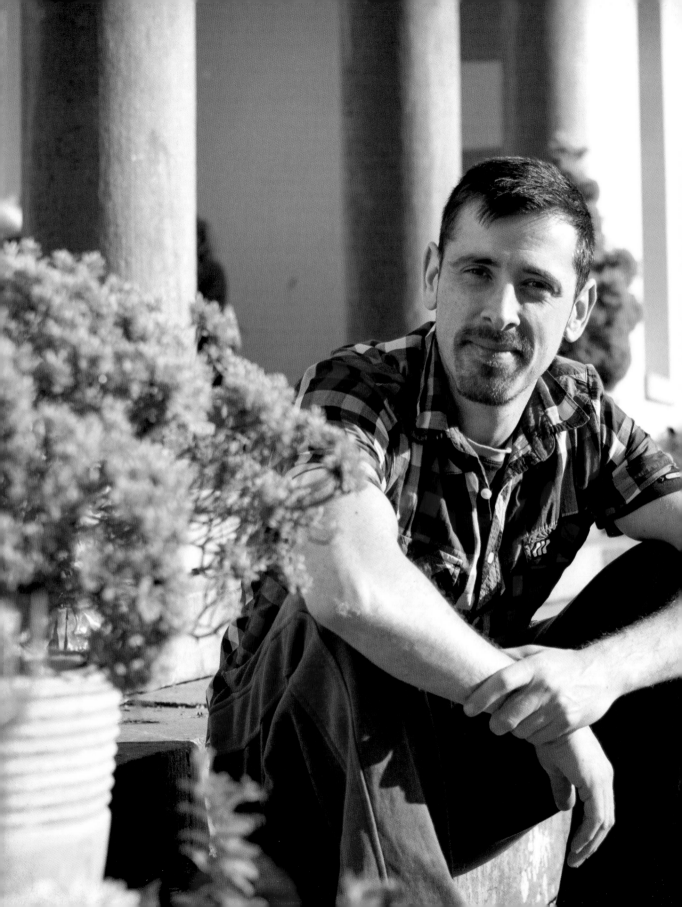

▶ I'd been travelling for a long time, and I really missed my gym at home, to the extent that I was carrying skipping ropes with me. So I got to this tropical island in Malaysia, and after a few days I found this outdoor exercise place where someone had made weights out of concrete and paint buckets. So I thought, 'Yeah, I'm going to try them out'! I got so tired, I thought I'd go into the sea and stretch it out. I went out exhausted … I didn't even go far, only about 10–20 metres from the shore, when a wave about twice as high as me just grabbed me and pulled me out. All of a sudden I was about 50 metres from shore, and the waves kept pulling me back. I had no strength in my arms and started to panic. I saw my girlfriend out doing a yoga pose facing the other way … I thought, 'Right, I have two choices here. I can get out of here dead or alive. I can start shouting and screaming, but she probably wouldn't hear me, or I can stop panicking and start thinking.' Straight away my brain went calm and remembered this thing in a book called *Papillon*. The guy is a prisoner who escapes by floating out on coconuts. He says the only thing that will keep you alive in the waves is your breath, so breathe and hold it in. That's all that keeps you up, otherwise you're gone. I remembered this and every time a wave came I would turn around, take a deep breath, and do nothing, and the waves would push me forward. I eventually got out, but I don't think I've ever been so close to death. A few hours later this Swedish scuba-diver guy came up to me and said, 'Did you swim on that beach? No one swims there! Somebody died there only a week ago!' That night I was in such a state of trauma I couldn't sleep at all. It was probably when my body released all the fright and shock I had to hold back earlier. ◀

I used to teach in Zambia, and I also trained the cross-country running team back in the '80s. One Sunday morning I went out for a run by myself in the bushes. There's no signposts or anything, just footpaths through the bushes, and I always loved the fact you could just run without focusing on anything, like lights or crossroads. I could usually easily find my way back, but that morning I went a bit further than normal, and I ran by a group of young children washing stuff in the lake. I could see they got sort of scared of me – white people in that area was very rare and frightening for them. I saw them run back to their homes, but I didn't pay much attention to it until I saw a group of adults running after me with machetes and swords. Well, I got pretty frightened then, and I started to run faster, but soon I realised I wouldn't be able to outrun them. I suppose we think very quickly when we're in danger, so I decided to stop and start walking towards them. It was quite serious, and I still don't know how I stayed calm, but I was very lucky because one of the members could talk a little bit of English, and I could explain the situation. Without knowing it, my morning run became an invasion of a local village. They treated their territory as we treat our own homes, and I guess I wouldn't be happy either if strangers were running around my house and scaring my children … Africa does have the same boundaries and rules, just on a different scale. ◀

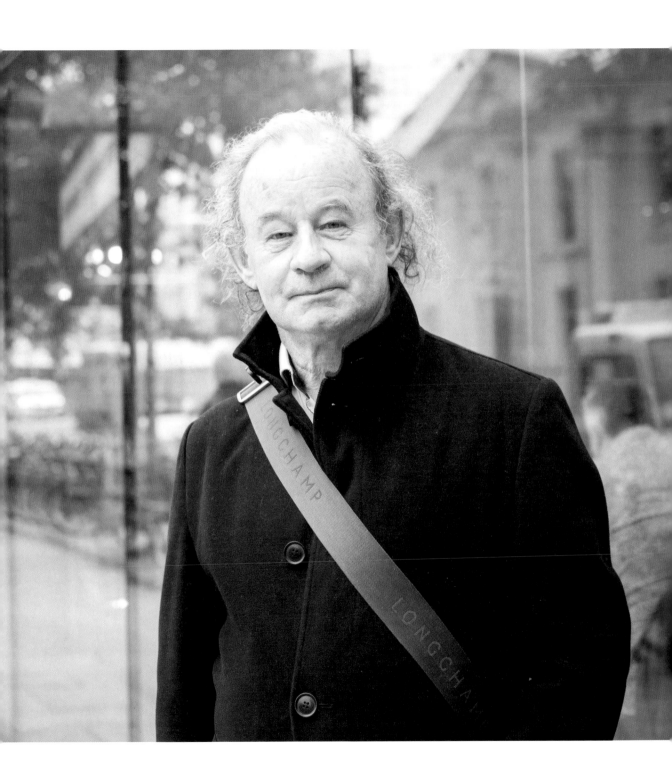

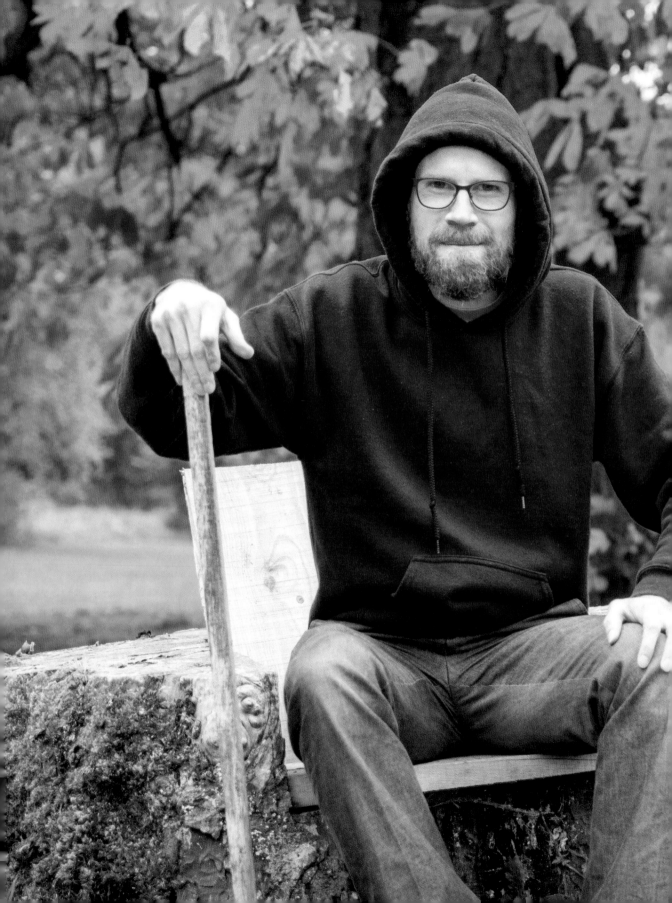

Some years ago, while in my early twenties, I developed a quite unpleasant eye disease. When I say I developed it, I don't mean that I created it in a lab or anything. It just sort of happened to me. I remember sitting one morning in the bedsit where I lived in Rathmines reading a book, and thinking there was a haze of dirt on the right side of the right lens of my spectacles that I couldn't scrub clean … and which even seemed to linger when my glasses were off my face. That was the beginning of my troubles with Uveitis. Anyway, there was a whole lot of jiggering about over the course of the next year or two, with doctors and hospitals and faith healers and medications and the like. In the midst of it all, one particularly weird and memorable moment occurred. The illness had been getting worse and had spread to both eyes. I was put on some new, more powerful pills. I was in that bedsit that I mentioned earlier when I suddenly started to stressfully realise that this being sick business was now my life, and that it might remain so. 'This could be your life' – I was repeating in my mind – 'This could be your life.' I often chat away inside my head as though I am two or more people. Then I was lying down on the ground in a sort of depressed and shivery way until – kaboom-kabash – I suddenly became quite comforted by a strong sense of knowing that I would be fine, which seemed to be coming from outside of me. Then I tilted my head and … this is the strangest part … half-sensed, half-saw the top of the wall/edge of the ceiling becoming somewhat transparent. I could perceive, or maybe just imagine very vividly, lots of smiles shining down on me. A few days later, I had an appointment in the hospital where I was told that my left eye was clear and that my right eye had improved substantially. That was the start of the beginning of the end of my troubles with Uveitis. ◀

▶ Two years ago my mam passed away suddenly, just a couple of days after her 45th birthday. The last thing she said was, 'Night, Aoife, love you,' and by the time I got downstairs to say goodnight she was struggling to breathe. I remember just feeling numb and afraid … I've always used my work as a coping mechanism, and I don't think it's fully hit me yet, as all my energy has gone into my work. Being an illustrator has become a full-time job now. I finished college in June just gone and had a lot more free time on my hands to think about everything, which was tough because I always pushed my feelings to the side. After having time to think, I made the decision to set out for my biological father one last time. I had been looking for 17 years with only his name to go on, so I decided to contact an agency to find him, and they did! I travelled to the UK with family and I got to meet him for the first time in my life. As soon as I saw him, I knew it was him. We had the exact same eyes and smile, and were both lost for words, so just hugged for ages. We got on great and spent the day together sharing stories and catching up. Leaving was really tough, though – he had explained to me he has a problem with drink. Hopefully us getting in touch will give him the strength he needs to get help. It's the beginning of a new chapter for the both of us. ◀

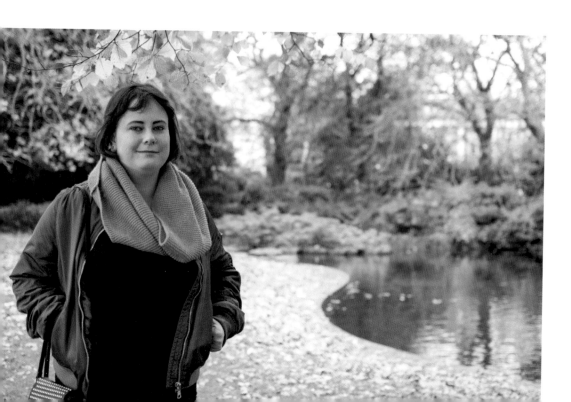

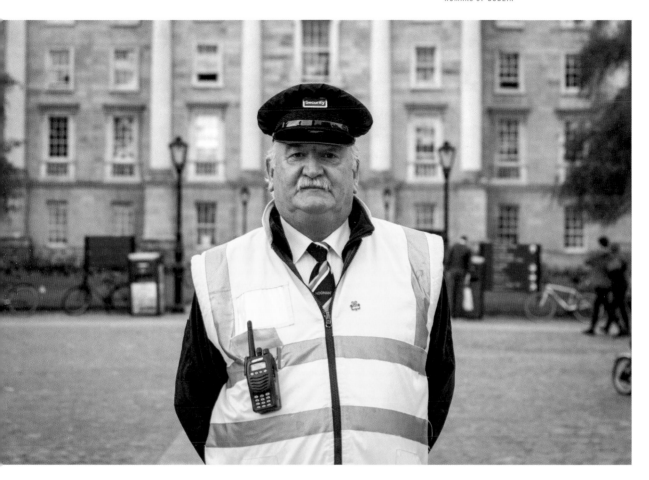

▸ I spent 18 years of my life in the army and another 30 in the police force. As a police officer I specialised in high-speed car chases. It required 110 per cent concentration because we drove at 70–90 km per hour, on small streets. I loved the excitement and adrenalin rush. In 1983 I was chasing a stolen car up Dame Street towards Christ Church when we crashed into each other. I spent eight months in hospital. Most people expected that to be the end of my car-chasing career but I couldn't wait to get back. The force had to retire me to get rid of me! ... This is really just a hobby for me. It gives me a reason to wake up in the morning. ◂

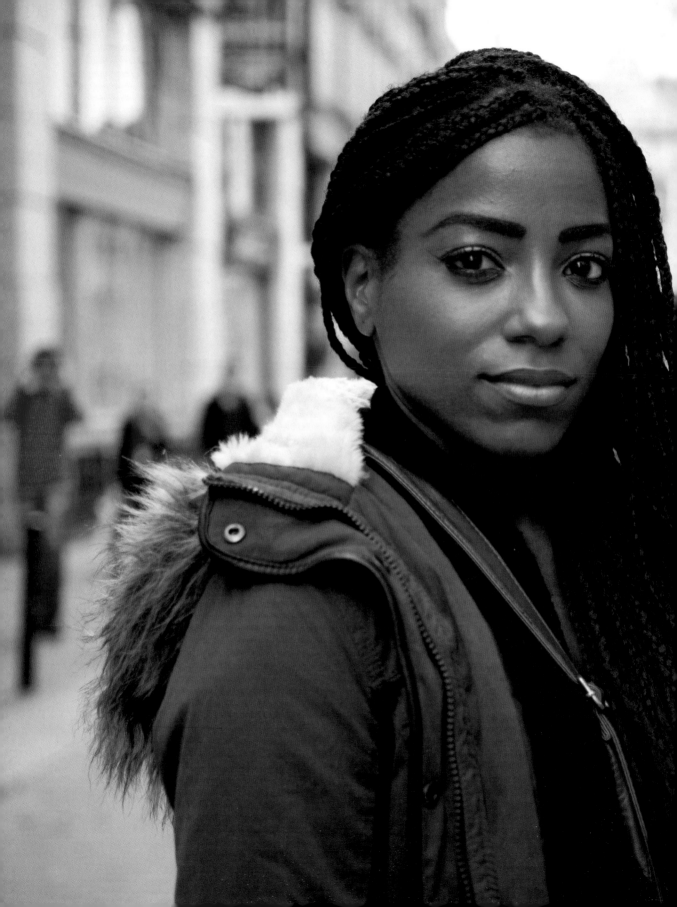

▶ On our flights the alcohol is free, so sometimes people drink too much and open up to us and tell their life story. These are intercontinental flights, so they have the time for it too. They often share things they would probably never tell to anybody, but they think they can talk to us because we'll most likely never see each other again. Last time a guy told me how he discovered his wife is cheating on him with his best friend. It was so sad, not only because of the story, but he was crying, so what do you do? I started to cry too … And it doesn't look very professional when all the other passengers are watching you crying with a stranger … I often feel more like a therapist than a flight attendant after these long flights. ◀

▶ Spending some time in a hostel in my early 20s, after falling out with my parents and becoming homeless, was one of the most difficult times in my life. I found myself in some really messed-up situations by making bad choices and hanging out with the wrong people, and I knew something needed to change. I was wild and couldn't live my life like this anymore … Losing loved ones through drugs and alcohol abuse should've given me the wake-up call I needed, but it didn't. I reached the scariest time in my life when I was in a toxic relationship for almost two years while living in the UK. I suffered a lot of mental and physical abuse, and I remember crying to a family member, asking when it's gonna stop, but I didn't know how to get away … I thought about suicide sometimes; I felt like there had to be a nicer place called heaven, right? Or so we're told … When I finally got away and drove home on the boat with all my stuff, I just felt free. That was about three years ago now. I came home to Dublin and went to college to do fashion design, and finally started to live my life again. My friends and family helped me through it and I'm blessed to have such amazing people around me. From that moment I decided to take a different path and look after myself. It was like the penny dropped, and something inside my brain just switched on. I stopped partying and went on my first ever Buddhist retreat. I started bringing those teachings into my life and slowly things just got better. I changed my appearance, I changed my circle of people, and I was happy. I worked on my inner self, my health and wellbeing, and, most importantly, my mental health. I know now who I am and what I want out of life. I don't have everything I want, but I most certainly have everything I need … Taking it one day at a time! ◀

▶ I really wish I had been more confident when I was younger. I would've grabbed more opportunities and tried to make a bigger difference in people's lives. Even when I was honoured with this opportunity, my friends and family were really surprised that I wanted such a visible role. I never liked being the centre of attention. I always preferred boosting others and pushing them forward.

I remember my first day in the Mansion House. I looked around and thought, 'Oh my God, what have I done?' I made myself sick with nerves. I couldn't eat knowing that I had a speech coming up and, trust me, as an Ardmhéara (Lord Mayor) you have a lot of speeches to make.

It's incredible how much I have changed in just four months. I've found out that nerves can be a good thing. It means that you care about what you are doing. Stepping out of my comfort zone has given me so much more confidence. It's wonderful to have good people supporting you and pushing you forward, but the most important thing is to believe in yourself.

I'm still nervous but I treat the feelings very differently now. It makes me better at my job. I think that if I wasn't nervous I'd probably be doing something wrong. ◀

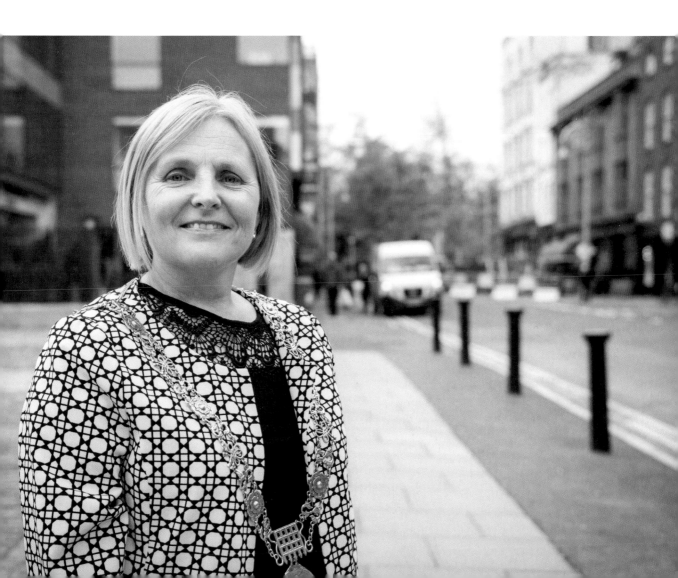

I won't lie to you, I've been in prison and learnt my lessons the hard way. I lost my brother, and I've been in some really bad situations. But I turned my life around. I went to rehab, and I haven't touched anything in five years now. I have a job, I work hard, and the biggest reward is the peace of mind. I have nothing to worry about! Charity work became my new addiction. You know what I did last year? I was out dancing for a charity in Northside Shopping Centre with a bucket in my hand, on my own for the whole Christmas week, and a guy came up to me and said whatever I made that week he'd match it. I made €1,300 and he matched it! In the last 18 months I boxed together over €100k for different charities. And you know what my mother said to me a few weeks ago? She said she's proud of me. I don't think she ever said that to me before. ◀

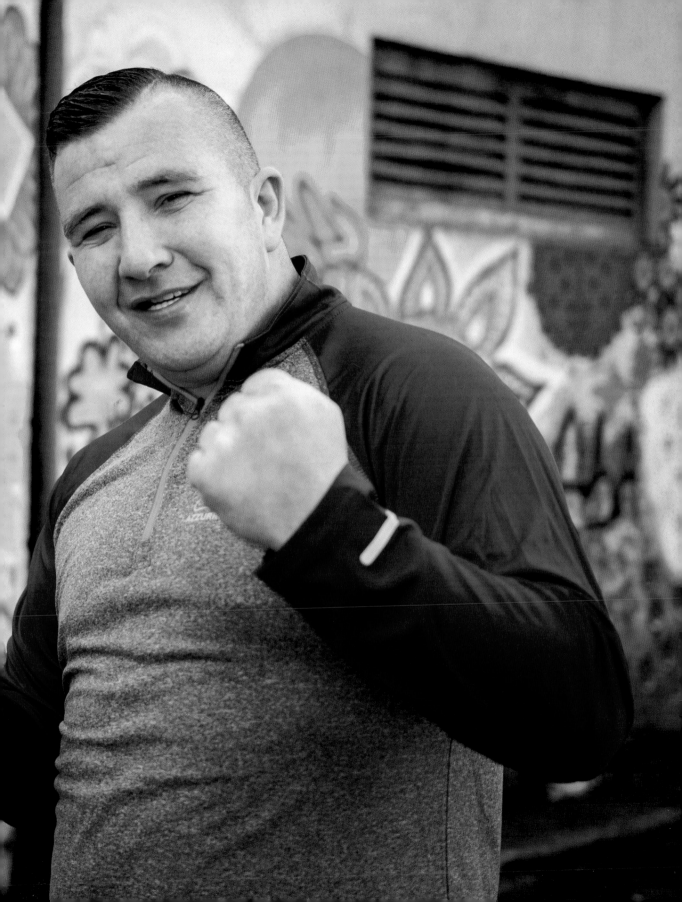

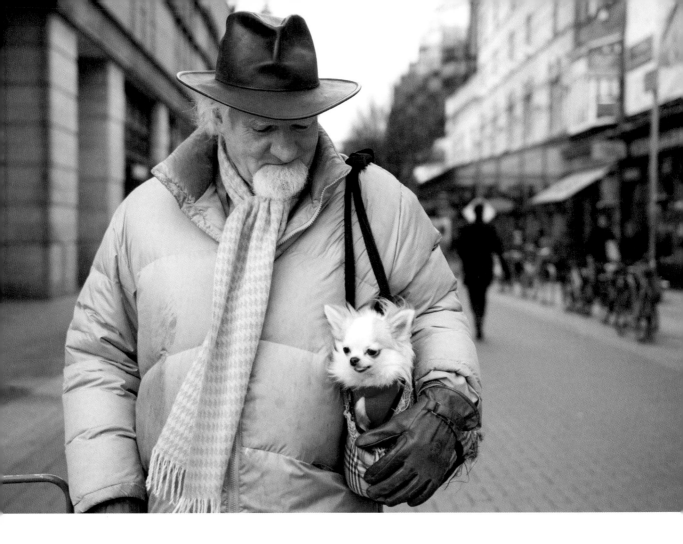

▶ His name is Mario. He's a very cultured dog. He goes to every art exhibition you can find in the city. He's very independent and loves talking to everyone. He's also got a very good memory. I know this because we were in the Solomon Gallery a few months ago, and we saw some beautiful art pieces that he seemed fascinated by. We ate some lovely canapés too. We were down that street a few days ago and when we were passing by he spotted it and raced up to the same door as if to say, 'C'mon, we had a good time here, let's have a look again!' ◀

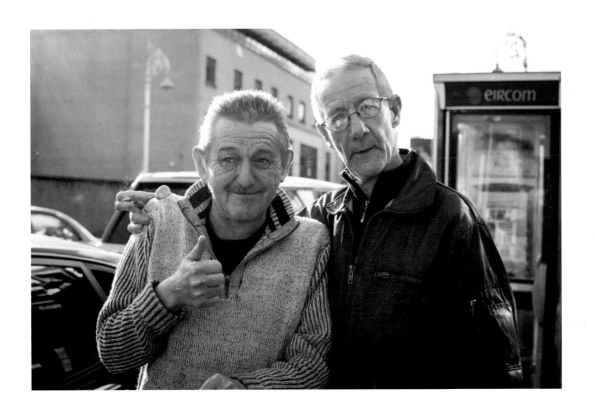

▶ Best buddies for 40 years! ◀

He was just lying down under the bridge in his sleeping bag feeding pigeons. He looked like a Dickens character. I just thought, 'Jesus, this guy looks really interesting,' so I parked the car and went back to ask if he would mind me taking his photograph. He didn't answer, just nodded his head. I took a few shots, and I tried talking to him but he ignored all my questions. When I went back to the studio and put the photos up on screen, there was one photograph I really liked. I just couldn't get the image out of my head. So the next day I made a point of going back to the bridge. I said, 'Hello, how are you today?' He replied, 'Excellent, thank you!' in a very well-spoken, almost aristocratic, tone. From that moment on I was hooked. I sat down with him and we talked for about half an hour. He gets no money from the government and he doesn't beg. He doesn't see himself as a homeless person. His home is the bridge. He's unique, you know? Ever since that day we're kinda mates – whenever I have some free time I go down to visit him. I bring some food or even take him out for the day. We've been to many places that interest him and even as far as Belfast. Some days he doesn't say a lot, other days he says a little. I know him over two years now and I still don't know his full story. I once asked him if he has a drink or drug problem and he amusingly replied, 'I should have, but I don't.' Many of us have a bucket list of places we'd like to visit, many of them in exotic locations around the globe. Martin's list is far more humble. Last week I drove to the bridge and arrived to find him packing his stuff away for the day. He told me he was off to the library for the afternoon to catch up on some reading. I asked him if he'd like to go for a drive and he said yes before I could finish the sentence. He had always been curious about the Hell Fire Club in the Dublin Mountains. At one point, as we stood at the top of the hillside, I asked him if he'd ever consider living anywhere else other than under the bridge. 'I think I'd like it here,' he replied with a grin. ◀

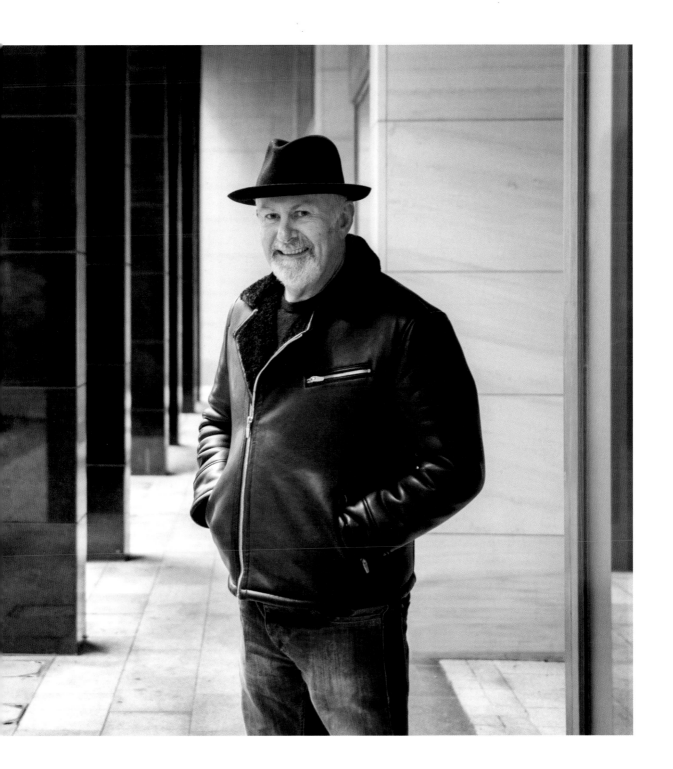

187

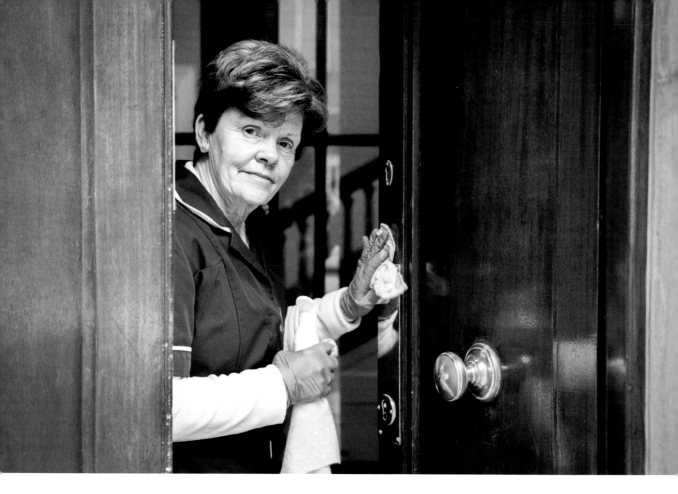

▸ I don't feel old, but you know what I do feel? I feel
expired. Society has moved on from my time. In my time,
everything was so much easier. You had time for yourself,
and even if you didn't have the most amazing job you
could still save up enough for a mortgage. I wouldn't be
young now, there are too many expectations around. And
maybe the new generation will not even realise it because
they were born into this rush of a life. I feel lucky that I
grew up in the generation that I did … ◂

▶ My father was an Irishman and I was raised in Ireland. I was already in my mid-teens when my family decided to move back to Thailand. I went to an international school where I was taught both Thai and English. I had to live at the college because my family's home was just too far from the school. I didn't know much Thai at the time. I knew how to say, 'Mom, I'm hungry,' but that was about it, and it didn't seem to be very useful between the students. The first few days I was pretty nervous. There were kids of all ages there asking questions and I couldn't speak a word, and barely any of them could speak English so I felt like an outsider. After school, my teacher would give me private lessons to help me keep up with my classmates but it just didn't work. I was too stressed, I guess. One day he told me, 'I give up,' and that we wouldn't be having any more private classes. I felt really bad about my situation and that my parents were spending so much for my education. I was too afraid to tell them what happened so I thought of a plan. Every day I would take a book from the library, get to a computer, use Google Translate, and ask my friends in my class how to pronounce certain words and their meanings. It wasn't easy, but after a half year, I was able to speak and understand Thai at a level that I could keep up with the rest of my class. If it wasn't for my friends, and perseverance, I probably would have given up. ◀

▶ I bought it like this about two years ago from a friend for €70. She had broken it and didn't want it anymore. My phone was very old so I needed an upgrade. I don't know what a normal screen feels like – I've never had a smartphone before, so I don't even know what I'm missing. But it's a great conversation piece! ◀

Is it working fine?

▶ Yes, I just need to copy and paste p's and O's. ◀

▶ I love Dublin with all my heart, I always have. It's made me who I am today. Nowhere I've been is anything like it. It wasn't until I was in my late teens/early 20s that it really crept inside my bones. I grew up in a happy family but watched my mother struggle with her own demons for years which led to a lot of rebellion and many regretful incidents as a teen. I learned to distract myself from it. When she passed away over five years ago, I didn't know how to react. I was completely lost. I left home, a new woman moved in, and the family became a very distant place for all of us. The gap left from my mother passing was filled with all the compassion and opportunity a city like Dublin could give. I distracted myself with the vibrant events industry, promotions, marketing, arts, and a social scene that swallowed me up in one wholesome gulp. I let it consume me completely and became so obsessed with my devices, spending 16 hours a day on them, working and socialising. As a result, I was losing concentration, sleep, and the ability to be still and began suffering from panic, anxiety, and constant stress. I worked hard trying to get myself away from it all. Working with my business partner really helped a lot. I realised what we do could help others and hence the idea for Unplug.ie was born – teaching people to have a relationship with their tech. Stepping away from the noise, I realised I never grieved properly. I always made myself busy to escape the inner madness of my mind, and so I'm now travelling the world to work everything through and avoid the vacuum distractions of my first true love, Dublin. ◀

▸ We're together five and half years now. We used to work together, but we lost touch and after years we bumped into each other again. Since then we're together. ◂

What do you love the most about her?

▸ Too many things, man, she takes care of me so well ... ◂

Whenever somebody is giving short answers to complex questions or not feeling comfortable answering my questions, I don't push it. I ask one or two more questions, I say thank you for your time, and I walk away. This is exactly what happened in this case as well. I could see that the guy wasn't feeling comfortable so, after the interview, as I was walking away, the guy came back to me, asking from about halfway, 'What's the name of your page again?' As he approached me I tried to reply, but then he said much quieter that he was about to propose, and he turned and walked back. That was it. Nothing else. I was standing there and my heart started pumping. I really didn't know what to do. He didn't ask me to go after them or anything, but I started to walk, and slowly I followed them, kind of hiding behind the bushes, and in that moment he went down on one knee and I took these photos ...

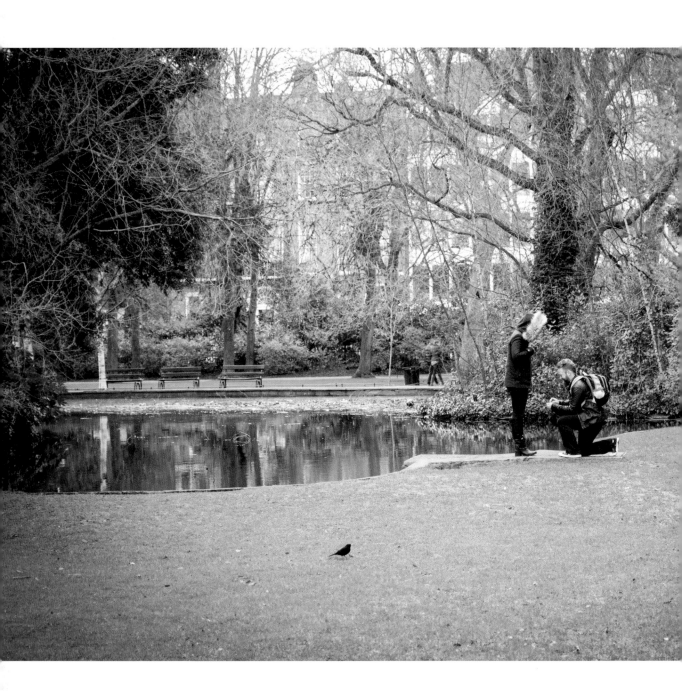

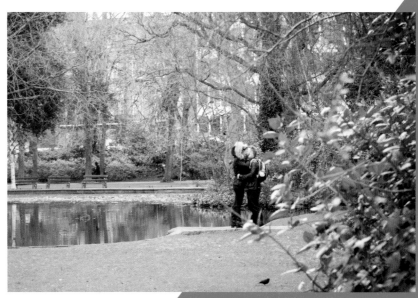

Their engagement photos made it onto online media portals, got printed in *The Irish Times*, and we were all invited onto *The Ray D'Arcy Show* so they could tell their story. And I was invited to their engagement party as well!

Congratulations, Sam and Claire! I wish you all the best in your life together.

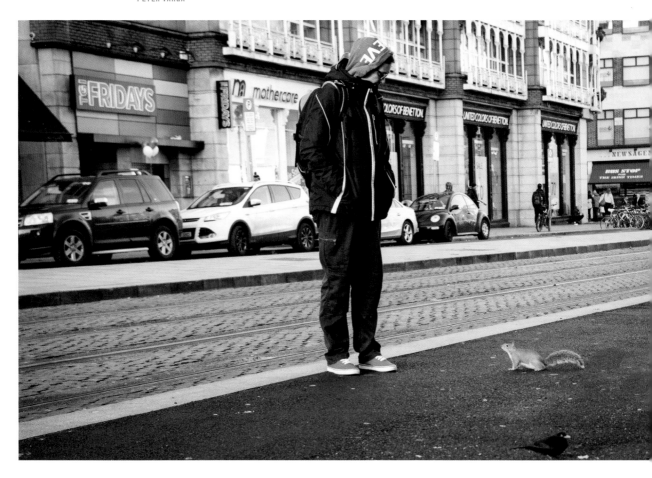

Well, this is not an everyday scene on St Stephen's Green.

▶ I had no idea what I wanted to do with my life for a very long time. Even though I'm from the countryside and I did gardening with my parents, I never really enjoyed it. It was just a task that had to be done. When I moved to New Zealand I worked in hotels and cafés while I was studying, and the house I lived in had a horrible back garden. So in order to get cheaper rent, I asked the landlord if I could clean it up a bit. I was only doing it when I had free time, but after a while, I somehow had more and more time to take care of it. Not only did I clean it up, but re-design the whole thing. It was like therapy for me. Some days I couldn't wait to get out and do it. When I came back to Dublin I did the same with my new landlord and even made a **BBQ** area just to be able to call friends over in the summer. And only then I realised it's really what I want to do. So I studied horticulture, applied for this job, and haven't had to work a day since! I'm here 10 years now and they haven't hired anyone else since then. I feel very, very lucky. ◀

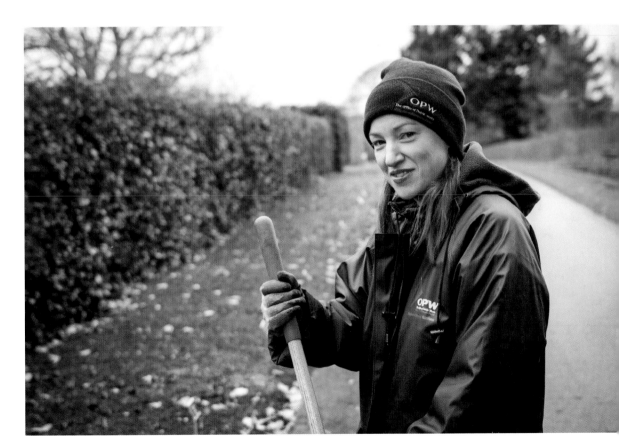

197

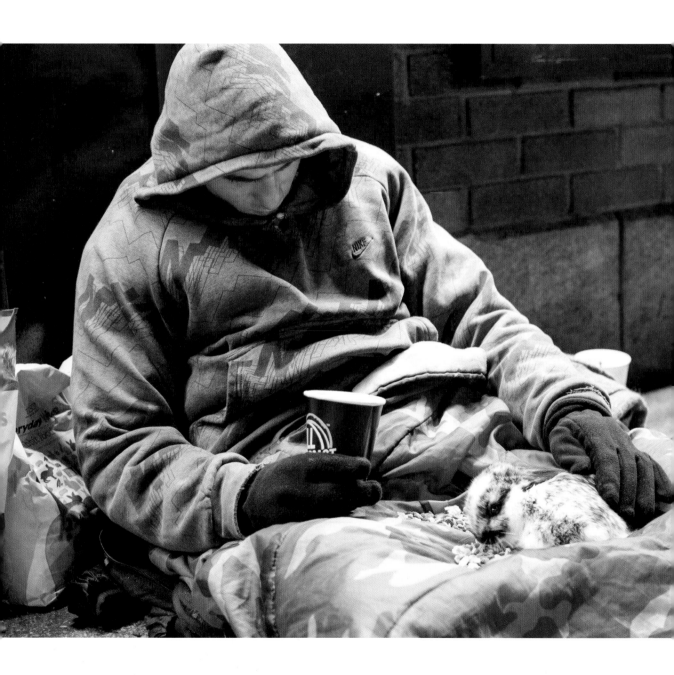

A few days ago a guy wanted to buy him. I said, 'No, he is not for sale,' and then he took out €250 from his pocket and asked again. I really love him, so I said no again. The next day the guy came back and said he was drunk and that he's sorry, and gave me €50. That was the most money I ever got from someone …

▶ In the early '80s, I was an apprentice gilder and restorer in London when I was 21. A lovely rag-and-bone man called Tommy used to come by the studio on his rounds, with his pony and cart, collecting unwanted items which he would later sell on. We always used to make a big fuss of him and his pony and he was part of the colourful community that made up Ladbroke Grove and Notting Hill in those days. One day I was late for work and rushed out of the tube station to see Tommy and his pony trot up the main road driving his cart. I jokingly stuck out my thumb to hitch a ride and, to my delight, he pulled up, stopped the traffic, jumped down, took off his cap, and hastily combed his hair, then sat me on the seat, which was an upturned fridge. He handed me the reins and sat beside me, and together we clattered up Ladbroke Grove, him ringing his bell and me calling out, 'Rag-and-bone, rag-and-bone!' It was actually one of my proudest moments and I considered it a privilege. They were very much part of London life years ago. I expect they have all gone now, but I hope some of them have survived. It must have been a tough life. To this day, *Steptoe and Son* is one of my favourite old TV programmes. ◀

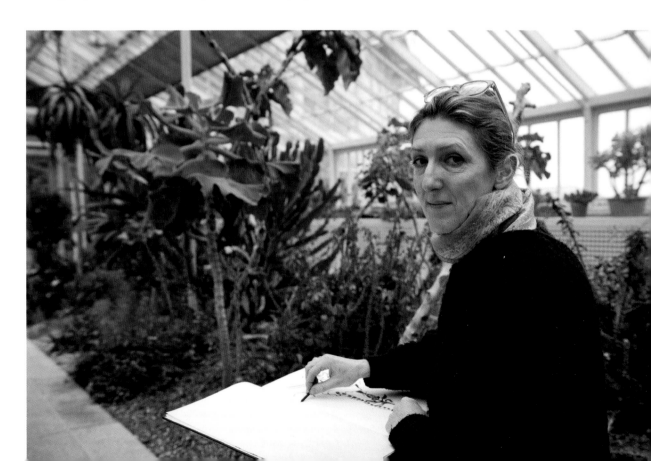

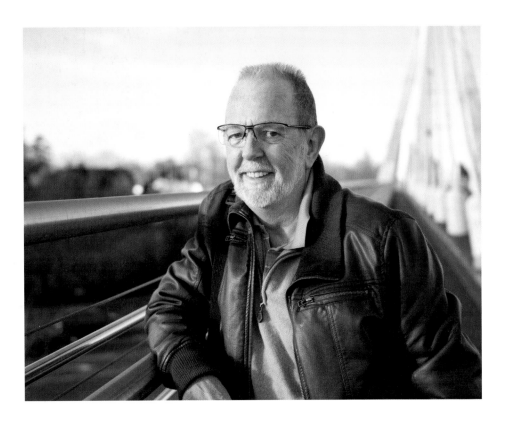

▶ There were things I always wanted to do. But you know how life is —
you get used to living every day like you would have them forever. But
when you wake up and a doctor tells you that you were in a coma and
that you died three times in the previous five weeks, you become aware
of certain things. It was the heart attack that convinced me to start
my bucket list. You know, this time last year, to walk 100 yards took
me 10 minutes. Only a few weeks ago I came back from Kenya. I was
there for a two-week wildlife photographic safari. It was the most
amazing trip of my life, that none of my doctors would recommend
for me to do. It may sound stupid, but that heart attack was the best
thing ever happened to me. It has opened so many doors. I met so
many new people and I have done things that I wouldn't have dreamed
about a year ago. If I can give you one piece of advice — if you have
plans for your life, if you've got any dreams — don't wait for your own
heart attack! ◀

It was just one of those nights where all your plans get screwed-up. I was meant to be meeting friends and I was all ready to go out and join them, but no one was answering their phone. I decided to complain about my loser Friday to one of my best friends back in Russia, Valia. She was travelling to another city with her friends for a bachelorette party. So I wrote to her and her answer was really short. All it said was, 'Oh Nina we're having so much fun and I'm so drunk. I love you loads and please remember that you are never alone. You are never alone.' I answered that I love her too, but to be honest I was a bit surprised with her message because we were in touch regularly but we didn't really tell each other very often that we love each other. Within a few hours the driver in her car fell asleep and they crashed into a tree. She died immediately. Those were actually her last words to me. When I woke up in the morning, I was still wondering why my night out didn't happen. And then another friend of mine called and told me the news. This is when I realised that actually last night worked out, because we had that last moment to say, 'I love you.' ◀

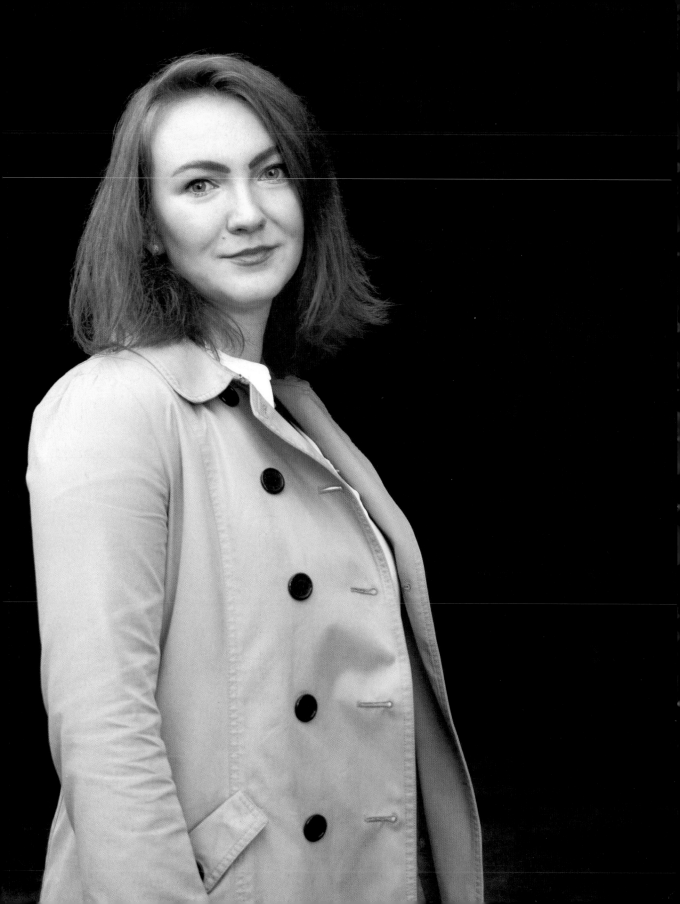

When I was in my late teens I met a girl, and she became very, very special to me. She was my first love. We were together for quite a while, but I guess we were just too young … We met too early. She wanted to do other things, so we decided to go different ways. We kept in touch on and off for a long time, but after that, I hadn't seen her for years. I knew she got married, I knew she had children. Some of her friends kept in touch with me, so I always knew what was going on. She was always very special to me and never really left my thoughts. A few years later somebody told me she developed cancer. I actually met her about two years before she died. Her friends organised a reunion but I didn't think it'd be the last time I saw her. One Sunday afternoon, out of the blue, a friend of hers called me and said, 'Hi, Michael, I have someone here that wants to talk to you.' She said, 'Hi, it's me, Kathy. I just would like to say goodbye. I know I'm going to die soon, and I wanted to let you know you were very special in my life too.' Every time I think about that phone call I get very sad. It was the nicest phone call I have ever received in my whole life. It meant so much to me. That someone who knew they were terminally ill and hadn't a lot of time could actually think about me and tell me that … I guess it is true, it's never too late to tell somebody how you feel. She died that week, but she'll always be in that very special place in my heart. ◀

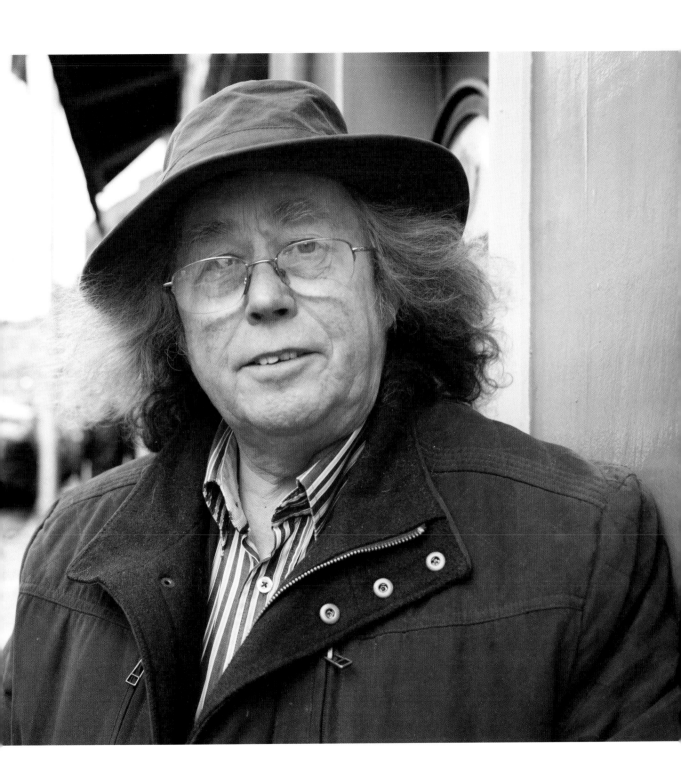

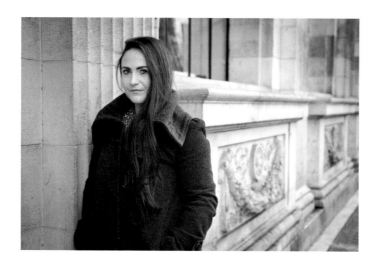

▶ My cousin passed away last week through suicide. Stephen was a 20-year-old, devoted father of a beautiful little girl. He idolised her and she loved him. He was found on her second birthday, a few days after seeking help from the hospital. After long hours of waiting he was refused treatment because he didn't live in the catchment area. How pathetic is that? He was sent home after telling them he was suicidal. They told him someone from the clinic in his area would be in contact but no one did. It is now too late.

They tell people suffering from mental health difficulties to speak up, to talk to professionals, to not suffer in silence, when in reality they make it so difficult to receive treatment. Who are we supposed to turn to if our own healthcare system deems us unworthy? I guess it's a perfect opportunity for me to raise awareness, not just for my family but for everyone who has been in a similar situation. This has to stop. How many more lives will be lost through the ignorance and heartlessness of our healthcare system? Don't let another family be a statistic. Lives matter, but yet we're treating people like they are nothing. ◀

▸ Growing up disabled I always felt I didn't fit in anywhere. I had no friends, school was hell … I was abused a lot verbally, and I came out quite mentally broken. I'm not saying every school would be the same, but probably I just went to a bad one. When I came out, my confidence was non-existent. I started to play these online war games, day in and day out. One day I went to an army shop to look around. I wanted to buy a rifle to display on my wall and this is where I met these guys. Well, they were a bit wild … Like **WILD.** They were all strong characters, some of them ex-soldiers, and it was all very new to me, but they invited me to see them playing and from the very first day they included me. They treated me as one of them. That was the very first time I felt I belonged somewhere, even though I had nothing to do, really. I saw the obstacles. But I turned to my dad and said, 'I think I found my calling … '

My friends call me Tank. I'm an airsoft fighter. ◂

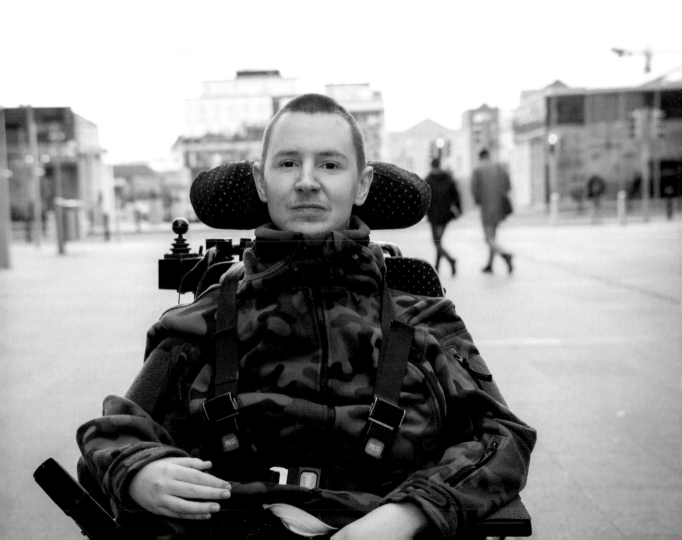

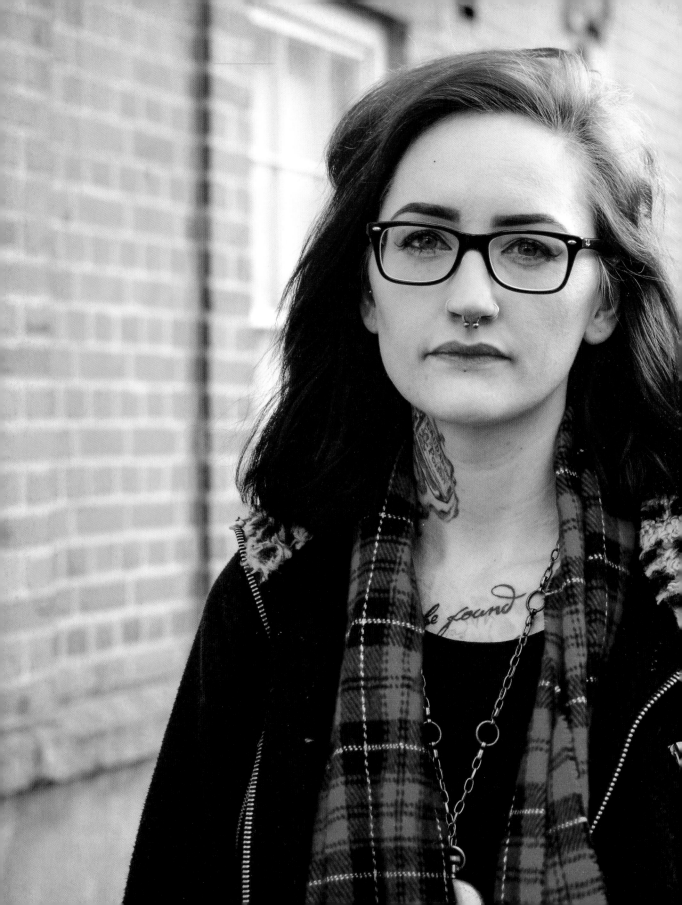

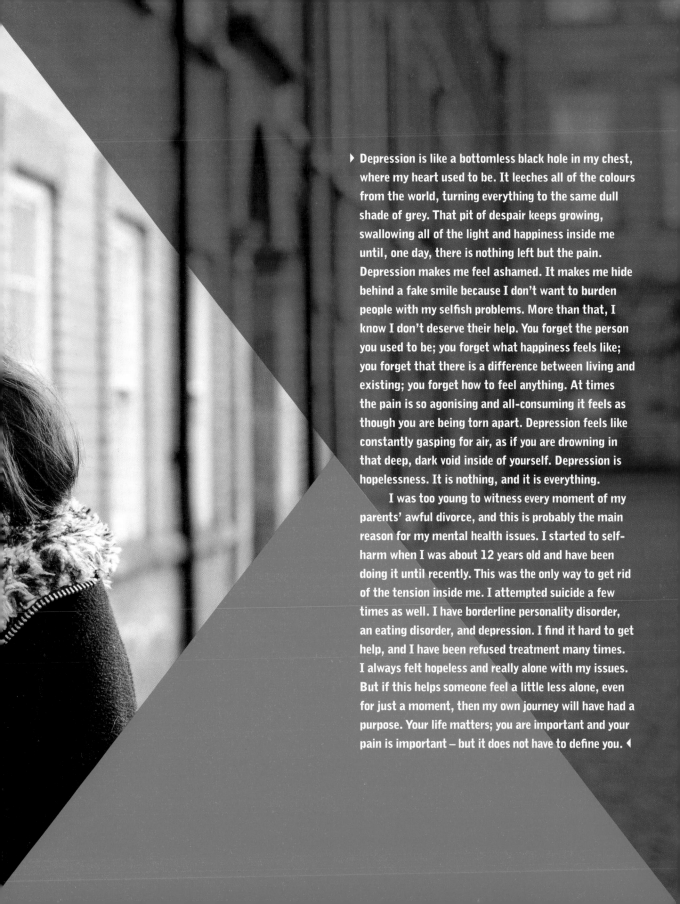

▶ Depression is like a bottomless black hole in my chest, where my heart used to be. It leeches all of the colours from the world, turning everything to the same dull shade of grey. That pit of despair keeps growing, swallowing all of the light and happiness inside me until, one day, there is nothing left but the pain. Depression makes me feel ashamed. It makes me hide behind a fake smile because I don't want to burden people with my selfish problems. More than that, I know I don't deserve their help. You forget the person you used to be; you forget what happiness feels like; you forget that there is a difference between living and existing; you forget how to feel anything. At times the pain is so agonising and all-consuming it feels as though you are being torn apart. Depression feels like constantly gasping for air, as if you are drowning in that deep, dark void inside of yourself. Depression is hopelessness. It is nothing, and it is everything.

I was too young to witness every moment of my parents' awful divorce, and this is probably the main reason for my mental health issues. I started to self-harm when I was about 12 years old and have been doing it until recently. This was the only way to get rid of the tension inside me. I attempted suicide a few times as well. I have borderline personality disorder, an eating disorder, and depression. I find it hard to get help, and I have been refused treatment many times. I always felt hopeless and really alone with my issues. But if this helps someone feel a little less alone, even for just a moment, then my own journey will have had a purpose. Your life matters; you are important and your pain is important – but it does not have to define you. ◀

I was on the way to the internet café where I usually sleep when this guy came up to me. He called me by my name, started talking to me, and said he'd met me before. My sight and memory are really bad, so I probably just forgot. He told me he had something for me and handed me a paper bag. Inside it was a belt, jeans, a thermal vest, and this jacket, all new. I was very grateful because my clothes were in a bad state at that time, but I wasn't only grateful because of that. This jacket made me visible. I became a middle-class man. A few days ago a Garda apologised to me for not holding the door for me on the way out. And then another day a lady smiled at me instead of crossing the street. I really feel these things. I can really feel the difference. I was always very emotionally sensitive, and my parents were always stressed which didn't help either. I find it very hard when people mistreat me. It's interesting how the mind works. I saw a documentary about misconceptions the other night. They showed ABC letters with a thin gap in the letter B, then they showed three numbers – 12, 13, 14 – and the number 13 looked exactly the same as the letter B. The same, but different.

The photo is for demonstration purposes only. The subject preferred not to have his photo taken.

▶ We're together almost 40 years now. I had some rebellious years, I have to admit, days when I thought I knew everything a bit more than I actually did. But then I just realised she's always right. So I would say the secret to a long-lasting relationship is simple. Listen, and do what she tells you to! ◀

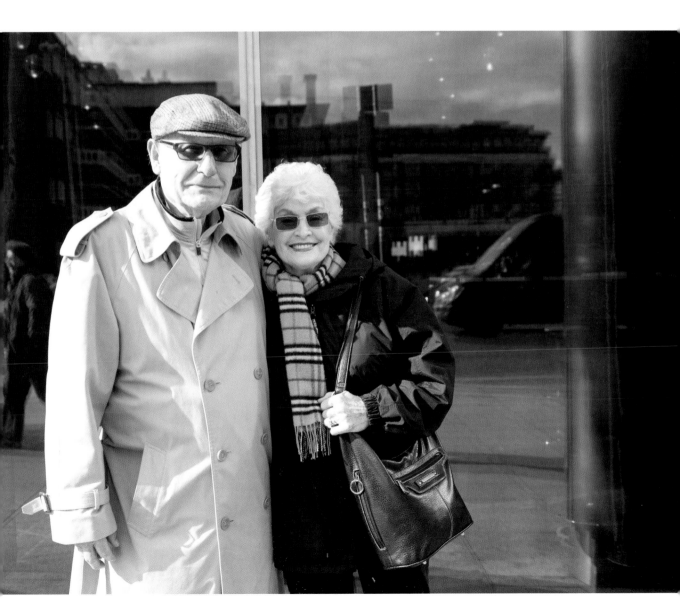

211

▶ I always wanted to study psychotherapy, but the courses were so expensive. When I almost gave up on the idea, I got hit by a car on my bicycle, so I used the money I got from the accident to do the course. But the funny thing was that the course was actually at the same place I got hit. I guess the world works in mysterious ways … ◀

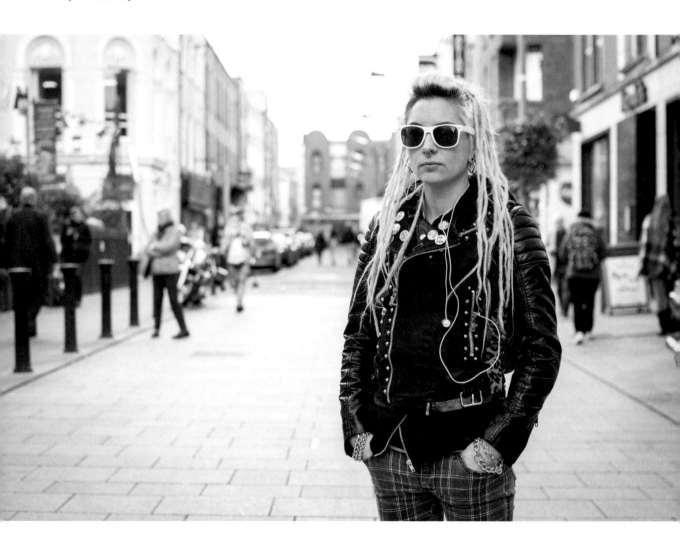

▶ We fell in love; we got a house; we got married; we started to plan a family; and we got pregnant. I didn't believe a bad thing could happen to us until the day we went for the scan. On the way to the hospital we were looking at crèches and schools, choosing which one would be the closest and the best for us, but after the visit everything changed. They told us that our baby had a condition that would inevitably end its life before it even had a chance to begin. They told us that the brain and the skull of our unborn child simply didn't form.

The doctor told us there was nothing he could do in this jurisdiction, besides support us through the pregnancy. He did not give any other options or information. At that time there was no Google and it was very hard to find information on the internet, but we found a geneticist in Northern Ireland who we could talk to. He referred us to the nearest hospital where a doctor agreed to take care of us.

That day will stay with us forever. It was still dark when we arrived at the border, and an army checkpoint stopped us asking where we were going and why. The procedure was illegal in Ireland and, although it was legal in England, we still felt like criminals. The whole situation made us feel unsupported and very alone. We didn't know who was safe to talk to. We couldn't bring our son's body back home, so we had to cremate him there and send it back by courier. We couldn't have a funeral or a proper grieving process. We couldn't talk to people around us. All of this made the whole situation even more difficult to deal with. Worst of all is that this happened 15 years ago and the legal framework here is still the same today and even more restrictive in Northern Ireland. There has been no change at all here. We would like to reach out to people with similar experiences, and tell them that they are not alone and that they need to stand up and speak publicly about their experiences in order to make a change. ◀

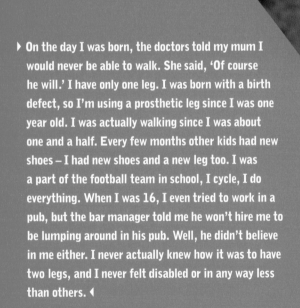

▸ On the day I was born, the doctors told my mum I would never be able to walk. She said, 'Of course he will.' I have only one leg. I was born with a birth defect, so I'm using a prosthetic leg since I was one year old. I was actually walking since I was about one and a half. Every few months other kids had new shoes – I had new shoes and a new leg too. I was a part of the football team in school, I cycle, I do everything. When I was 16, I even tried to work in a pub, but the bar manager told me he won't hire me to be lumping around in his pub. Well, he didn't believe in me either. I never actually knew how it was to have two legs, and I never felt disabled or in any way less than others. ◂

What is the best thing about having only one leg?

▸ Well, people ask me if I would have one wish would I wish for another leg. And I always say I don't think I would waste my wish for that. Having only one leg made me think more and made me more creative, and I think that helps a lot. I see the world differently from everybody else. I want people to look at me and get inspired by me running after my dreams. I want them to have no excuses and say, 'If he can do it, I can do it, too ...' ◂

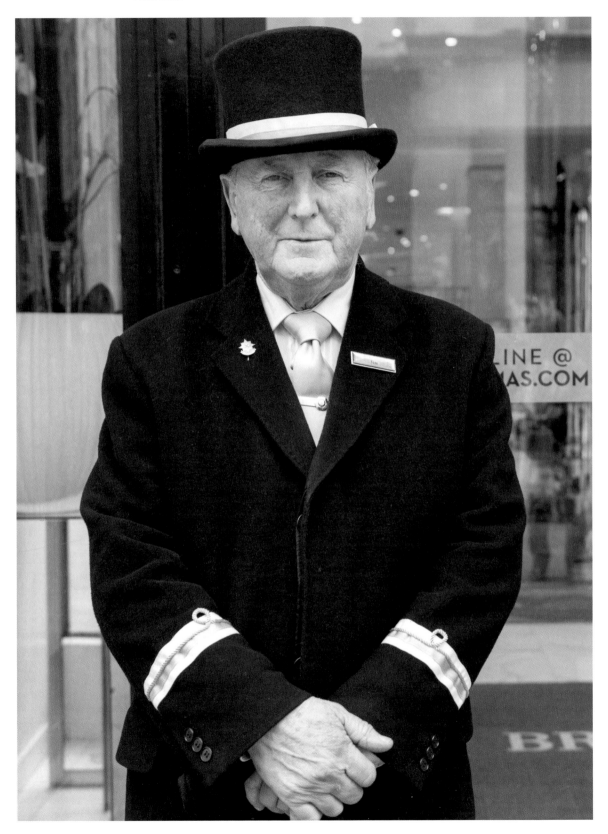

▸ I was sent out to Aden, which is now Yemen, with the British Army in 1967. They were getting independence, but the terrorists were still very active so we were there to fight them and help protect the city. There were 10,000 British troops there, in this small city, including the Royal Navy and everything. And one day I was on patrol when I came across a British man seriously injured by a grenade. All his back and the side of his face were bleeding. He was walking in the city alone so I immediately took the Land Rover, picked him up, and drove him to the closest army hospital. I left him, and even though I got back very quickly, I was in a big trouble because I left my patrol. I was supposed to call an ambulance, but this guy was bleeding so much there was no time to waste. I often wonder if he made it. There was so much going on there at that time I could never find it out. ◂

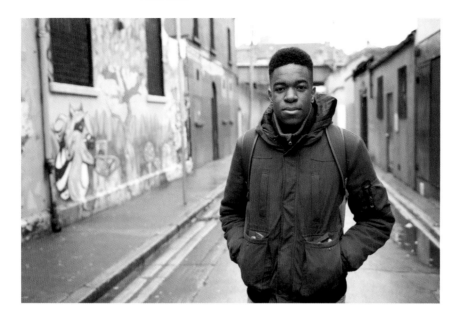

▸ I believe in God. I know He's real and that nurturing
my religion is great towards Him, but towards men …
College is pretty tough; I feel isolated and I don't have
many friends. Being religious and black are just two
potential reasons for people not to like me. ◂

▶ I've been on the streets for 25 years now. I can't read or write, but I hold two awards! 'Compassionate Citizen Award' and a 'Bravery award'. People often insult me saying that I only have animals in order to make more money, but they are my life, you know? I rescued Minty – I found him wandering around a field in Ballymun. In 2011, I was sitting on the O'Connell Bridge when a group of young guys were passing by and one of them suddenly grabbed Barney (another rabbit) from my hands and threw him into the Liffey. Just like this. I jumped in after him without thinking. The tide was low so my legs hit the bottom straight away. Everything turned white for a few seconds and I thought that was it. But I got back up and grabbed him. Sadly, he died in my arms later, but I'm sure he knew I loved him. Just have a look on the internet! Type 'rabbit thrown into Liffey' and you'll see it. ◀

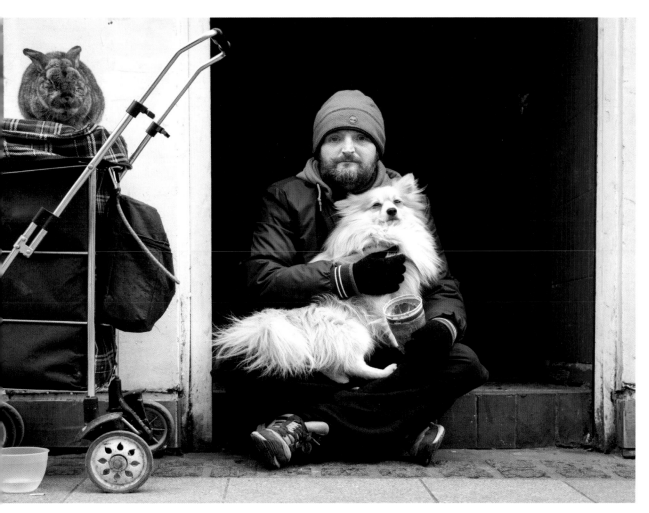

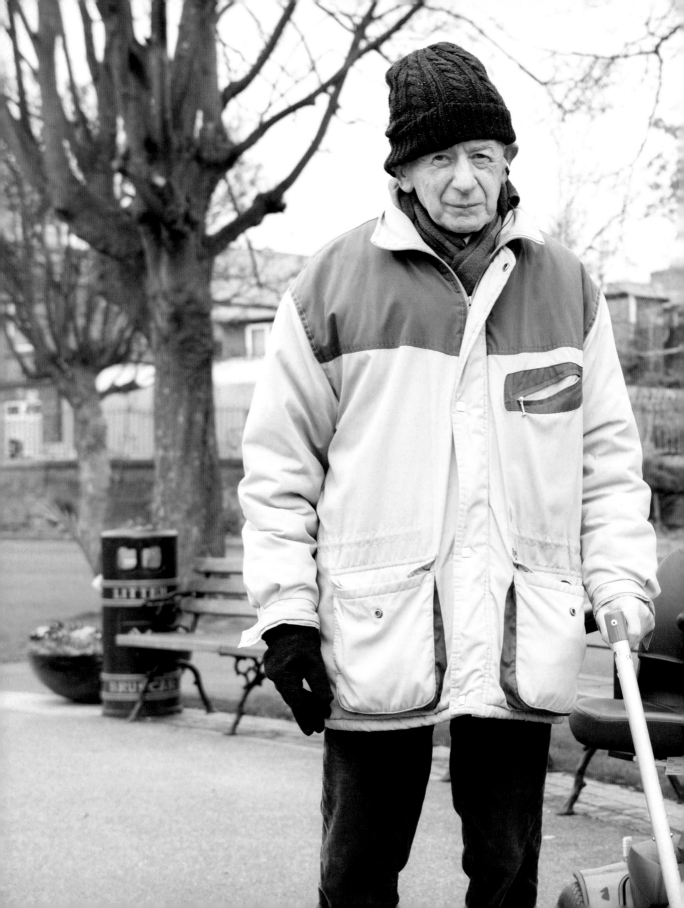

I used to be a teacher in a secondary school. I had many plans for my retired years, but only two months after the day of my retirement I got a stroke out of the blue and lost the use of my right side. That was three and half years ago now. It's very hard to accept that I won't be able to drive a car or play golf again, but I won't give up. I come here every morning when it's dry. This is my exercise track. I live close by and it's the perfect place for me to walk as I can sit down at any time if I get tired. I do a good few rounds every morning while listening to the radio. It's great exercise, not only for my body, but for my mind too. This was one of the most important things I was trying to teach to my students too. You should stay positive and never give up. ◀

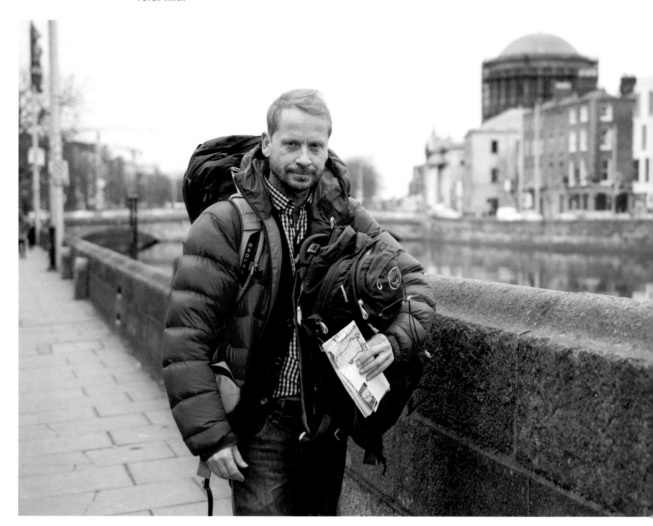

▶ One day on Silk Road in Pakistan I wanted to take my group to a restaurant I was recommended, but I'd gotten the name of it wrong and I couldn't find it. So I asked for directions from a passer-by and said, 'Can you tell me the way to the Palace Restaurant please?' And he replied, 'The Palace Restaurant? Hmm ... Okay, it's a bit difficult. It's not very close, but I will direct you there.' As we later discovered, where he directed us was the actual palace where the ruler of the State lived, and we knocked on the door and said, 'We are a group here to eat!' The doorman said, 'Hmm ... Okay, wait a minute please!' A few minutes later he came back and told us, 'The Mayor will entertain you for dinner, please come in!' So we went to the palace randomly, and I was trying to explain the situation, but the ruler said, 'Yes, yes, no problem, come for dinner,' and that he loved British people and admired Prince Charles. So he entertained 10 of us for dinner for free. And this is only one reason why I love my job. ◀

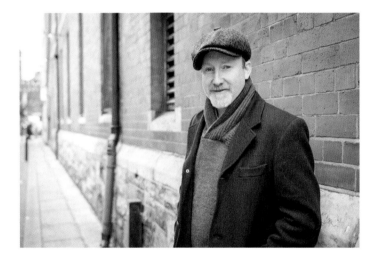

▸ I'm turning 40 soon. I don't sweat the small stuff anymore, and the things that used to be very important for me are no longer important. You're going to reach a certain age where all your friends settle down and get a mortgage, and do all that stuff that society says is important. But you're going to need the independence to say, 'You know, for me, right here, right now, it's not that important.' It's the same with food. If you talk to people with money and ask them what their favourite food is, they'll tell you, 'Oh, it's lobster and crab with champagne,' and it's true. All those things are lovely, but if you're hungry, if you're really hungry … a ham and cheese sandwich could be the most delicious thing you have that week. It's the same with life. You really have to learn how to appreciate the small things that life throws your way. ◂

My auntie died of breast cancer when I was 11. I was very close to her, she was like another mum. Months after her death I began to get sick, constantly vomiting and developing new pains and symptoms. After many visits to the doctor's I was told I just had a bug. Every few weeks I would be vomiting for at least three days and would spend a lot of my time in bed. It hurt to move as my stomach muscles had become so sore from vomiting. This continued for 10 years, and doctors could not understand what was wrong. Food and weight became an issue as I was afraid to eat in case I got sick. My life stopped and everyone else's continued. I watched family and friends grow and change from my bedside. I missed out on my teenage years. At night I would pray that I would die because I didn't want to go through another day of being so sick. I remember sitting crying one day, because I got so frustrated not knowing or understanding what was wrong, that I wished I had cancer because then I would know what it was.

A doctor in the Mater Hospital looked over my file and after many appointments and referrals he finally found out what was wrong. When my auntie died I never cried because I didn't want to upset anyone else. I never grieved. I bottled everything up and never accepted her death. I began **CBT** (Cognitive Behavioural Therapy) treatment which changed my life for the better. The hardest part of everything was changing my thinking and accepting the fact that she was gone. Those nights that I used to cry myself to sleep I held onto one thing; I held onto hope. I didn't want to die, I just wanted the pain and sickness to go away.

Now I volunteer with **The Andy Morgan Foundation Suicide Prevention and Mental Health Awareness.** I've seen the devastating effects that suicide has on families left behind, but I also understand when someone is in so much pain, mind and body, that letting go seems like the only way things will get better. I'm grateful for my life and I wouldn't change a thing because it made me who I am today. To those reading this, I hope you take my story as a sign to keep going no matter how hard things seem. It gets better. I'm living proof. I held onto hope and you can too. ◀

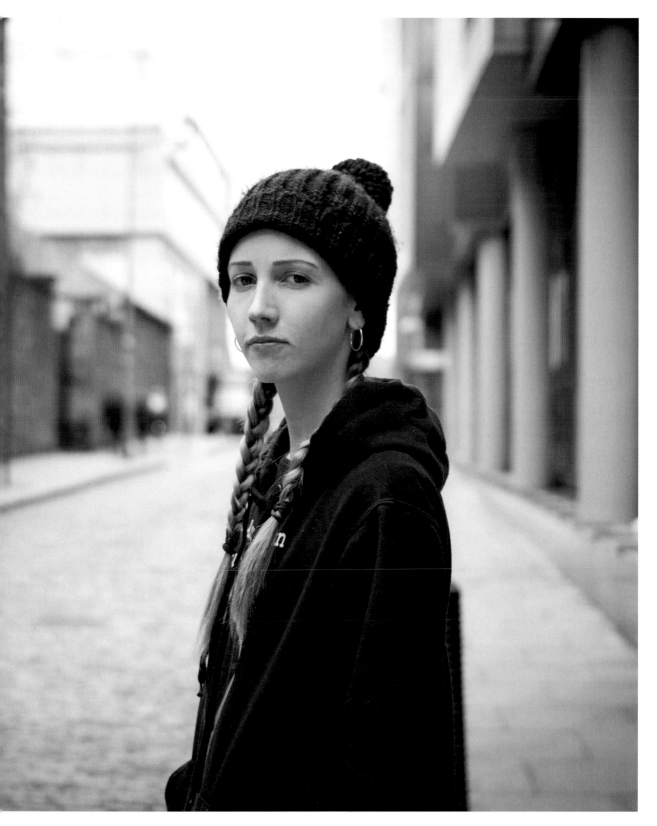

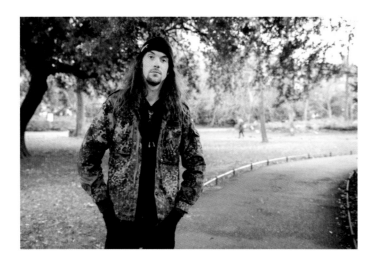

▶ My mother and I found my oldest brother motionless in the hall when I was four. He had hung himself. Once my mother began screaming and crying I knew something was wrong. We were all devastated, and it was exacerbated four years later when my father died on our holiday in Italy. My mother's mental health was destroyed. A year passed and my paternal grandmother passed away. Five years later, when I was 14, I walked into the sitting room and found my mother on the floor. A few hours later, she passed. From all these events my life consisted of agoraphobia, panic attacks, depression, anxiety, withdrawal, and anger. When people ask me how I survived I tell them it was three things. Firstly, I began to play guitar when I was 17. It taught me that when one puts their mind to something, and they want it badly, anything is possible. Secondly, helping my sister with her daughter. She was practically my mother growing up. Putting a smile on their faces is what puts one on mine. And the third thing was meeting my best friend and her family two years ago. I never met a family so strong. Thanks to them I got back in touch with my faith, I became vegan, I learned about the world, and it really got me through my life knowing they were proud. The long-term plan is to write music and get back to Africa where I was when I was 16, helping the locals. I can't thank those people enough, and those negative and positive experiences, for making me who I am. ◀

▶ I've loved hiking since I was about 12. There were a group of us that went hiking every weekend. I'd leave school around midday on Friday, go home for tea, and my mother would have my bag ready to pick up. Afterwards three or four of us would meet up and you wouldn't see us till 8 o'clock on the Sunday night. We used to jump on the turf lorry where it'd take us to the mountains. We lived on sausages and beans those weekends. Later on, some girls joined us as well. Don't take it wrong, but there was a place up in the mountains, called Mollie's Hole, and we'd go swimming in Mollie's Hole – it was part of the river – naked any time of the year: January, February, you name it! We were mad. At night we slept in plastic bags, one on the bottom and one on the top. That's it! And on Sunday afternoons we would take the lorry again back down to the city to watch the Irish dancers on the streets. I had a great life. Jesus, I had a wonderful life! You guys haven't lived, you know that? ◀

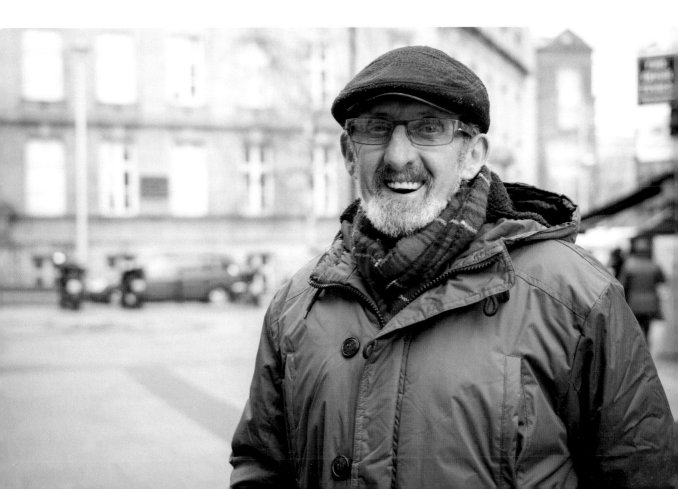

▶ You meet your mates, they get a pint for you, then you get another one, you have fun, you chat away … But it takes a hold of some people, and I was one of them. I was a heavy drinker for 14 years, and one day my sister found me unconscious in my apartment. It wasn't the first time either. I can't even remember anything, only waking up in Crumlin Hospital. She was there asking me, 'Don't you think it's enough now?' I haven't drank a sip since then and that was 16 years ago now. It's great, but getting off alcohol is a lonely road, you know? I'm not the sort of person who makes friends easily. I still go out sometimes to have a dance, and order lemonade, but it's not the same. I went to Mass as well a couple of times but I don't like them people. I'm not a mixer, you know? ◀

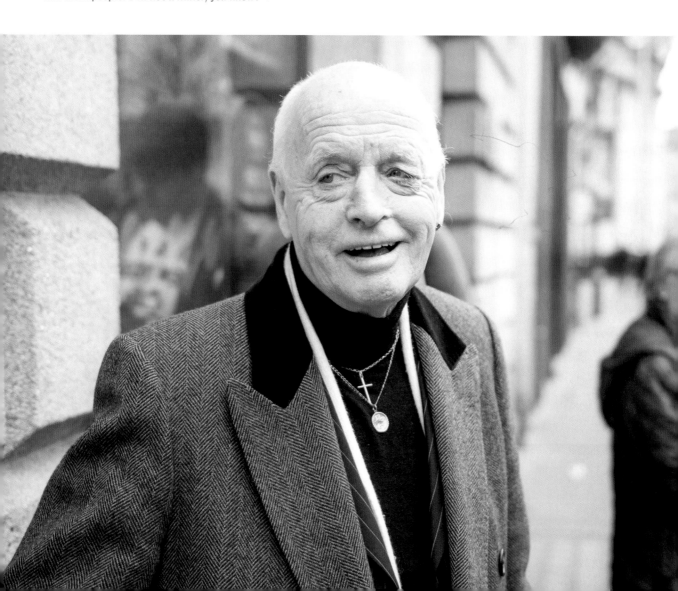

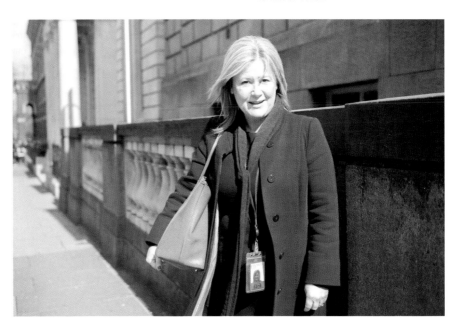

 People say it's the best to have your child in your 20s, well I had mine when I was **38** and it was the best time I could wish for. I did my thing – I lived, I travelled, I built a career, I had an amazing social life. I didn't miss out anything and sure I'm wiser than I was in my 20s. Also I was able to take a break when he was seven years old. They grow so fast and I didn't want to miss out those years. The best time for you to have a child is not when you are in the right age but when you feel like it's time to have them. ◀

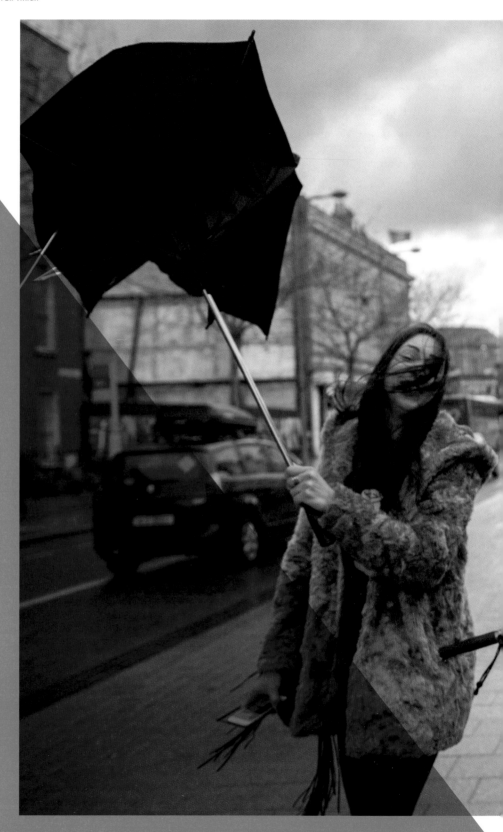

Inexperienced umbrella
users from Brazil.
Seen on O'Connell Street.

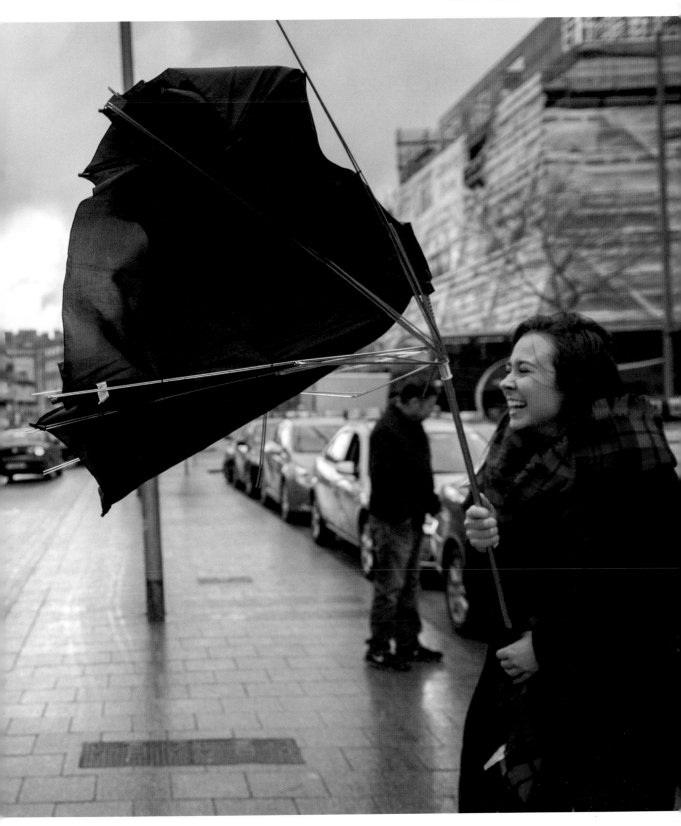

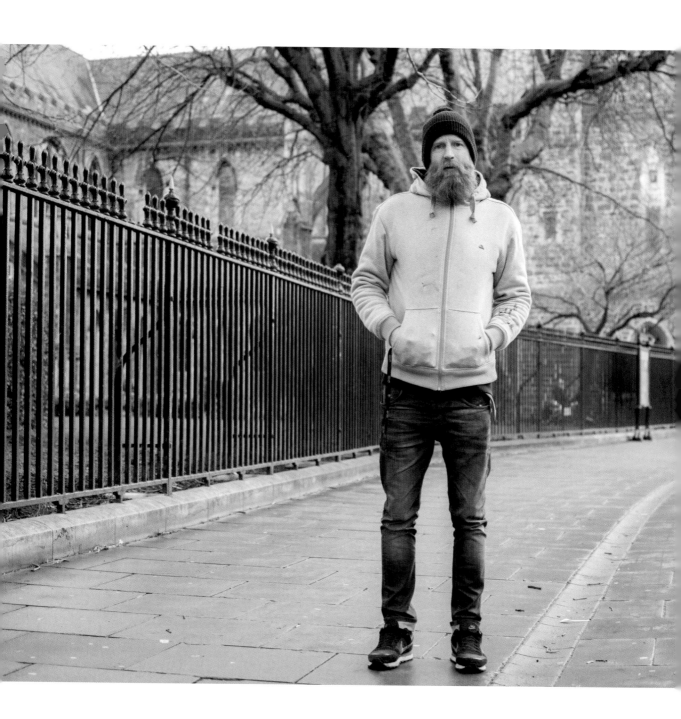

He broke up with his girlfriend in December last year – I think it was just before Christmas. But over Christmas and New Year he realised he really missed her and was still in love with her and wanted her back ... So he tried to talk to her, but she said no. He sent her flowers, and she still said no. This went on for a while. Then last week, he came and asked me to paint her portrait somewhere on St. William Street. I knew him already – he's a photographer. He took my portrait a few times and I painted his studio. He's a good guy and very openly passionate, so I took the job. The same day he called her to meet him and he said, 'I have a surprise for you.' She came to meet him, and when she turned around to see it, she cried. As far as I know they're talking and trying to fix their relationship. Art can do that ... I don't want to be a guy who fixes relationships, but I think art is an amazing tool for grabbing attention. What people do with that attention is up to them ... I love that I can use my art for something good. It feels amazing. ◂

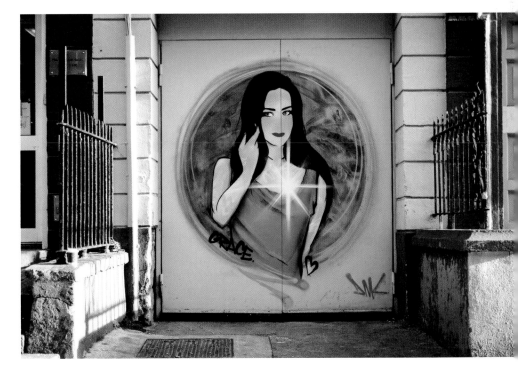

People say it's dangerous and that we'll get sick, but we're doing it regularly two years now, and all we ever got was a bit of a sore throat!

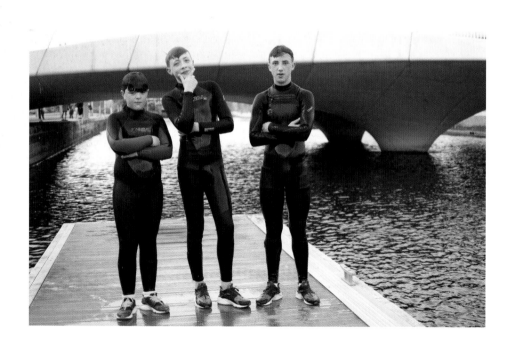

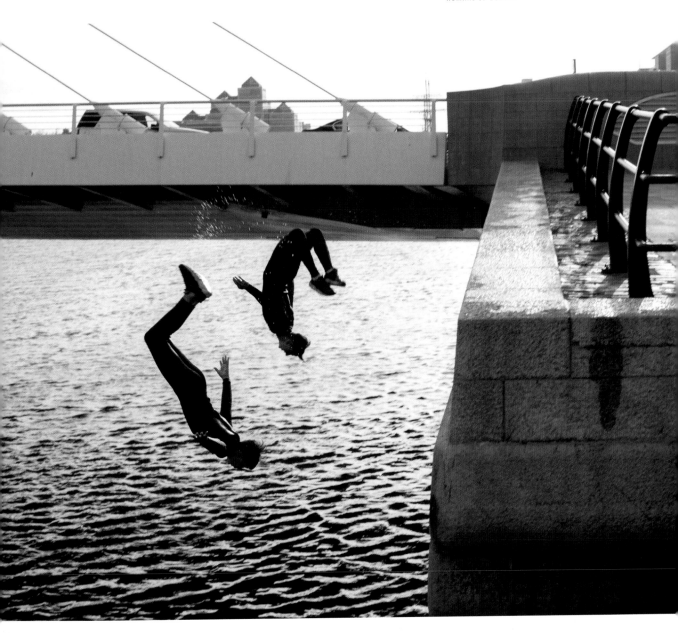

▶ I'm a pretty closed person, and not very social. I like being alone. Once a couple out in Kildare asked me to be caretaker of their house while they were travelling. All I had to do was live there, turn on the heating, and dust off the place. It was pretty isolating, but I enjoyed it a lot. I was on my own for 13 months, 7 days a week. I had my own routine every day. I had time to write a book which'll be published this autumn. Every two weeks, when I came back to Dublin for a day or two, I experienced culture shock and when I went to the first pub to get drunk. I never really worked or left my parents' house before that, although I registered for film extras and they called me a couple of times. Most of the time I just had to walk around or pretend to have a conversation in the background, but once they made me dance in a Bollywood movie, and another time I had to be a dead body and lie in a sack for hours, but for €100 a day you wouldn't say no. I find it hard to manage my life without the support of my parents, but my goal is to move out of the house. They're both retired now, and I really want to find a way to let them live their lives. ◀

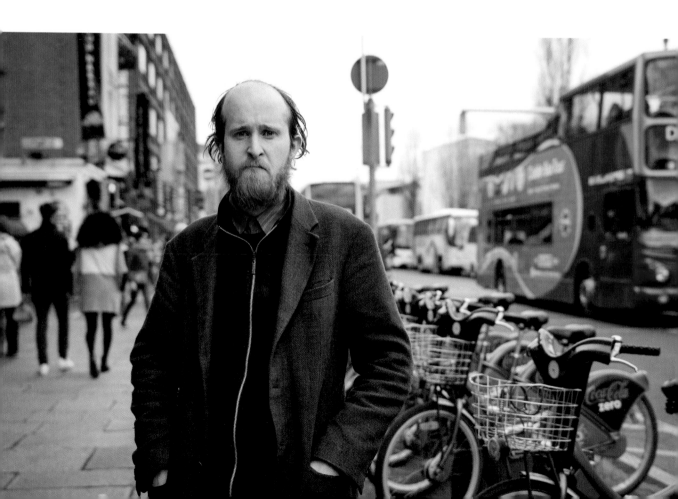

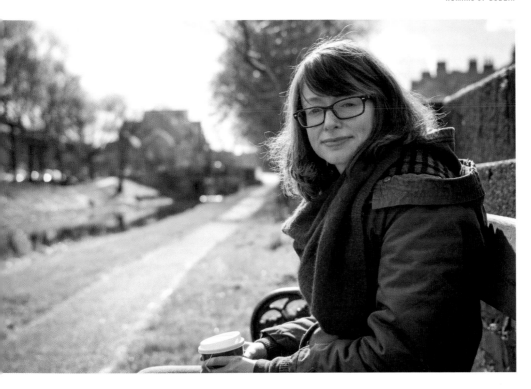

▶ I was in love, once! It wasn't until my mid-20s though because I'd always been really afraid of getting my heart broken. But then I met a guy. We were together for nearly two years and, while I was still terrified the whole time of getting hurt, we laughed so much together and he really brought me out of my shell. I was crazy about him so I decided it was worth the risk! I did get my heart broken in the end but I would never give back that experience, because everything can change so quickly.

When I started getting sick I still thought everything would work out okay, but my illness became serious really fast and I found out there was no treatment available here. Since then I've appreciated every memory, both good times and bad and even the heartbreak. Nothing prepares you for something like this; I've had to find more courage and perseverance than I ever thought I could have. I want so much to make new memories too so I've been trying to fundraise to go to the US as soon as possible for the medical care that could save my life.

There are some things I'll do differently if I get a second shot. I'll try to let people in more and not be so afraid of getting hurt. Whether it would go well or not doesn't even matter. It's the chance to live life and even make mistakes, and get back up to try again each day, that's what matters. ◀

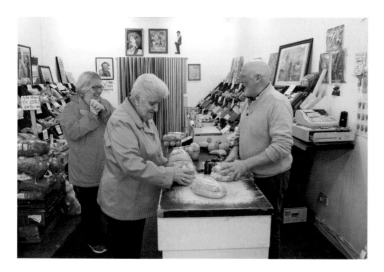

▶ Without music I wouldn't even open the shop, I'm telling you! You know
what? This morning a guy came in, he is working in the council … but,
anyway, there was a song playing called 'Volare'. So he went down to get
his oranges and I said to him, 'If you guess what *volare* means, you get
your grapefruits for free!' Then he said, 'What do you mean? They're two
oranges!' I said, 'Well those things in your hands are grapefruits!' Oh
boy, you should have seen the people laughing! Then he's looking at his
grapefruits and says, 'How would I know what *volare* means if I don't
even know what an orange looks like!?' The place was in racks – you can
imagine … That was only about two hours ago, and there are so many
conversations like that every day. This is why I'm still selling fruits here
at the age of 72, and this is why my customers are still coming back –
and this is something that Mr Lidl can't beat! ◀

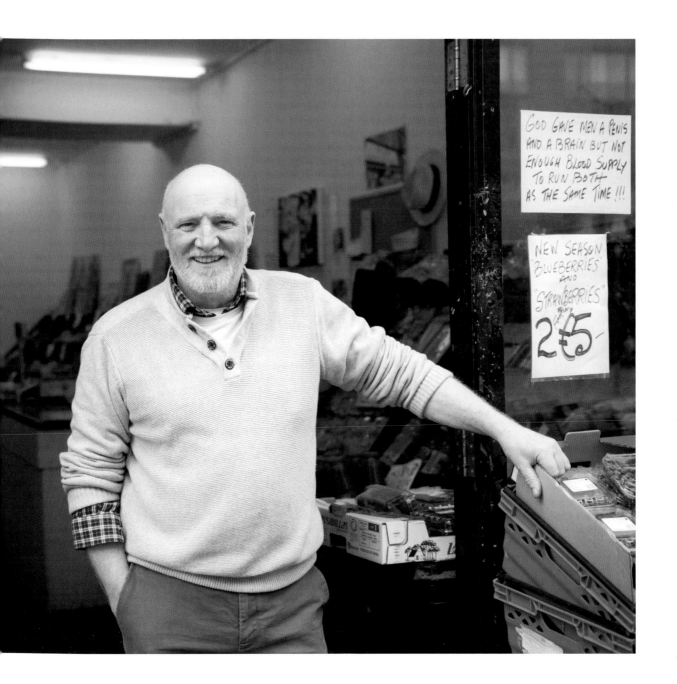

▶ I met her in a dusty village in **Northern Kenya**. I'd just spent a month trekking with a charity that uses camels to deliver medication to isolated tribal communities. When we arrived back at base camp with the camels, **Emma** was there helping out. I fell for her straight away. She was so full of laughter, had this mad curly red hair, a big cheesy smile, and an amazing Irish accent, which being from **Yorkshire** was something new to me then. I have no idea what attracted her to me ... I was a bit of a mess. I had been living in a tent for a month, washing in rivers and cleaning my teeth with a twig. So I've concluded, she just must have a weird thing for sunburnt men who smell of camels! ◀

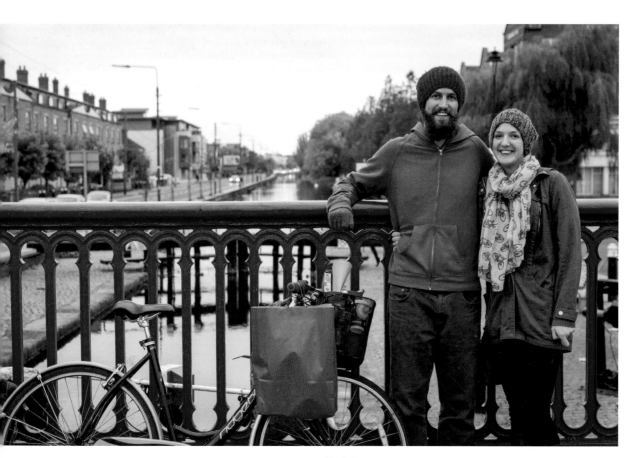

240

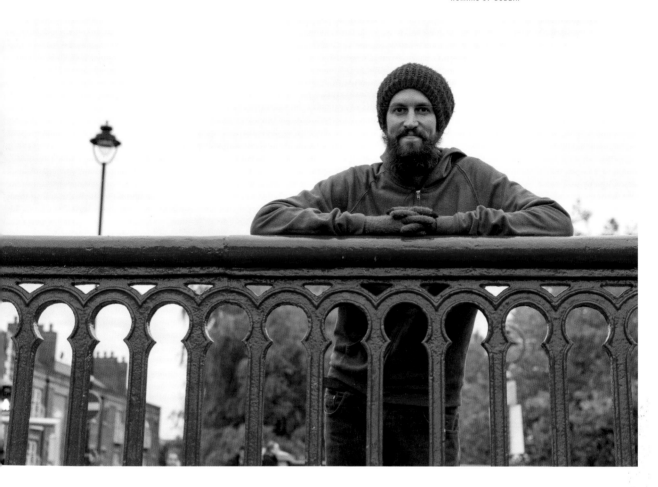

▸ You know I'm tall, gangly, and not really built for
dancing. And before I met her I never enjoyed dancing.
I hated it really. It was just something confident people
did. The first night we ever went out was in a random
town up north, and we ended up dancing until sunrise
with the locals, in a dodgy backstreet dance hall. After
that we went dancing in every dodgy backstreet bar and
club we could find across the country. I emailed home
to an old friend explaining I had met a girl. He replied
immediately that if I had met someone who could
get me onto the dance floor, she must be it and that I
should do everything I could to hold on to her. That was
about six years ago and I am still holding on. ◂

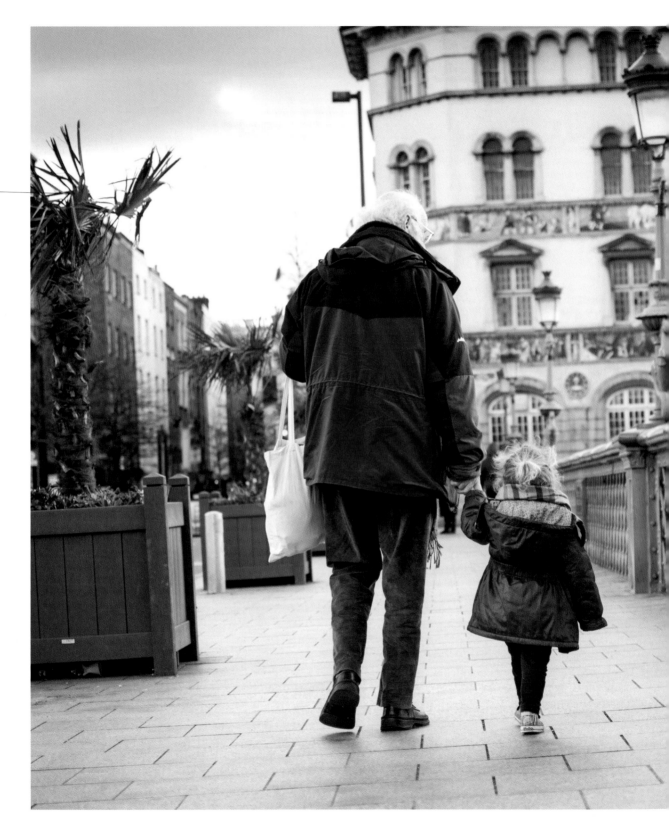

The End …

**Your story is missing
from this book!
This is your page.**

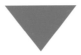

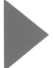 **Your photo**

ACKNOWLEDGEMENTS

Thank you ...

to Maria, for believing, and transforming me patiently from a little green frog into the prince of her dreams (LOL). Without your support, I would probably be a latte art champion by now ...

to my mom, Anya, köszönöm azt a leírhatatlan mennyiségű szeretetet és a személyiséget amit nekem ajándékoztál. A te büszkeséged tesz a legboldogabbá!

to Brandon Stanton, the amazing man behind Humans of New York, and all the Humans of ... projects for inspiring me to start out on the project of my life.

to Dawid Kitura, for being beside me from the darkest times to the craziest weekends in every situation. You are more than any friend could wish for. You are like a brother to me! *Polak, Węgier, dwa bratanki, i do szabli, i do szklanki!*

to Patrick O'Leary, for teaching me how to **BELIEVE** in everything you want in life, and for believing in me and helping me to take the first steps out of the coffee shop and start my journey to pursue my dreams.

to Caitriona Bolger, well ... she is my quote editor. She has been there every evening to make sure whatever you read will make sense to everyone, not only to me! You are simply amazing and I can't thank you enough.

to Niall Carson, for showing me the most exciting side of photography. Thank you for all the adrenalin-pumped, insane photo adventures, and for sharing all those incredible stories of your life that inspired me in so many ways.

to the Institute of Photography, and to the greatest teachers in my life, Dave McKane and Michael Holly.

to my dear commissioning editor Conor Nagle, for believing in this book and my photography, and to all the team at Gill Books, for your energy and focus in bringing this book to life and shaping it into something special.

to Michael Freeman and the whole DailyEdge team, for loving and reposting the stories, for inviting me to their offices, and for helping me to get in touch with Conor.

to all the amazing and inspiring people in this book, for taking the time to talk to me and share their stories with me. Each of you have shaped me into the person I am today.

to all the people who cared to follow my page, thank you for all your messages, comments, and likes.

to my favourite books, which kept me inspired all the times, *Steal Like an Artist* by Austin Kleon and *The Sartorialist* by Scott Schuman.

And, of course, thank you to Dublin, for giving me a home so far from my own and for letting me become somebody here.

It is true, the best things in life are free.

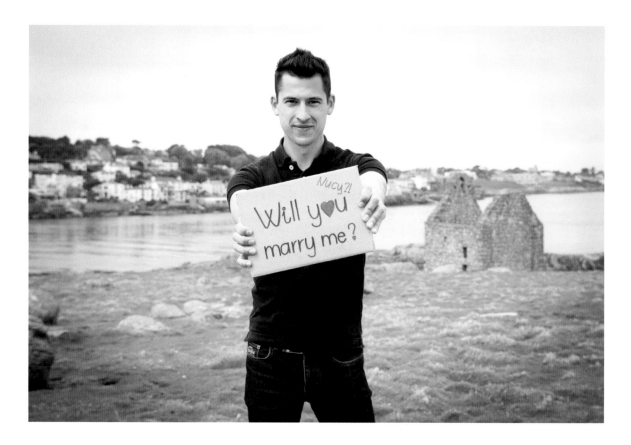

Four years ago, I started working in a sandwich bar. I'd been in Ireland about five years at that point and I didn't really know what I wanted to do with my life. There was a girl there that I really liked spending time with – we had a connection. About three months into my new job, we started going out. My life changed completely. She was beautiful, smart, outgoing and she believed in me. With her help, for the first time I began to think seriously about the future. If it hadn't been for her, I'd never have been brave enough to follow my dream of becoming a photographer.

I left my job, I went back to study and I started Humans of Dublin. At the start, it wasn't easy. I had no job and no contacts, all I had was a camera and an idea. But she never stopped encouraging me and offering support in every imaginable way. Because of her, my life totally changed. As her career began to take off, mine did too. Humans of Dublin grew and grew, and now I spend every day doing what I love. Without her, none of this would have been possible.

The last four years have been the best of my life. When you meet that person who changes everything, who you're meant to be with, why wouldn't you do everything in your power to keep them in your life?

Maria, if you're reading (and I know you are), I have one question: will you marry me?